CLASSIC CAMERAS

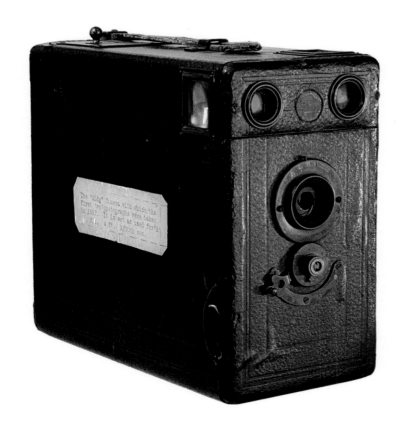

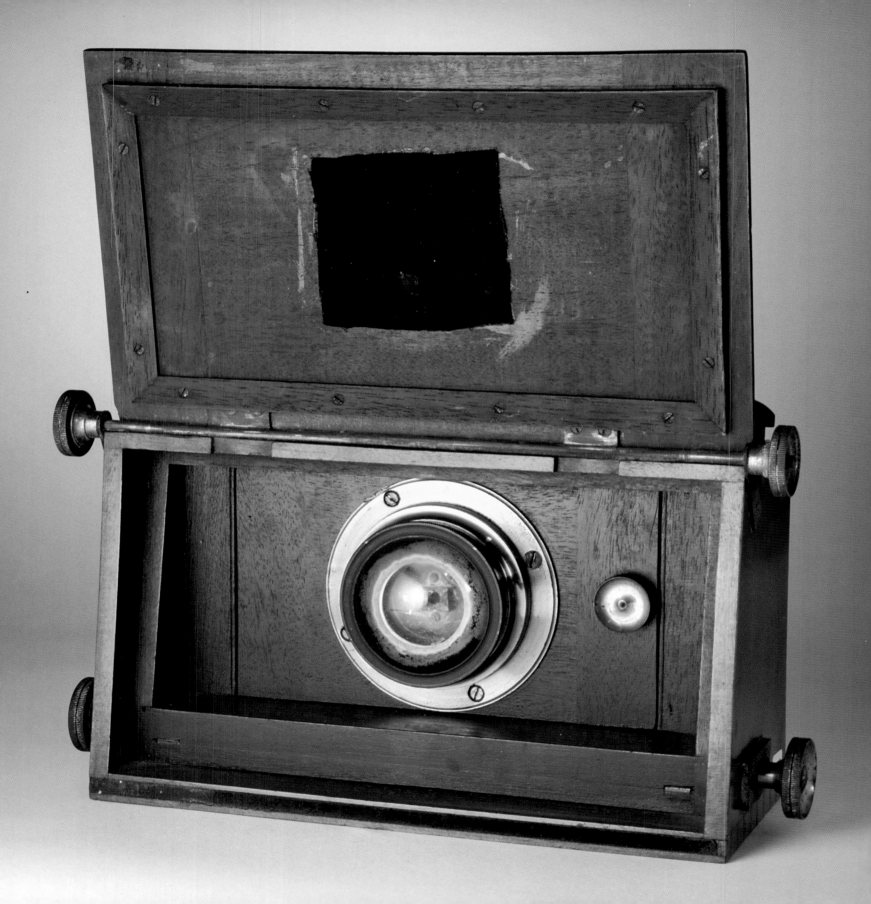

CLASSIC CAMERAS

COLIN HARDING

CURATOR, NATIONAL MEDIA MUSEUM

PHOTOGRAPHED BY

PAUL THOMPSON

photographers'
pip
institute press

First published 2009 by
Photographers' Institute Press
An imprint of:
Guild of Master Craftsman Publications Ltd
166 High Street,
Lewes, East Sussex BN7 1XU

A catalogue record for this book is available from the British Library.

Associate Publisher: *Jonathan Bailey*
Production Manager: *Jim Bulley*
Managing Editor: *Gerrie Purcell*
Editor: *Gill Parris*
Managing Art Editor: *Gilda Pacitti*
Designer: *Ali Walper*

Set in Perpetua, The Mix and Engravers Gothic

Colour origination by GMC Reprographics
Printed and bound in Thailand by Kyodo Nation Printing

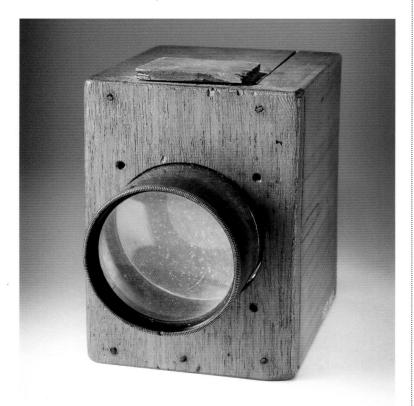

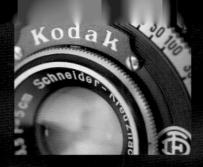

Introduction

WHAT MAKES A CAMERA A 'CLASSIC'? THIS SEEMINGLY SIMPLE QUESTION HAS BEEN THE SUBJECT OF MUCH DEBATE AND, INDEED, SOME ARGUMENT AMONG THE NORMALLY PLACID COMMUNITY OF CAMERA COLLECTORS.

'... in order to be considered a classic, a camera must embody some quality which raises it above the common herd.'

Those seeking a definitive answer to the question 'What makes a camera a classic?' will not find it within the pages of this book. Both an adjective and a noun, 'classic' is defined in the dictionary as, amongst other things, 'of the highest quality', 'of enduring interest, quality or style', 'standard or typical' and 'definitive'. Classic cameras may be all of these things but, ultimately, the term defies any rigid categorization. In my humble opinion, in order to be considered a classic, a camera must embody some quality that raises it above the common herd. This quality might be revealed through many different criteria, for example, construction, ingenuity, innovation, design, commercial significance, application, or personal association.

Classic cameras transcend temporal, monetary and quantitative boundaries. Many of the cameras included in this book are old, rare, sophisticated and expensive, but some are relatively common, simple, cheap and modern. Whilst no one, I suspect, would challenge the inclusion of the Leica, some might question the Kodak Instamatic's status as a classic. Yet, I would argue that its combination of innovative design and enormous commercial success clearly marks it out as one of the most significant cameras of the twentieth century. At the end of the day, 'classic' status, like beauty, often lies largely in the eye of the beholder.

The difficult task of selecting which cameras to include in this book was as much a subjective as an objective process, and I make no apologies for this. We all have our favourite cameras and some, unfortunately, will not appear here.

I hope, however, that I have at least succeeded in creating a broad survey encompassing the famous and the relatively unknown, the rare and the commonplace, the old and the relatively modern – together with a dash of the unusual for good measure. This book is not intended to be a comprehensive history of the camera or even, indeed, a definitive study of those particular cameras that I have selected. Limits of space and, more importantly, enormous gaps in my personal knowledge preclude this. I hope, however, that the book will whet the appetites of those who wish to learn more about the history of the camera and its many fascinating manifestations.

All of the cameras featured in this book share one thing in common. They are all from the collection of the National Media Museum (formerly the National Museum of Photography, Film & Television) in Bradford, United Kingdom. For the past twenty-five years I have had the enviable privilege of working with this, one of the world's pre-eminent collections of photographic technology.

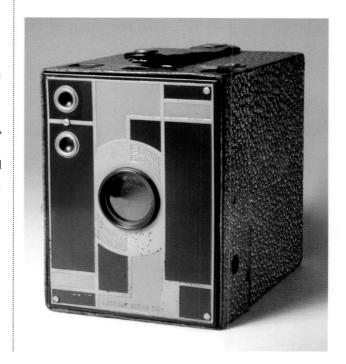

It is, perhaps, more accurate to describe this photographic cornucopia as a 'collection of collections', incorporating, as it does, the holdings of The Science Museum, The Kodak Museum and The Royal Photographic Society. Each of these institutional collections has a long and proud independent history and each, individually, is regarded as 'world class'. Now united at the National Media Museum, they form a resource that is unparalleled in its breadth and scale.

The origins of the collection can be traced back to February 1882 when a letter, written by the distinguished photographic scientist William Abney, appeared in *The British Journal of Photography*: 'Gentlemen, The Director of the South Kensington Museum is anxious to obtain a collection illustrating the history of photography from its commencement ... illustrations of early processes would be most valuable, also apparatus possessing an historical interest'. The editor commented '... surely no more favourable conditions or greater inducements could be offered to the possessors of historical interest than the promise of a permanent home in the great National Museum'. From these humble beginnings, well over a century ago, the collection has grown to encompass thousands of items. Together, they trace the evolution of photographic apparatus from the camera obscura to the latest digital cameras – from William Henry Fox Talbot's experimental 'mousetraps' to today's mobile phone cameras. All of this material is now assured of a safe and permanent home 'in the great National Museum'. This book can only hint at the wealth of treasures contained within the collection. The majority of the cameras in this book are on permanent display at the Museum and all of them can be viewed by appointment in *Insight*, the Museum's Collection and Research Centre.

Colin Harding
Curator of Photographic Technology
National Media Museum, Bradford

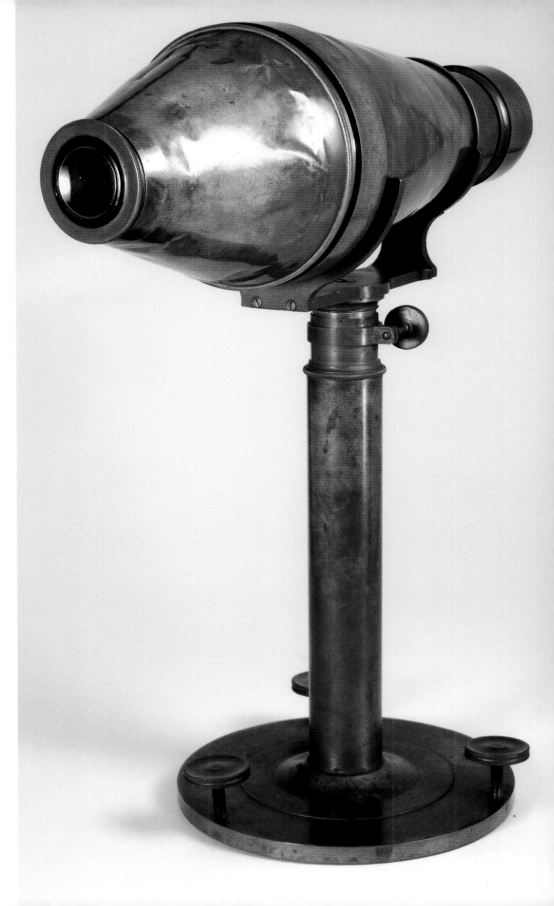

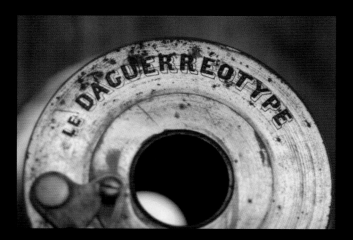

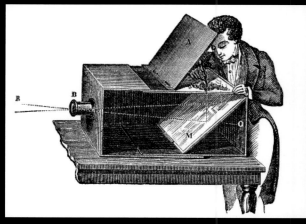

THE EARLY YEARS

THE CAMERA WAS INVENTED LONG BEFORE PHOTOGRAPHY
AND THE PHENOMENON OF THE CAMERA OBSCURA HAD
BEEN KNOWN SINCE ANCIENT TIMES. BY THE SEVENTEENTH
CENTURY, PORTABLE VERSIONS WERE BEING USED BY ARTISTS
TO HELP WITH DRAWING AND PERSPECTIVE. THE FIRST
PHOTOGRAPHIC EXPERIMENTS WERE MADE USING CAMERA
OBSCURAS. THE PUBLIC ANNOUNCEMENT OF THE INVENTION
OF PHOTOGRAPHY IN 1839 WAS FOLLOWED BY A RAPIDLY
GROWING DEMAND FOR COMMERCIALLY PRODUCED CAMERAS,
AND MANY OPTICIANS AND SCIENTIFIC INSTRUMENT MAKERS
DEVISED INNOVATIVE NEW DESIGNS.

Top left: The Giroux (page 18)
Top right: Camera Obscura (page 15)
Left: Talbot's 'Mousetrap' (page 16)

The Camera Obscura

INITIALLY A SKETCHING AID FOR ARTISTS, THE CAMERA OBSCURA,

OR 'DARK ROOM', WAS THE FIRST DEVICE TO HARNESS

THE IMAGE-FORMING PROPERTIES OF LIGHT.

It may seem an anachronism, but the camera was actually invented hundreds of years before the birth of photography. Those with the benefit of a classical education will know that 'camera' is the Latin word for 'room'. The word still retains this original meaning in several modern usages. We talk, for example, of private discussions taking place 'in camera' – literally, in a closed room. So what have rooms got to do with photography? The link is the phenomenon known as the 'camera obscura' or 'dark room'.

The phenomenon of the camera obscura had been observed since ancient times. If a small hole is made in the window blind or shutters of a darkened room, an inverted image

'Many artists ...

used a camera

obscura to aid them

with composition,

perspective and

drawing, although

most were naturally

reluctant to admit

the fact.'

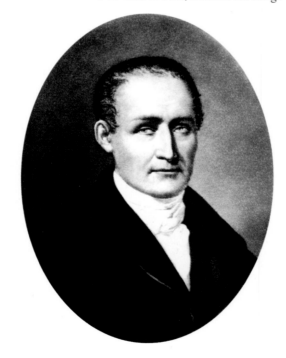

of the scene outside the window is produced on the opposite wall of the room. In the early sixteenth century, Leonardo da Vinci wrote a clear description of a camera obscura in one of his notebooks. At about the same time, it was realized that a brighter and sharper image could be produced by replacing the small hole with a lens. Incidentally, the word 'lens' also has an interesting etymology: 'lens' is Latin for lentil and the first, simple, lenses – which were bi-convex in shape – got their name from the fact that they were shaped like the brown lentils used to make soup.

In 1568 a Venetian, Daniel Barbaro, recommended the camera obscura as a useful aid for artists: 'By holding the paper steady you can trace the whole perspective outline with a pen, shade it and delicately colour it from nature'. Many artists – most notably, Vermeer (1632–75) – used a camera obscura to aid them with composition, perspective and drawing, although most were naturally reluctant to admit the fact.

At first, camera obscuras were actual rooms. However, by the seventeenth century smaller, portable versions, more practical for everyday use, appeared. Some of these were large, elaborate devices incorporating tents or sedan chairs, but the most convenient and popular form were small wooden boxes, fitted with a lens at the front, projecting an image onto a ground glass screen at the rear. This design was later refined by adding a mirror behind the lens at 45 degrees to reflect the image onto a horizontal glass screen (see page 15).

During the eighteenth century, this became the most popular form used by artists. It had two advantages: firstly, the artist could easily trace the image by placing a piece of thin paper on the glass screen; secondly, the mirror served to correct the inverted image so that it could be viewed the right way up. It was devices like these that became the first photographic cameras when they were used by the inventors of photography – Niépce (left), Daguerre and William Henry Fox Talbot.

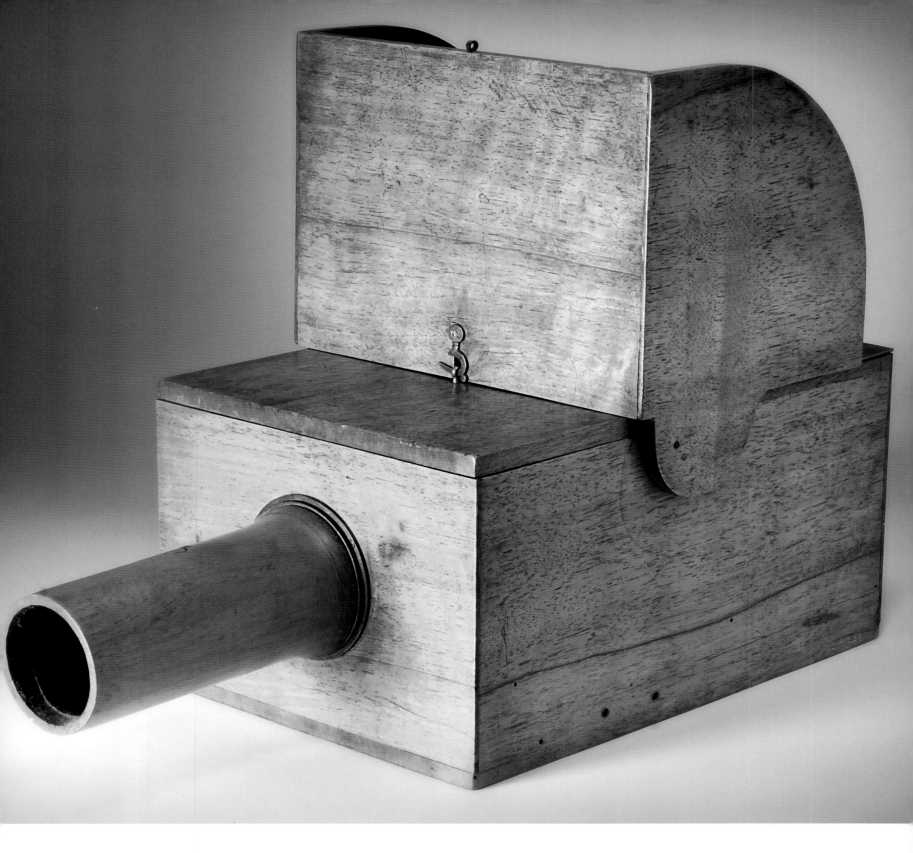

This particular camera obscura (page 13) was owned by Talbot who used it whilst on a trip to Italy in 1823. Ten years later, in 1833, he was in Italy again, on his honeymoon. This time, in order to record the landscape, he had taken along a sketching aid called a *camera lucida* — a

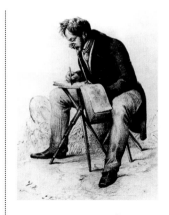

device invented by the English physicist William Hyde Wollaston in 1807. The name was a misnomer — this wasn't a camera at all in the accepted sense of the word: the camera lucida was a prism mounted on a brass rod. When the artist looked through the prism a virtual image was produced which could be traced on paper (right). Simple in theory, but in practice the instrument was notoriously difficult to use and Talbot quickly became frustrated in his attempts to sketch Lake Como, calling his drawings 'melancholy to behold'. Reflecting on his failure as an artist, he considered a different approach: 'I thought of trying again a method I had tried many years before ... to take a camera obscura and throw the image of the objects on a piece of transparent tracing paper laid upon a pane of glass in the focus of the instrument ... It was during these thoughts that the idea occurred to me ... how charming it would be if it were possible to cause these natural images to imprint themselves durably and remain fixed upon the paper.' This was the genesis of photography.

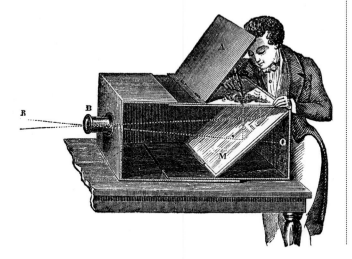

'*... in order to record the landscape, he had taken along a sketching aid called a camera lucida ... '*

Talbot's 'Mousetrap'

THE EARLIEST CAMERAS WERE SIMPLE WOODEN BOXES FITTED WITH LENSES TAKEN FROM TELESCOPES AND MICROSCOPES. THESE 'MOUSETRAPS' WERE DESIGNED TO CAPTURE LIGHT.

Upon his return to England, following his honeymoon in Italy in 1833, William Henry Fox Talbot (facing page, bottom right) began experimenting with sheets of paper made light-sensitive by coating them with silver salts. He soon succeeded in making what he called 'photogenic drawings' (facing page, top right) – negative, silhouette images of objects such as leaves or lace, produced by direct contact-printing. Naturally, Talbot also tried to capture images directly from nature by placing his photogenic drawing paper in a camera obscura. However, he found that the comparative insensitivity of the paper, combined with the limited aperture of the lens, meant that an image was obtained only after a very long exposure.

'One camera, possibly the earliest, was made by simply sawing what looks like a cigar box in half ...'

In the summer of 1835, helped by a spell of particularly sunny weather, Talbot tried again. Crucially, he had by this time devised a process of improving the sensitivity of his paper. He had also correctly reasoned that exposure times could be shortened by using a camera with a small image size and a large aperture lens. Interestingly, this is exactly the same idea that was adopted nearly a hundred years later for the Ermanox camera (see page 104). Consequently, Talbot had made a number of small wooden boxes, only about 2 or 3 inch (51 or 76mm) cubes, which he fitted with lenses taken from the eyepieces of telescopes and microscopes. There is an undocumented tradition that these first photographic cameras were made by a local carpenter named Joseph Foden. Some, however, are too crudely made to be the work of any self-respecting craftsman. One camera, possibly the earliest, was made by simply sawing what looks like a cigar box in half, so it is quite possible that William Henry Fox Talbot made at least some of them himself.

Talbot placed these boxes around the family home, Lacock Abbey in Wiltshire, and waited for the sun to work its 'little bit of magic'. In a letter, Talbot's wife, Constance, wrote about her husband's seemingly eccentric behaviour and referred to these little boxes as 'mousetraps'. The name has stuck and they are now usually referred to as Talbot's mousetrap cameras. On reflection, they do indeed resemble simple traps, designed in this case, however, to capture the sun rather than unwanted pests.

With his 'mousetrap' cameras, Talbot reduced the exposure times needed to as little as ten minutes on a bright day. The world's earliest surviving negative, of a latticed window at Lacock Abbey, was taken in August 1835 using one of these little cameras. This negative, along with several examples of Talbot's experimental cameras – priceless artifacts from the birth of photography – are now preserved at the National Media Museum in Bradford.

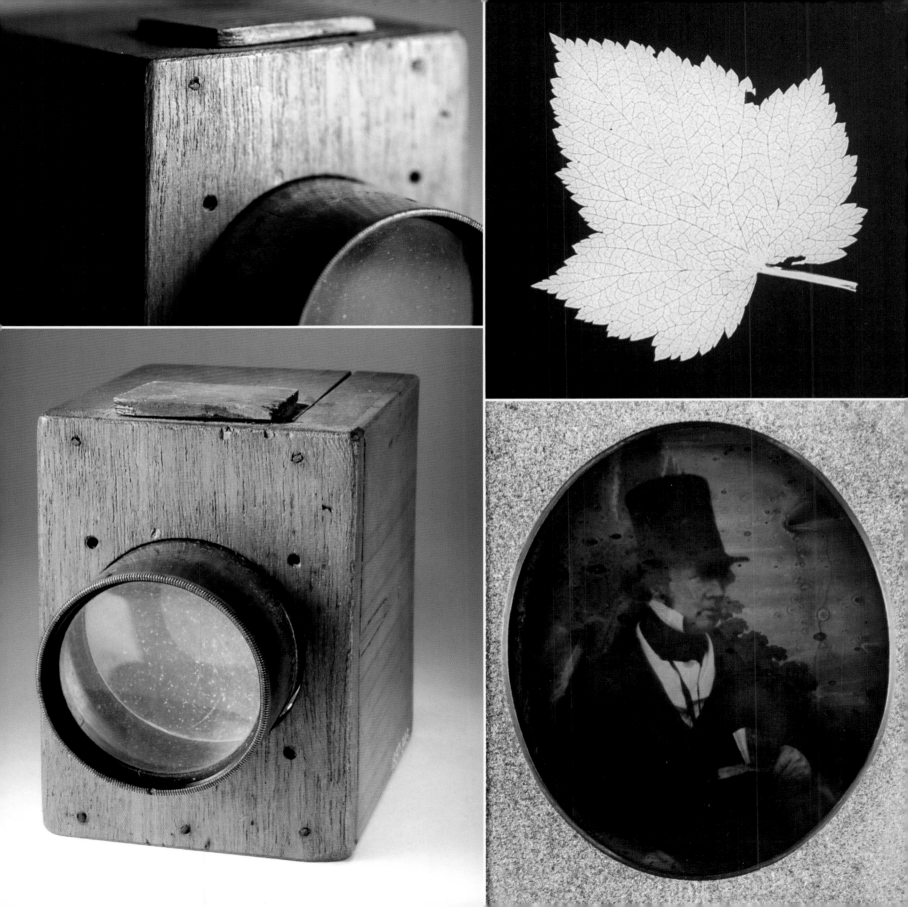

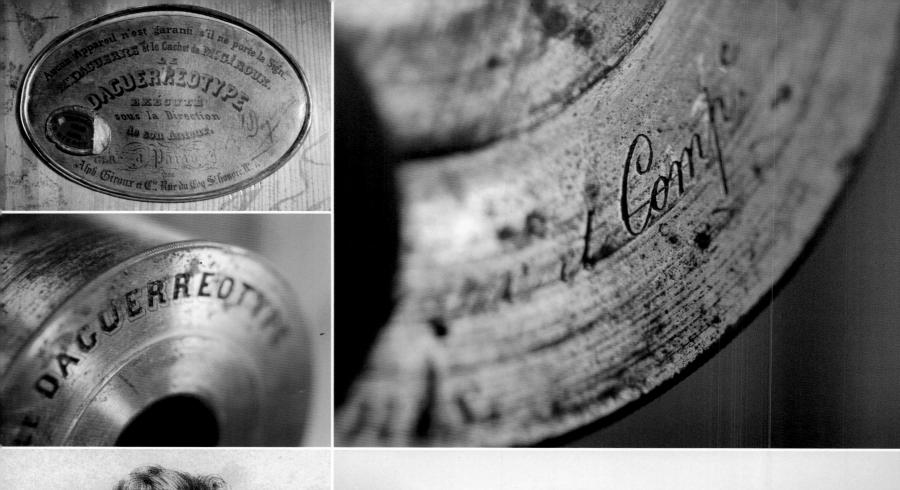

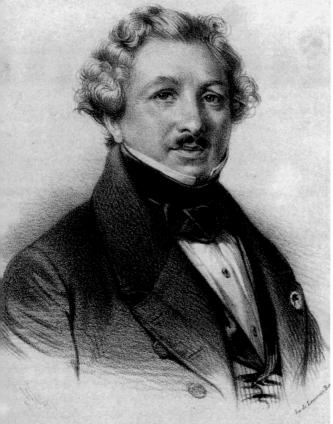

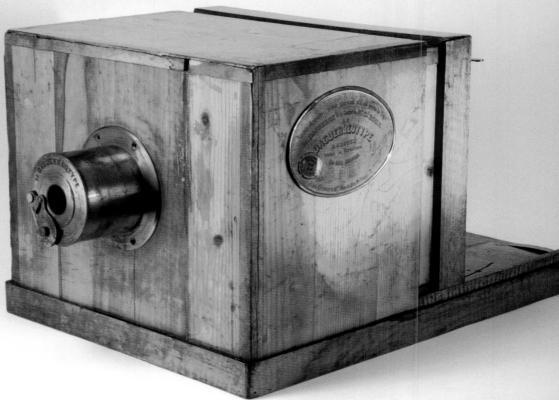

Giroux Camera

MADE BY STATIONER ALPHONSE GIROUX, THE DAGUERREOTYPE HAS BEEN DESCRIBED AS 'THE MOST IMPORTANT CAMERA IN THE HISTORY OF PHOTOGRAPHY'. ONLY A DOZEN SURVIVE.

On 7 January 1839, the distinguished French scientist, François Arago, made the first public announcement of the invention of photography. The Daguerreotype process, named after its inventor, Louis Jacques Mandé Daguerre (facing page, bottom left), was announced at a meeting of the *Académie des Sciences* in Paris. No working details were revealed, however, until August that year when the first instruction booklet appeared. The person chosen by Daguerre to publish details of his process was Alphonse Giroux, who owned a stationery shop on the Rue de Coq Saint Honoré. Since Giroux was related to Daguerre's wife this was a perfectly understandable case of 'keeping things in the family'. More surprising, however, was Daguerre's decision also to entrust Giroux with the manufacture of the equipment needed for his process.

One box, fitted with a ground glass focusing screen and plate holder, slid on a baseboard into a slightly larger box that was fitted with the lens. The Chevalier achromat lens had a focal length of 15 inches (381mm) and an aperture of approximately f/15. Since, using Daguerre's original process, exposure times were measured in minutes rather than seconds, no shutter was needed. The plate was exposed by moving aside a pivoted cover in front of the lens. The plate size was 6½ by 8½ inches (165 x 203mm), which was to become the standard 'whole-plate' size from which many of the later plate sizes were derived. Named *Le Daguerreotype*, each camera carried a guarantee of authenticity in the form of an oval plaque on its side. In addition to a wax seal and Daguerre's signature this was inscribed in French: 'No apparatus is guaranteed if it does not bear the signature of Mr Daguerre and the seal of Mr Giroux. The Daguerreotype, made under the direction of the inventor in Paris by Alph. Giroux and Co, Rue de Coq St Honoré, No 7.' Only about a dozen Giroux cameras have survived. Three of them, including one owned by William Henry Fox Talbot and modified by him for use with his calotype paper negative process, are now in the collection of the National Media Museum in Bradford.

'The camera, as designed by Daguerre and manufactured by Giroux, was of sliding box construction .'

Charles Chevalier, the scientific instrument maker who had made all of Daguerre's experimental apparatus, was naturally incensed, commenting that: 'An optician was needed, a stationer was chosen'. Chevalier's feelings were placated somewhat when he was asked to supply the lenses for Daguerre's cameras – a task that was clearly beyond Giroux. A contract was drawn up whereby Giroux was to keep half of the profits from the sale of apparatus and the other half was to be divided equally between Daguerre and Isidore Niépce, the son of Daguerre's business partner, Nicéphore Niépce, who had died six years earlier. The camera, as designed by Daguerre and manufactured by Giroux, was of sliding box construction.

Until recently, it had always been presumed that the Giroux camera was the very first photographic camera to go on sale to the public. As such, it has been described as 'the most important camera throughout the whole history of photography.'

In May 2007, however, what is possibly a slightly earlier camera was auctioned in Vienna. The only known example of a daguerreotype camera made by the Parisian manufacturer Susse Frères, it was bought by an anonymous bidder for nearly £400,000, making it not only the earliest but also the most expensive camera in the world.

Voigtländer Daguerreotype Camera

WITH ITS FAST, CUSTOM-BUILT LENS, THE VOIGTLANDER CAMERA CUT EXPOSURE TIMES DRAMATICALLY, MAKING PORTRAITURE A PRACTICAL POSSIBILITY FOR THE FIRST TIME.

Peter Wilhelm Friedrich Voigtländer was born into a family of optical instrument makers. His grandfather, Johann, had established a small business in Vienna in 1756, manufacturing microscopes, compasses and other optical instruments. Johann had three sons, the youngest of whom, also named Johann, carried on the family business after his father's death and began making lenses in about 1808. After he retired in 1837, the management of the family business was taken over by his son, Peter, then aged just 25.

By this time the house of Voigtländer had already gained an enviable reputation as one of the very finest European optical instrument makers. Peter, although still comparatively young, already had a wealth of knowledge and experience. His early education and practical instruction came from his father. For his more advanced and theoretical education he later enrolled at the Vienna Polytechnic Institute. Peter Voigtländer's primary area of interest was optical theory. It was almost inevitable, therefore, that he soon befriended and began to collaborate with the brilliant mathematician Josef Max Petzval who in 1837, the same year that Peter took over the running of the family business from his father, had become professor of higher mathematics at the University of Vienna. In 1840, Petzval, who had not designed a lens before, mathematically calculated the optimum arrangement for a lens intended specifically for photography. Up to this time, camera objectives were simple lenses that had been designed for other uses.

'Resembling a cross between a thermos flask and a mortar bomb, Voigtländer's camera was of all-metal construction.'

The slowness of these lenses exacerbated the lack of sensitivity of the earliest photographic processes. Petzval entrusted the construction of his lens design to his friend, Peter Voigtländer.

The Petzval lens had an aperture of about f/3.6. This made it sixteen times faster than the simple meniscus lenses that were currently in use and reduced exposure times from minutes to seconds, making portraiture a practical possibility for the first time. In 1841, Voigtländer fitted a Petzval lens into an all-metal daguerreotype camera that he both designed and manufactured. Resembling a cross between a thermos flask and a mortar bomb, Voigtländer's camera was of all-metal construction. It consisted of a conical brass body with a Petzval lens at its apex. A shorter conical focusing attachment with a ground glass screen and a magnifying eyepiece could be screwed into the other end of the camera body. In use, the camera rested in a cradle on top of a telescopic pillar. After focusing, using a rack and pinion mechanism, the camera was removed from the cradle and carried to a darkroom where the focusing attachment was removed and replaced by a plate-holder containing a sensitized circular daguerreotype plate. The camera was then carefully repositioned on its stand and the exposure made by removing and replacing the lens cap.

It is estimated that around 600 Voigtländer daguerreotype cameras were sold, but only about a dozen examples of this iconic and seminal camera are known to have survived. Over the years, however, the Voigtländer firm produced a number of replica versions of this, their very first camera. In 1939, 25 replicas were made to commemorate the centenary of the birth of photography. In 1956, 200 were made to mark the 200th anniversary of the founding of the company and in 1978, a further 100 replicas were produced. These replicas are now also highly sought after by collectors and can be easily identified because they all carry the serial numbers 81 or 84.

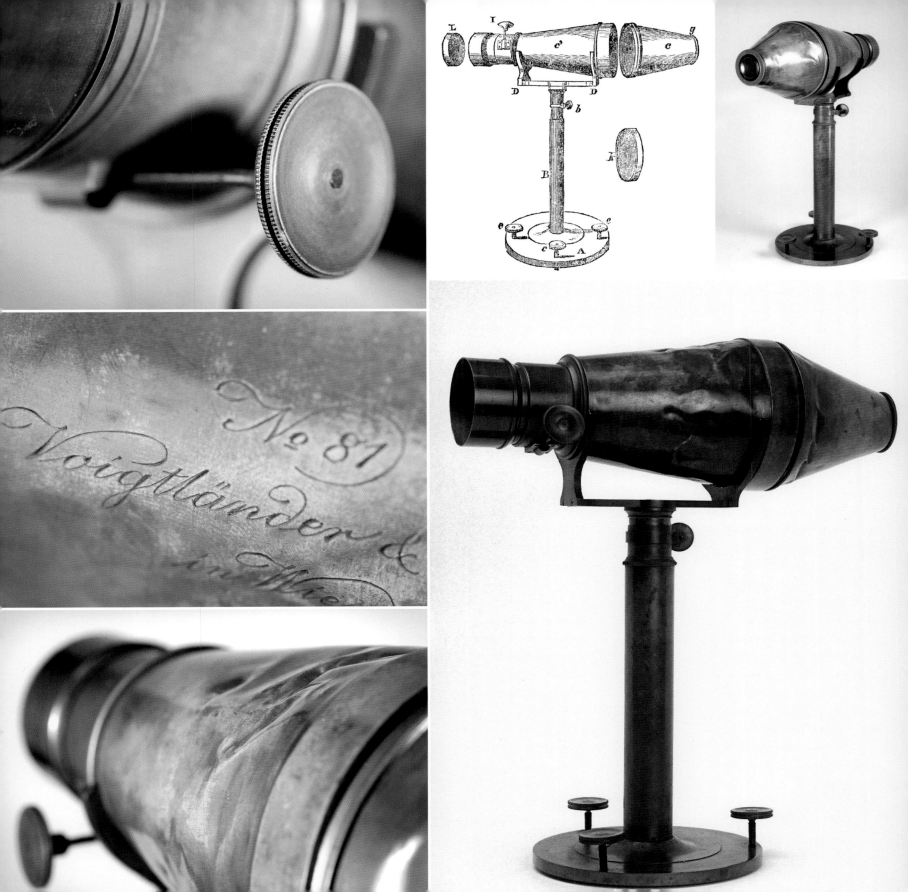

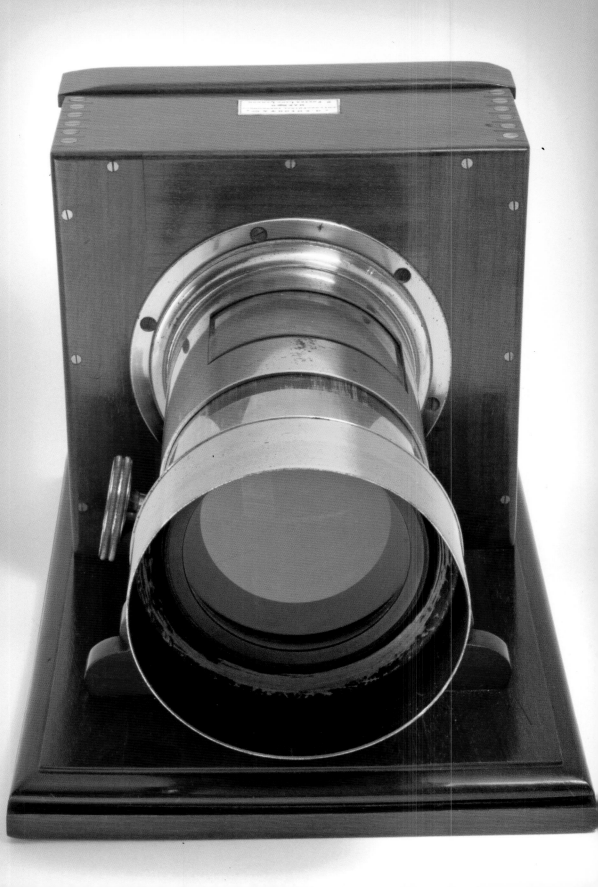

Knight's Daguerreotype Camera

WITH A VOIGTLANDER LENS AND AN UNUSUAL RACK-AND-PINION FOCUSING SYSTEM, THIS SUPERB MODEL WAS MANUFACTURED BY BRITISH PHOTOGRAPHIC DEALER GEORGE KNIGHT IN 1853.

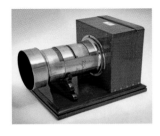

'Good pictures can be produced with it in bad weather and on dull days, when other lenses would be useless.'

Based in Foster Lane, Cheapside, London (right), George Knight was one of the first photographic dealers in Britain. As early as 1845, George Knight and Sons were advertising a sliding-box calotype camera manufactured to a design by George Cundell (see page 24). In 1852, Knight became the British agent for Voigtländer lenses. His 1853 catalogue lists a number of daguerreotype cameras designed specifically for use with Voigtländer lenses, including this camera fitted with a compound portrait lens.

Of unusual design, but showing superb workmanship, this simple camera consists of a wooden box, containing the dark slide and focusing screen, to which is attached a brass-bound Voigtländer No 4 combination achromatic lens. Rather than the more usual sliding-box arrangement, focusing is achieved solely by a rack and pinion adjustment on the lens. The large aperture and short focal length (about 2½ inches/64mm) of this lens meant that it was particularly suitable for portraiture. The catalogue description states: 'It is admirably suited for taking portraits in private rooms and other places not generally adapted for the purpose, and also portraits of children. Good pictures can be produced with it in bad weather and on dull days, when other lenses would be useless.' The camera, complete with lens, sold for £25.5s. The lens alone, however, if bought separately, cost the princely sum of £23.

The lens barrel on this camera has been cut to take Waterhouse stops. In July 1858, John Waterhouse, in a letter to the *Photographic Journal*, suggested changing the aperture of a lens by using a series of diaphragms made from brass strips which could be slid into a slot in the lens barrel between the lens components. By about 1860, most lens makers were fitting their products with Waterhouse stops. The illustration of this camera in the 1853 catalogue shows the lens without Waterhouse stops, of course. It is possible that this camera was modified after it had already been in use for several years. Alternatively, it may date from around 1858–1860, making it a comparatively late example of a British daguerreotype camera.

The whole of the Apparatus, Instruments, Materials, and Tests described in these, and in various other Works in the several branches of experimental Science, may be procured of

GEORGE KNIGHT AND SONS,

MANUFACTURERS OF

CHEMICAL AND PHILOSOPHICAL APPARATUS,

AT THEIR EXTENSIVE

WHOLESALE AND RETAIL ESTABLISHMENT,

FOSTER LANE, LONDON.

Cundell's Camera

A KEEN INNOVATOR, GEORGE CUNDELL HELPED TO POPULARIZE CALOTYPE PHOTOGRAPHY AND PRODUCED THE FIRST CAMERA TO INCORPORATE A LENS HOOD AND FOCUSING SCALE.

George Smith Cundell, the eldest of four brothers, was born in Leith, Scotland, in 1798. One of his brothers, Joseph, remained at home whilst George, Charles and Henry Cundell moved to London in the 1820s. There they befriended a fellow Scots exile, the young engineer James Nasmyth. Many years later, Nasmyth recalled in his autobiography: 'Among my most intelligent friends in London were George Cundell and his two brothers ... the elder brother was an admirable performer on the violincello and he treated us ... with noble music from Beethoven and Mozart He was thoroughly versed in general science, and was moreover a keen politician. He had the most happy faculty of treating complex subjects, both in science and politics, in a thoroughly common-sense manner.'

In February 1844, George Cundell wrote what was regarded as the first, definitive practical account of the calotype process, 'On the Practice of the Calotype Process of Photography', published in *The London, Edinburgh and Dublin Philosophical Magazine* in May of that year. In this paper, Cundell not only gave detailed information about the chemical working of Talbot's process but also described a calotype camera of his own design since 'Before anything good can be produced in calotype, the operator must be provided with a properly constructed camera obscura.'

Cundell's camera was of conventional sliding-box pattern but incorporated several important innovations. It was the first camera to have internal baffles to minimize reflections inside the camera body (facing page, bottom left). It was also the first to have a lens hood or, as Cundell described it, an 'elongation of the mouthpiece'. More significantly, it was the first camera to be provided with a focusing scale or, to be precise, two focusing scales. With the simple lenses in use at the time, different coloured light was focused at different points. A correctly focused image on the ground glass screen could result in an unsharp negative.

'Before anything good can be produced in calotype, the operator must be provided with a properly constructed camera obscura.'

During the early 1840s George Cundell devoted his considerable scientific knowledge and commonsense to the service of photography. In 1841, William Henry Fox Talbot had patented his 'calotype' paper negative process. However, would-be photographers were frustrated by the lack of any detailed published instructions on how to work the process. As Lady Elizabeth Eastlake wrote in *The Quarterly Review* in 1857: 'Mr F. Talbot's directions, though sufficient for his own pre-instructed hand, were too vague for the tyro; and an enlistment into the ranks of the "Pilgrims of the Sun" seldom led to any result but that of disappointment.' She continued: 'Mr George Cundell gave in great measure the fresh stimulus that was needed.'

Cundell differentiated between what he called chemical focus and optical focus – 'the former being about one thirty-sixth part shorter than the latter for parallel rays' – and provided focusing scales for both. With a pair of graduated scales you could ensure accurate focus by 'merely measuring the distance of the object, if near, or by guessing at it if out of reach.'

Cundell's camera was initially supplied by J.C. Dennis, Astronomical, Philosophical and Optical Instrument Makers of Bishopsgate, London. By 1845 it was being advertised by George Knight and Sons of Cheapside – 'Calotype camera. On the plan of Mr Cundell, with Meniscus lens and graduated scales. £2.12s.6d.'

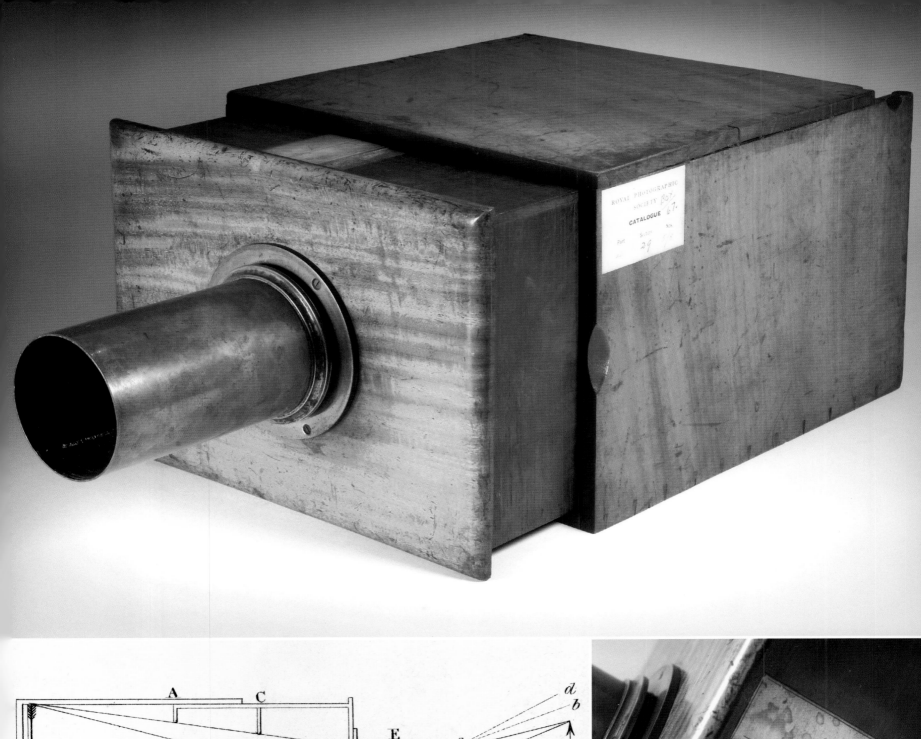

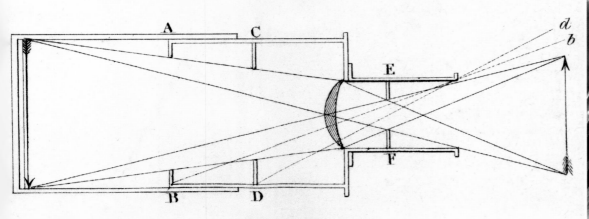

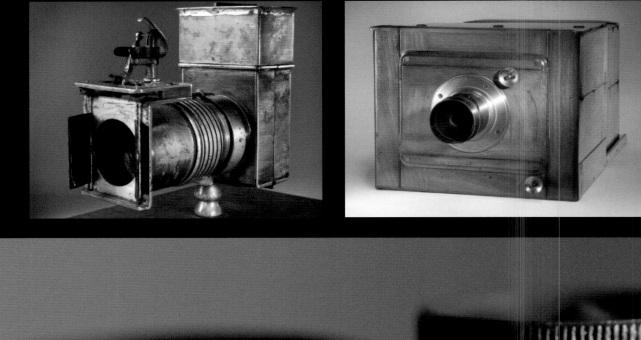

WET PLATE CAMERAS

THE INTRODUCTION OF FREDERICK SCOTT ARCHER'S WET

PLATE PROCESS IN THE EARLY 1850s STIMULATED A

GROWTH IN COMMERCIAL PHOTOGRAPHY. THE 1850s

SAW THE EMERGENCE OF SPECIALIZED PHOTOGRAPHIC

MANUFACTURERS AND THE APPEARANCE OF INNOVATIVE NEW

CAMERA DESIGNS. SLIDING-BOX CAMERAS, THE PREDOMINANT

DESIGN DURING THE 1840s, WERE STILL PRODUCED, BUT

THEY WERE GRADUALLY SUPERSEDED BY COLLAPSING AND

FOLDING BELLOWS CAMERAS. INTERNAL-PROCESSING

CAMERAS, SEEN AS A WAY OF REDUCING THE AMOUNT OF

EQUIPMENT TRAVELLING PHOTOGRAPHERS HAD TO CARRY,

WERE ALSO DEVISED. THE POPULARITY OF STEREOSCOPIC

IMAGES IS REFLECTED IN THE VARIED DESIGNS FOR TWIN-

LENS BINOCULAR CAMERAS.

Top left: Skaife's Pistolgraph (page 45)
Top right: Ottewill 's Double Folding Camera (page 30)
Left: Dancer's Binocular Stereoscopic Camera (page 42)

Archer's Camera

DESPITE INVENTING THE COLLODION PROCESS AND USING IT TO CREATE THE FIRST PORTABLE DARKROOM, FREDERICK SCOTT ARCHER DIED PENNILESS, A 'MARTYR OF SCIENCE'.

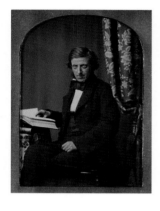

'Archer ... didn't patent his process and he received no financial gain from its widespread adoption.'

Photography's first decade was characterized by the use of two very different processes – the direct positive daguerreotype process on metal and the negative/positive calotype process on paper. In 1851, however, another process appeared which was to rapidly supersede both of these and dominate photography for the next thirty years. This was the wet plate or collodion process, invented by Frederick Scott Archer (left).

Archer was born in Bishop's Stortford, Hertfordshire, in 1813. A butcher's son, he had been a silversmith's apprentice, a coin valuer and a sculptor before taking up photography in about 1847 as an aid to his work. Archer used the calotype process but wasn't satisfied with the quality of the paper negatives it produced: 'The imperfections in paper photography … has induced me to … find some other substance more applicable, and meeting the necessary conditions required of it, such as fineness of surface, transparency and ease of manipulation.' The 'other substance' that Archer experimented with was collodion – a recently discovered substance that was used as a medical dressing. A sticky solution of gun cotton in ether, collodion dried quickly to form a tough, transparent waterproof skin. Archer coated a glass plate with a mixture of collodion and potassium iodide, then sensitized the plate by immersing it in a solution of silver nitrate. Because the plate had to be exposed immediately, before it dried, the process was popularly known as the wet plate process. Archer published the full details of his process in the journal *The Chemist*, in March 1851.

Like George Cundell before him, Archer was interested in camera design as well as photographic chemistry. In April 1853, he demonstrated a camera made to his own design at a meeting of The Photographic Society. Archer's camera, 'where the whole process of a negative picture is completed within the box itself', was also a portable darkroom. At the back of the camera were two black velvet sleeves, through which the photographer could put his hands to manipulate the glass plate – sensitizing, developing and fixing it. An amber window allowed the photographer to see what he was doing. Trays and bottles of chemicals were stored inside the camera. When folded for carrying, the camera was very compact, measuring only about 12 x 12 x 18 inches (305 x 305 x 457mm). Folding collodion cameras, based on Archer's design, were made and sold by Thomas Ottewill & Co from 1854.

Archer wasn't a commercially motivated man. He didn't patent his process and he received no financial gain from its widespread adoption. When he died in 1857, aged just 44, his family was left penniless. The *Journal of the Photographic Society* reported, somewhat melodramatically: 'Another victim has been added to the long catalogue of martyrs of science. Mr. Frederick Scott Archer, the true architect of all those princely fortunes which are being acquired by the use of his ideas and inventions, after struggling for some time for bare existence, has now departed from among us; and, as the end of a life's labour, has left all that he held dear and sacred, a dependent wife and family, destitute.'

A charity fund was set up by the photographic community which eventually raised over £700. One of the contributions, a cheque for £25, came from the Secretary of the Photographic Society of Scotland, Charles Kinnear (see page 35).

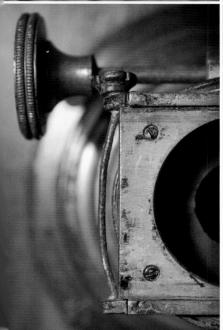

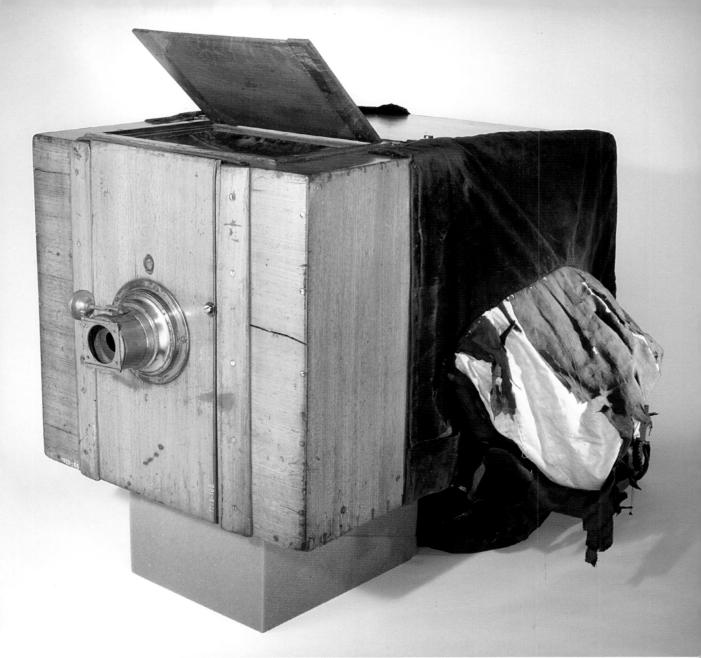

THE SCOTT ARCHER
REGISTERED
FEBY 24 1854
ACT 6 & 7
VIC. C. 65
Nº 3570
106 G RUSSELL ST BLOOMSBY

1929-169

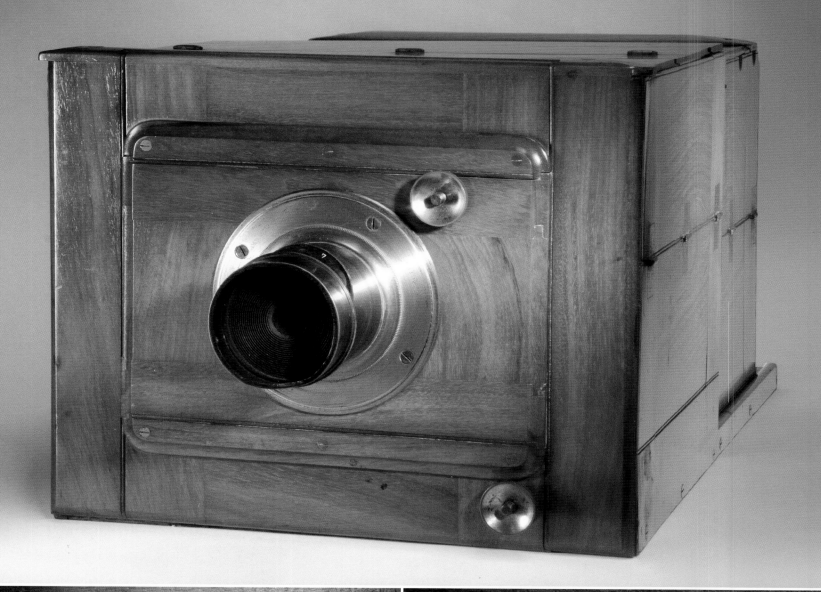

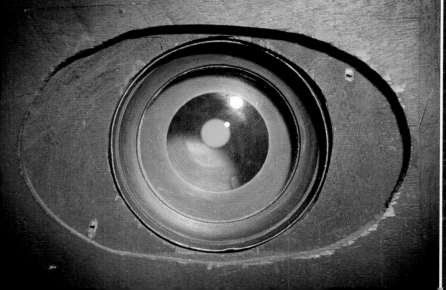

Photographic Institution.
168, NEW BOND ST.
LONDON.

T. OTTEWILL,
Regist.d 25 May, 1853 – N.º 57.

Ottewill's Double Folding Camera

IMMORTALIZED IN VERSE BY LEWIS CARROLL, THOMAS OTTEWILL'S INGENIOUS FOLDING CAMERA DESIGN COMBINED OUTSTANDING QUALITY WITH UNPRECEDENTED PORTABILITY.

The very first cameras were simple boxes, with a lens at one end and a holder for sensitized material at the other. In order to facilitate focusing, a variation on this basic design soon appeared, known as the sliding-box camera. This design consisted of two separate boxes, one fitted with the focusing screen and plate holder which slid in and out of a slightly larger box on which the lens was mounted. This type of camera became the standard design for general photography during the 1840s and 1850s.

Although they were robust and simple to make and operate, sliding-box cameras suffered from a serious drawback – they were heavy, bulky and awkward to carry about. This was particularly inconvenient if you wanted to work outside the studio. To try and solve the problem, some manufacturers produced collapsible, folding versions of sliding-box cameras. A number of British makers introduced such cameras during the 1850s, including Horne & Thornthwaite and Bland & Long. However, the best-known and most successful of these ingenious folding cameras was Ottewill & Co's Double Folding Camera, whose design was formally registered in 1853. When the lens panel and focusing screen or dark slide are removed from the camera, hinges in the side panels of the two boxes which form the body of the camera allow them to be folded flat, making a compact package. The photographic press were impressed. The *Journal of the Photographic Society* thought that the design 'fully combines the requisite strength and firmness with a high degree of portability and efficiency'.

'Although they were robust and simple to make and operate, sliding box cameras ... were heavy, bulky and awkward to carry about.'

The camera's maker, Thomas Ottewill, had set up in business as a philosophical instrument maker in Islington, London, in 1851, making him one of the very earliest British manufacturers and retailers of photographic equipment. Ottewill & Co soon gained a reputation for producing cameras made with the highest quality of workmanship. When a young Oxford mathematics lecturer and keen amateur photographer named Charles Lutwidge Dodgson was shopping around for a new camera, the premises of Ottewill & Co were an obvious choice. In his diary for 18 March 1856, Dodgson recorded: 'we [his close friend Reginald Southey, who had taught him the basics of photography, accompanied him] went to a maker of the name of Ottewill, the camera with lens, etc, will come to just about £15'. Dodgson is, of course, better known as Lewis Carroll, the author of *Alice's Adventures in Wonderland*.

In 1857, Carroll was to combine his love of literature and photography in a poem entitled 'Hiawatha's Photographing'. This was a good-natured parody of Longfellow's famous poem 'Hiawatha', published two years earlier, which was immensely popular and spawned many parodies and imitations. Carroll's version is, perhaps, one of the better ones. It is also, surely, one of the very rare occasions in which a camera has been immortalized in verse:

From his shoulder Hiawatha
Took the camera of Rosewood
Made of sliding, folding rosewood;
Neatly put it all together.
In its case it lay compactly,
Folded into nearly nothing;
But he opened out the hinges,
Pushed and pulled the joints and hinges,
Till it looked all squares and oblongs,
Like a complicated figure
In the Second Book of Euclid.

Captain Fowke's Camera

A PROLIFIC INVENTOR AND ARCHITECT, WHEN CAPTAIN FRANCIS FOWKE TURNED HIS HAND TO CAMERA DESIGN HE PRODUCED THE LIGHTEST AND MOST PORTABLE MODEL YET.

Sliding-box cameras, the standard design in use during the 1840s and early 1850s, were heavy and bulky. Attempts were being made to alleviate this drawback by introducing collapsible, folding versions such as Ottewill's Double Folding Camera of 1853 (see page 31). The longer-term solution, however, lay in attaching the camera's lens panel to its plate holder with some form of flexible bag or bellows. As early as 1839, Baron de Séguier in France came up with a design for a daguerreotype camera fitted with bellows. However, it wasn't until the 1850s that the first commercial bellows cameras appeared. Indeed, if you had mentioned the word 'bellows' to photographers in 1850, their first thought would have probably been about a recent musical novelty, the concertina, patented by Charles Wheatstone in 1844.

Francis Fowke was born in Ballysillan, Northern Ireland, in 1823 and was commissioned into the Royal Engineers in 1842. He is best known as an architect and was responsible for the general design of the Albert Hall in London. However, his creativity also found an outlet in a stream of inventions, including a military fire engine, an improved umbrella, a portable bath and, of course, one of the first bellows cameras.

Fowke's camera had rectangular-section leather bellows connecting two wooden frames. A removable baseboard could be fitted onto either the long or short sides of these frames for horizontal or vertical-format pictures. A brass rod attached to the back panel gave extra support and stability. The lens (unfortunately missing in this example) was fitted onto a four-sided wooden extension shaped like a truncated pyramid. Fowke's camera was manufactured from the summer of 1857 by the London firm of Ottewill & Co.

Through Fowke's contacts, Ottewill secured a government contract to supply the cameras to the Royal Engineers. Their advertisements describe it as 'invented for and used by the

'The first British camera to use concertina-pattern pleated bellows was patented in May 1856 by Captain Francis Fowke.'

In Britain, a number of prototype designs for cameras with flexible bodies appeared in the early 1850s, such as those by Richard Willats and Major Halkett. However, the first bellows cameras to come into general use were made in America. In November 1851, William Lewis (father) and William Lewis (son) of New York were issued with a patent for a daguerreotype camera fitted with square-section bellows connecting the lens panel to the body of the camera, containing the plate holder. The first British camera to use concertina-pattern pleated bellows was patented in May 1856 by Captain Francis Fowke (left).

Royal Engineers ... the most portable as well as the lightest camera in use.' The bellows construction meant that when collapsed and folded flat the camera for 10 by 8 inch (254 x 203mm) plates measured only 12¾ by 10½ by 3½ inches (324 x 267 x 89mm).

Captain Fowke died of a burst blood vessel in December 1865 at his official residence in the South Kensington Museum, whose construction he had supervised. This particular camera belonged to Fowke himself. Appropriately, in 1908 it was presented to the Science Museum (the successor of the South Kensington Museum) by his son.

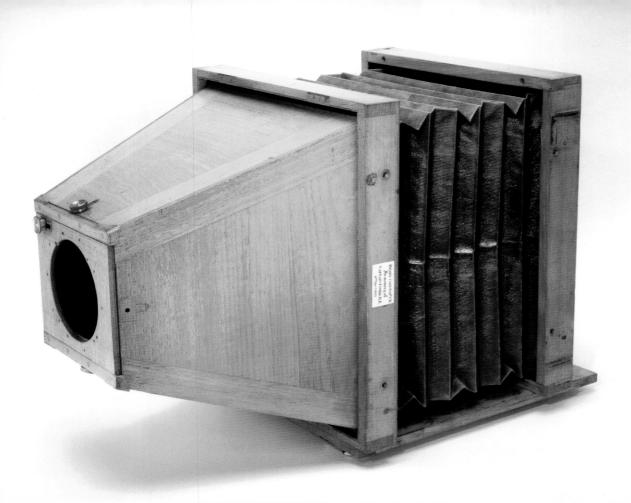

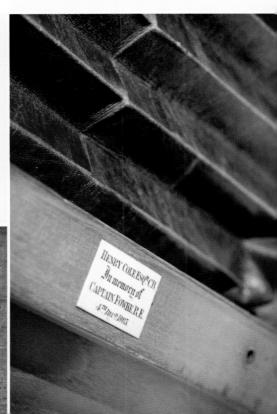

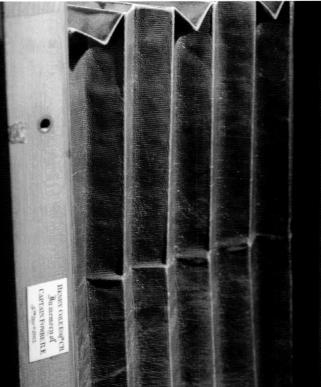

PHOTOGRAPHY.

T. OTTEWILL & CO.'S NEW TEAK CAMERAS FOR INDIA.

Capt. Fowke's Camera Open.

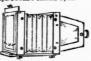

T. Ottewill's Registered Camera.

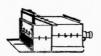

Capt. Fowke's Camera Shut.

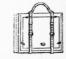

T. OTTEWILL AND Co. beg to inform the Trade and Public generally, that having made for the Government departments Capt. Fowke's Cameras with Teak, and having also made several improvements in the construction of the same, they can highly recommend them as being the most portable as well as the lightest cameras in use; the 10×8, with single back, inner frames, focussing screen, &c. is in the small compass, when closed, of 12½ inches × 10½ × 3½, outside measurement.

T. OTTEWILL & Co.'s new STEREOSCOPIC BOX CAMERA has given general satisfaction, and they have already been favoured with very great patronage for it; the box contains camera and lens six backs and focussing screen, tripod head and board; the board is so arranged that any angle can be obtained. The box is 13½ inches long by 7 inches wide and 5 inches deep, outside measurement.

Their DARK BOX also continues to receive public favour for transferring prepared plates from the box to the camera in sunshine, without injury.

Their REGISTERED DOUBLE-BODIED FOLDING CAMERA continues to give, as it always has given, the greatest satisfaction, for its simplicity and portability.

ILLUSTRATED PRICED CATALOGUE sent free on application. Manufactory, Charlotte Terrace, Islington, London.

HENRY COLE Esqʳ. C.B.
In memory of
CAPTAIN FOWKE, R.E.
4ᵀᴴ Decʳ. 1865.

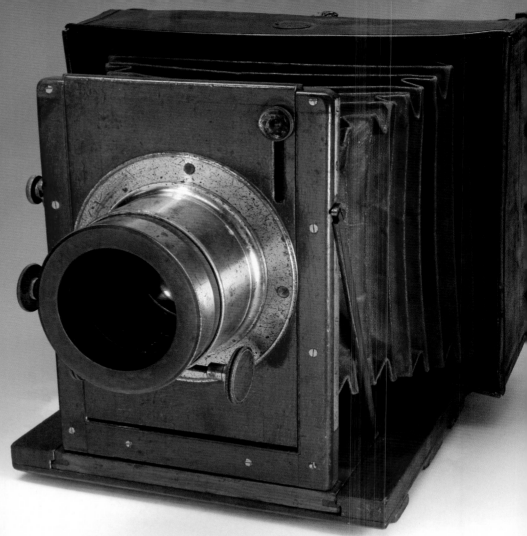

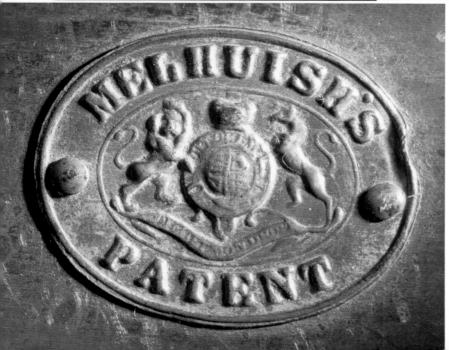

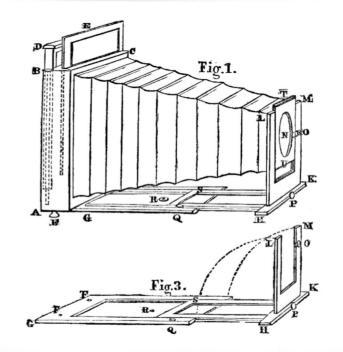

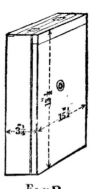

A.J. Melhuish's
Kinnear-Pattern Camera

PIONEERING THE USE OF THIN SHEET METAL AND TAPERED

BELLOWS IN ITS CONSTRUCTION, ARTHUR MELHUISH'S CAMERA

SET THE STANDARD FOR OTHER MANUFACTURERS TO FOLLOW.

Arthur James Melhuish is best known as the co-inventor (along with Joseph Blakey Spencer) of the first practical roll holder for strips of sensitized calotype paper, patented in May 1854. A few years later, however, in 1859, he took out two separate patents for 'Improvements in the Construction of Cameras'. Ahead of his time, Melhuish suggested that cameras could be made both lighter and more compact by constructing their bodies from thin sheet metal rather than wood. Melhuish's Patent Camera was available from early 1860. *The Photographic News* noted: 'For upwards of twenty years we have been using cameras of various kinds of wood which ... have possessed the

This camera is fitted with tapered bellows, known as Kinnear-pattern after their inventor, Charles George Hood Kinnear. An architect and inventor, Kinnear was born in Fife, Scotland, in 1830. An enthusiastic photographer, he was a founder member of the Photographic Society of Scotland in 1856. The following August he set off on a photographic tour of northern France, using a folding bellows camera made to his instructions by an Edinburgh camera maker named Bell. Kinnear's camera, which he later described at a meeting of the Photographic Society, was the first to incorporate tapered rather than square-cut bellows: Since each fold lay within the next, larger fold, this meant that the camera could be made considerably more compact. 'The body of the camera is formed on the gusset principle of the concertina, of two thicknesses of a close but not very heavy black cloth, with strips of pastboard between. The body tapers from back to front, so that the gussets fold into one another' (facing page, bottom right).

'This camera is fitted with tapered bellows, known as Kinnear-pattern after their inventor, Charles George Hood Kinnear'

undesirable qualities of great weight, liability to warping and braking, and to distortion ... In a comparison between the cameras now in use and the metal camera, we find that when the two kinds are made of equal strength, the metal one, if of brass, is one third lighter in weight.' Melhuish's original patent concerned the construction of sliding-box cameras. This slightly later, folding model for 10 by 8 inch (254 x 203mm) plates was probably made by Melhuish & Co in about 1862. It is a composite design, with the baseboard and lens panel made from mahogany and the rear standard made from soldered brass sheets. It carries an embossed oval plaque with the Royal coat of arms and the words 'Melhuish's Patent.' Extremely rare, it is the only known surviving example.

When closed, Kinnear's camera for 12½ by 10½ inch (318 x 267mm) plates was only 3½ inches (89mm) thick. Kinnear compared his camera to Captain Fowke's earlier design (see page 33), then being manufactured by Ottewill & Co: '... my camera is stronger than Capt. Fowke's, and so is less liable to be injured by the rough usage to be met with in travelling, and is besides more rigid; and, moreover, it costs only one half the price of the other.'

Kinnear's design was soon accepted as the standard and was taken up and improved during the 1860s by a number of British manufacturers, including Rouch, Ottewill, Meagher and Bland & Co.

The Dubroni

'LEARN THE ART OF PHOTOGRAPHY IN ONE HOUR', BOASTED

THE MANUAL FOR JULES BOURDIN'S DUBRONI SYSTEM, THE

FIRST SUCCESSFUL CAMERA WITH BUILT-IN PROCESSING.

The idea of a camera that could not only take photographs but also process them immediately after exposure is almost as old as photography itself. William Henry Fox Talbot described such a camera in 1839 and several designs were patented in the 1840s and 1850s. It was not until the 1860s, however, that the first practicable and successful camera with internal processing appeared. Invented by a Frenchman, Jules Bourdin, it was called the 'Dubroni'.

Jules Bourdin trained at the prestigious *Ecole Polytechnique* in Paris and later worked as an engineer in Russia and on the Suez Canal. Throughout his life he indulged his talent and passion for invention and, in 1860, when he was just twenty-two years old, he took out a French patent on a new system of photography which he called the 'Dubroni' – a name derived from an anagram of his surname. It is said that he took this unusual step because his father, a solid and respected member of the bourgeoisie, did not want to see the family name tainted by association with the twin evils of commerce and photography.

The Dubroni camera consisted of a ceramic or amber-coloured glass 'bottle', the front and back of which had been cut away. This bottle was sandwiched between two wooden panels, the lens was mounted in the front panel and the rear panel had a hinged door to allow access for placing a ground glass screen in position for focusing, or a glass plate for sensitizing and exposure. When the door was closed, a spring on the back pressed the glass plate tightly against the edge of the bottle, forming a waterproof seal.

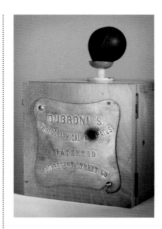

'By placing your eye to the lens, as if the camera was an opera-glass, it was possible to check on how development was progressing.'

There was a hole in the top of the bottle, fitted with a light-tight valve, through which chemicals could be introduced using a pipette and rubber bulb.

To take a photograph, silver nitrate solution was squirted into the camera using the pipette, and the camera was then tilted backwards so that the solution flowed evenly over the glass plate. After removing any surplus solution, the exposure was made by removing the lens cap. As a rough guide, a landscape subject on a bright day required an exposure of up to five seconds and an outdoor portrait anything up to ten seconds. To develop the negative a solution of pyrogallic acid was introduced into the camera. The back of the camera was fitted with a red or yellow glass window. By placing your eye to the lens, as if the camera was an opera-glass, it was possible to check on how development was progressing. The developer was then poured away and the negative, whilst still inside the camera, was washed, using water. The negative could then be removed from the camera for fixing and varnishing ready for printing.

The Dubroni was sold as a complete photographic outfit, fitted into a compact carrying case with all the requisite materials – plates, chemicals, printing frame and sensitized paper. It was marketed primarily at those who had little or no photographic experience, especially travellers or tourists. By carefully following a step-by-step manual of instructions it was claimed that anyone could 'Learn the Art of Photography in One Hour'. To keep things as simple as possible, all the chemicals needed were contained in clearly numbered bottles. Advertisements for the camera boasted: 'The marvellous thing about this apparatus is that it can be used by everyone, even those who have never before taken a photograph … A boon for the ladies, no need for them to risk staining their fingers.' In Britain, Dubroni outfits were sold by Lechertier, Barbe & Co, 'artists' colourmen and stationers' of Regent Street, London, with prices starting at £2.

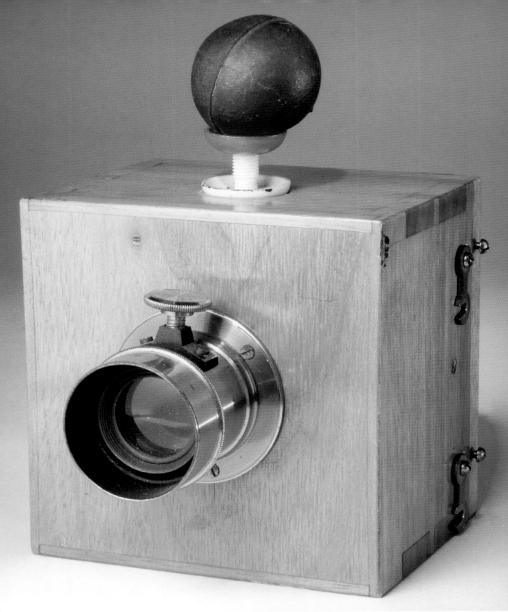

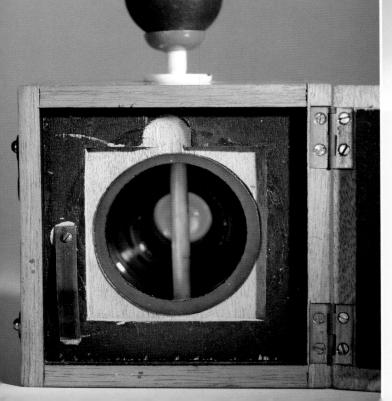

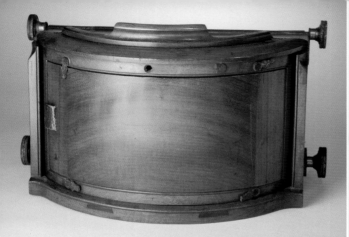

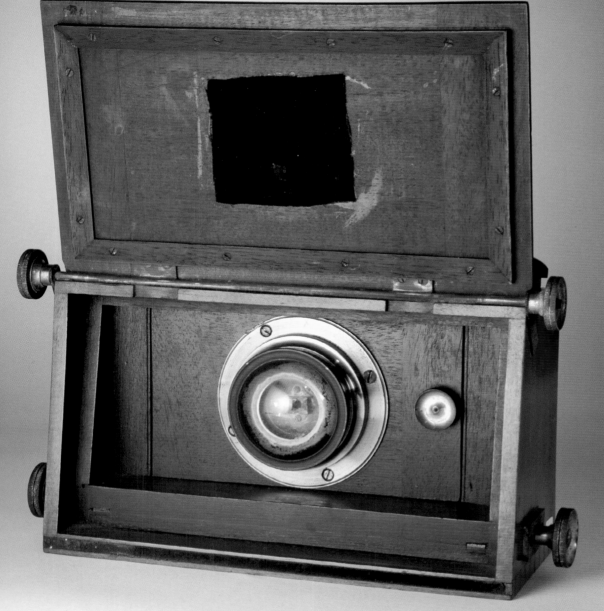
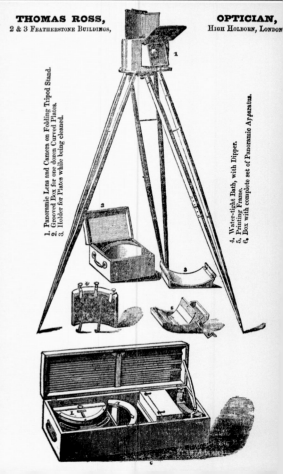

Sutton's Panoramic Camera

THOMAS SUTTON'S EARLY ATTEMPT AT A WIDE-ANGLE LENS CONSISTED OF A GLASS SPHERE FILLED WITH WATER. BESET BY PROBLEMS, HE SOLD THE PATENT ONLY TWO YEARS LATER.

'Sutton's camera was inspired not by careful study of optics but by an idle moment, spent gazing at a cheap holiday souvenir.'

Panoramic photographs date back to the earliest days of photography. In June 1843, by rotating his camera slightly after each exposure, William Henry Fox Talbot took a series of photographs, each overlapping the previous view slightly. This simple method, however, only works for static subjects. Over the years, many cameras have been devised for taking panoramic photographs in a single exposure. These fall broadly into three groups – cameras with rotating lenses and fixed plates or film; rotating cameras with moving plates or film; and, finally, cameras with fixed, wide-angle lenses. Of this last type, the very first example was devised by an Englishman, Thomas Sutton, in 1859. Sutton's camera was inspired not by a careful study of optics but by an idle moment spent gazing at a cheap holiday souvenir.

Thomas Sutton was born in London in 1819 and studied at Cambridge University. In 1847 he moved to Jersey where he opened a photographic studio, and in 1856 he founded a magazine called *Photographic Notes*.

Sometime in 1859, Sutton was looking at a glass 'snowstorm' novelty, of the sort popular with Victorian tourists, which had been brought home from Paris as a souvenir. He noticed how images were projected by light passing through the water-filled globe. This led to the idea that a wide-angle lens could be made from a sphere of glass filled with liquid. Sutton's lens, patented by him in September 1859, consisted of a glass globe filled with water, giving a wide field of view of 120 degrees.

In 1860, Sutton commissioned the London photographic and scientific instrument maker Frederick Cox to manufacture a camera that would incorporate his lens. Ideally, to compensate for the lens's curvature of field, the photographic plate used in this camera should also have been spherical, with a radius of curvature equal to its focal length. In practice, a workable compromise was reached by using curved glass plates. However, since the camera was designed for use with the wet-plate process, this meant that there also had to be a special, curved sensitizing tank and a curved printing frame.

By the end of 1860, Cox was advertising Sutton's camera in four different sizes. However, he had great problems in finding suitable glass for the lenses. In January 1861, Sutton announced that Thomas Ross, the prominent London optician and instrument maker, was to take over the manufacture of his camera. Ross's lenses were a considerable improvement and, in August 1861, Ross bought the rights to Sutton's patent. Ross sold the cameras as complete outfits, costing up to £50, including camera, lens, tripod, sensitizing bath, printing frame, carrying case and twelve plates. The camera itself is of comparatively simple construction, with a mahogany hinged flap that serves as a shutter and spirit levels to ensure that it is horizontal.

Ross was unable to make the camera into a commercial success and it doesn't seem to have been advertised after 1862. The total number of cameras produced isn't known but it is estimated that fewer than thirty were made.

Johnson and Harrison's
Pantascopic Camera

A CLOCKWORK MOTOR EVENLY ROTATED THE INGENIOUS
'ALL-SEEING' CAMERA THROUGH A 110-DEGREE ANGLE OF VIEW.
ITS SPECTACULAR PANORAMAS WERE MUCH IN DEMAND.

In 1860, Thomas Sutton introduced a panoramic camera (see previous page) which incorporated his wide-angle spherical lens and curved glass plates. Just two years later, another ingenious panoramic camera appeared. This camera, however, was very different, being the first panoramic instrument where the entire camera rotated and the image was recorded on a flat glass plate which was moved in synchronism. Patented in September 1862 by two Englishmen, John Robert Johnson and John Ashworth Harrison, they named it the Pantascopic, or 'all-seeing', camera.

The Pantascopic camera was a wooden, box-form camera fitted with a meniscus lens and a wheel diaphragm with four apertures – roughly f/8, f/11, f/16 and f/22. The camera recorded a 110-degree angle of view. Small ivory pegs set in the top of the camera indicated the field of view since the arrangement of the plate holder made it impossible to use a ground glass focusing screen. Earlier rotating panoramic cameras had been turned by hand. In order to give a much more consistent rate of rotation, and therefore more even exposures across the whole of the image area, the Pantascopic camera used a clockwork motor fitted inside the camera body. The camera, supported on steel castors, sat on a circular brass turntable. The drive was provided by a toothed shaft which engaged in the serrated inside edge of the turntable. The speed of the motor, and thus the rotation rate, could be regulated by altering the blade angles of a vane governor.

'The Pantascopic camera was a wooden, box-form camera fitted with meniscus lens and a wheel diaphragm with four apertures.'

As the camera rotated, a cord-and-pulley arrangement slowly moved the plate holder laterally, past an exposure slot in the camera back, in synchronism with the camera rotation. Two different models were produced, for 7½ by 12 inch (190 x 305mm) and 4½ by 7 inch (114 x 178mm) wet collodion negatives. Exposure times varied, but were said to average around 30 seconds.

Although patented in 1862, it was a couple of years before the Pantascopic camera reached the market. In 1864, Johnson and Harrison founded the Pantascopic Company in Red Lion Square, Holborn, London, to promote their camera and the panoramic photographs made with it. As well as selling cameras and chemicals, the company also undertook commissions for panoramic photographs of 'private residences, estates, engineering works, &c'. In May 1864, the Company was awarded a silver medal at the annual exhibition of The Photographic Society of Scotland for a series of panoramic views of London. *The British Journal of Photography* commented upon seeing these prints: 'Intense sharpness ... characterizes every part of the print, the edges being in this respect on exactly the same footing as the centre, while the exposure has been so rapidly effected as to reproduce without blurring the various groups of men, women, children, dogs, boats &c., usually found along the banks of the Thames.' A number of these London views were subsequently included as illustrations in the *Royal Album Court Directory and General Guide*, published in 1866.

The Pantascopic was a successful design which was subsequently used by a number of landscape photographers. The distinguished French photographer, Adolphe Braun, used a Pantascopic camera for his exquisite series of Alpine panoramas, taken in 1868.

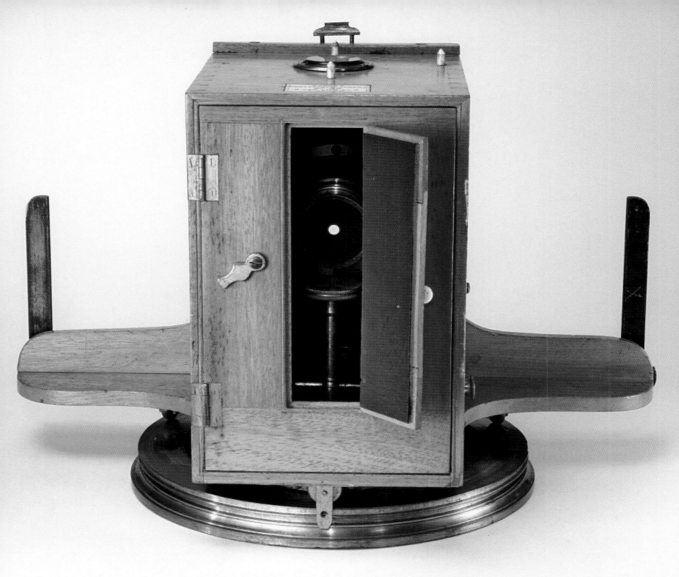

PATENT
PANTASCOPIC CAMERA
N.º 32
3 RED LION SQ.R
LONDON

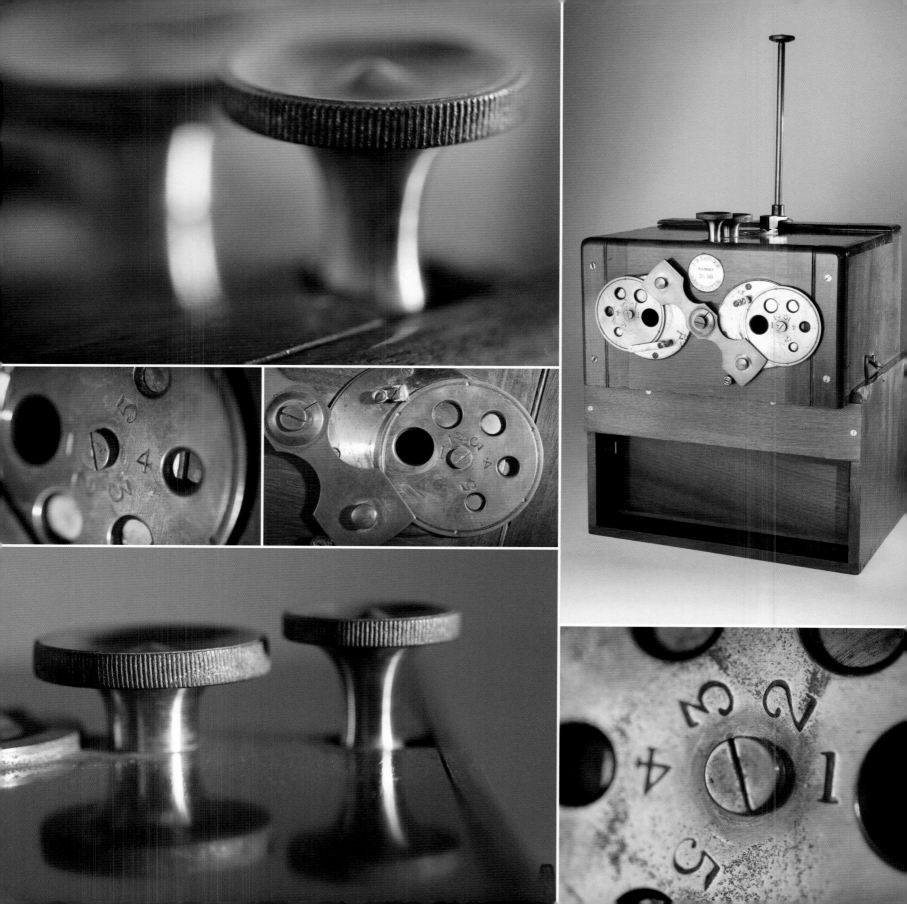

Dancer's Binocular Stereoscopic camera

THE INVENTION OF THE TWIN-LENS CAMERA IS A MATTER OF DISPUTE. JOHN DANCER BUILT HIS FIRST MODEL IN 1852 AND PATENTED AN IMPROVED VERSION FOUR YEARS LATER.

The principle of stereoscopic vision was first established in 1832 by the English physicist, Sir Charles Wheatstone. Wheatstone constructed a viewing device called a stereoscope which allowed the user to see an image in apparent relief, made up from a pair of drawings. Following the invention of photography a few years later, photographs were soon being used in place of drawings to create stereoscopic images. Stereoscopy required pairs of photographs to be taken from viewpoints approximately the same distance apart as human eyes. The simplest method of doing this was to move the camera a few inches sideways between each exposure. Another approach was to place two cameras side by side or, by logical progression, to fit a single camera with two lenses, side by side. The first twin-lens or 'binocular' stereo cameras appeared in the 1850s.

The concept of the binocular camera was first described by the Scottish scientist, Sir David Brewster, in 1849. One of the many people with whom Brewster was in regular correspondence was the Manchester-based optician and pioneer of photomicrography, John Benjamin Dancer. In 1852, Dancer constructed, but did not patent, the first binocular stereo camera. In October, the following year, a binocular camera devised by a Parisian photographer, Achille Quinet, was demonstrated at a meeting of the Liverpool Photographic Society. Quinet patented his camera – which he called the Quinetoscope – in January 1854, and subsequently claimed priority for the invention of the binocular camera.

'Stereoscopy required pairs of photographs to be taken from viewpoints approximately the same distance apart as human eyes.'

In July 1860, the Parisian scientific instrument maker Jules Jamin wrote to William Henry Fox Talbot for help and support, informing him that Quinet had 'seized on Mr Brewster's binocular chamber as being his invention; if you also had some information or if you knew of someone who constructs his instruments who would have produced this camera in England prior to 1853, you would also be doing us a service by enlightening us on this subject.'

By this time, several other binocular cameras had appeared on the market, including an improved model designed by Dancer and patented by him in September 1856.

Dancer's camera was of sliding-box design, fitted with a pair of matched lenses. To change the apertures, in front of each lens was a rotating disc with five differently-sized holes. This idea wasn't new, having been used by the Parisian optician Lerebours as early as 1841. A brass strip, pivoted in the centre, allowed the two lenses to be covered or uncovered simultaneously and acted as a primitive shutter. On top of the camera was a circular spirit level – essential for successful stereo photography where the camera has to be perfectly level during exposure.

Dancer's camera could be used with wet collodion plates but was also designed to take 'dry' collodio-albumen plates contained in a plate-changing box or magazine attached to the base of the camera. By using a brass rod, plates could be drawn up, one by one, for exposure in the camera. When the plate had been returned to the changing box after exposure, the magazine was moved along to bring the next plate into position. The number of each plate exposed could be read through a window in the side of the plate-changing box.

Skaife's Pistolgraph

THE PISTOLGRAPH WAS THE FIRST 'SNAPSHOT' CAMERA, WITH A SHUTTER CAPABLE OF CAPTURING AN ARTILLERY SHELL IN FLIGHT. REPORTS SUGGEST QUEEN VICTORIA WAS NOT AMUSED.

In May 1860, writing in *The Photographic News*, Sir John Herschel referred to 'the possibility of taking a photograph, as it were, by a snap-shot – of securing a picture in a tenth of a second of time.' On the basis of this remark, Herschel is usually credited with coining the term 'snapshot' to describe a photograph taken with a very brief exposure. Before it acquired the photographic meaning with which it is now primarily associated, the word 'snapshot' was originally a hunting or shooting term describing a shot taken quickly, without careful aim or preparation. Herschel's comment is usually regarded as prophetic. However, the previous year, a camera had appeared that was capable of doing precisely what Herschel had suggested – capturing a photograph in the blink of an eye. Named the 'Pistolgraph', it was the very first snapshot camera.

The Pistolgraph was the invention of an Englishman, Thomas Skaife (facing page, top right). Skaife was a successful miniature painter who exhibited his work at the Royal Academy during the 1840s. In 1856 he took up photography 'with the view of getting the sun to assist me in enamel painting'. In June of that year he patented one of the first camera shutters – a pair of flaps operated by an elastic band and released by a trigger mechanism similar to that of a pistol. Skaife estimated that his shutter was capable of exposures as brief as 1/10 second. At first, Skaife used his shutter with a conventional stereoscopic camera to take pairs of 'instantaneous' photographs. His greatest coup occurred in 1858 when he succeeded in photographing an artillery shell in flight as it was fired from a mortar. At the time, however, he was already working on a miniature camera of his own design that would incorporate his shutter.

GUIDE TO THE PISTOLGRAPH,
BY
T. SKAIFE.

SECOND EDITION, PRICE 1s.

SOLD BY THE AUTHOR AT
SKAIFE'S PISTOLGRAPH DEPOT,
47, BAKER STREET, LONDON, W.

'... the word "snapshot" was originally a hunting or shooting term describing a shot taken quickly, without careful aim or preparation.'

Initially called the 'Pistol Camera', this device went through a number of design changes to emerge, in late 1859, as the 'Pistolgraph'. Inspired by the scientific wonder of the time, the telegraph, the name was criticized by nearly everyone except the inventor himself. The *British Journal of Photography*, despite being impressed by Skaife's ingenuity, thought that the 'truly awful' term was a 'hideous and unscientific compound'. Moreover, despite its diminutive size, the camera only bore a very superficial resemblance to a handgun. There is a frequently repeated, but almost certainly apocryphal, anecdote that Skaife was once arrested for aiming his Pistolgraph at Queen Victoria.

Made entirely of brass, the Pistolgraph was only 3 inches (76mm) long. It came with a ball-and-socket support and a small wooden storage box that doubled as a base for the camera. The lens was mounted in a three-section focusing tube, at the rear of which was a plate holder. Skaife's two-flap shutter was positioned in front of the lens. The Pistolgraph produced circular negatives just over 1 inch (25mm) in diameter.

The relatively low sensitivity of wet collodion plates meant that the Pistolgraph had to be fitted with a very wide aperture lens. Skaife used the fastest lenses available at the time – f/2.2 and f/1.1 Petzval-type lenses made by Dallmeyer. Even so, available light was sometimes insufficient and Skaife took 'pistolgraphs' with magnesium flash powder soon after it first became commercially available in the 1860s. It isn't known exactly how many Pistolgraphs were produced but despite Skaife's extensive marketing efforts, the number sold must have been fairly small. However, if imitation is any measure of success the camera must have enjoyed some modest popularity because in 1860 the London camera firm of Ottewill & Co brought out a very similar instrument – complete with ball-and-socket stand and wooden carrying box. However, Ottewill's version (facing page, centre right) was made from mahogany rather than brass.

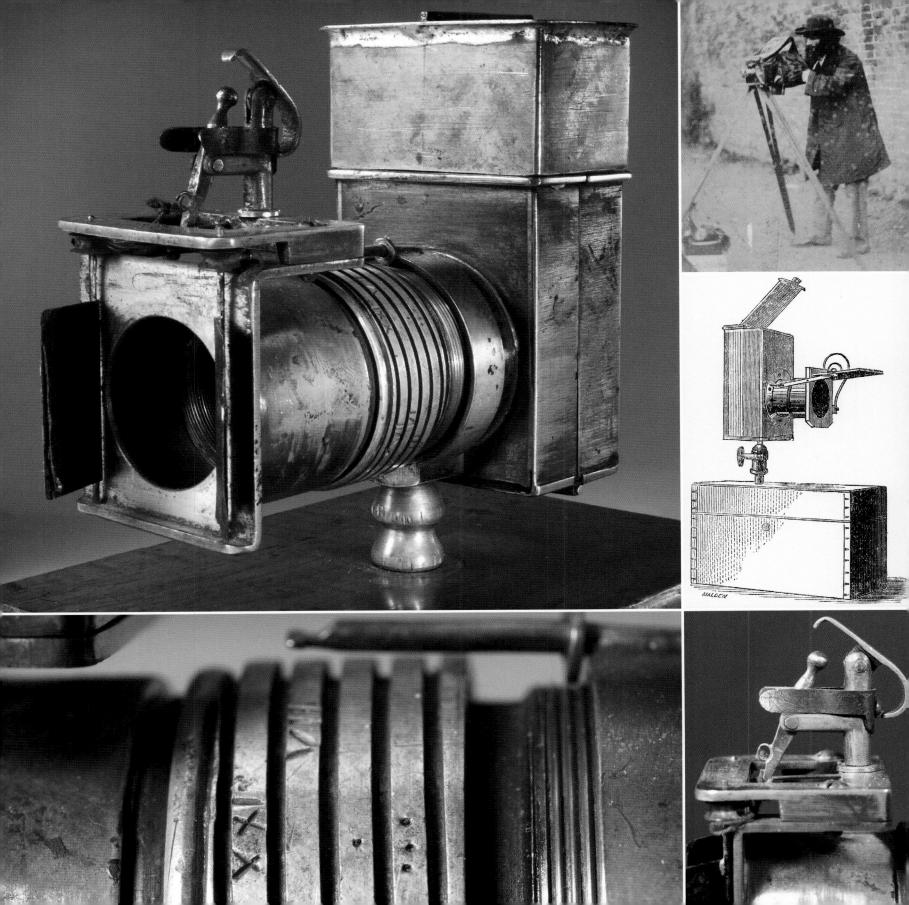

A BRIOIS
RUE DE LA DOUANE
PARIS

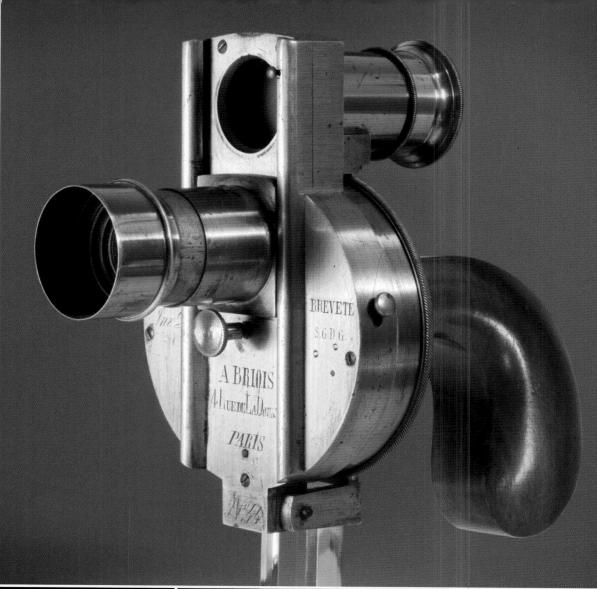

BREVETE
S.G.D.G.

A BRIOIS
4 RUE DE LA DOUANE
PARIS

N°14

BREVETE
S.G.D.G.

THOMPSON
Inv.t

A BRI

Thompson's Revolver Camera

DESIGNED BY A MYSTERIOUS ENGLISHMAN KNOWN ONLY AS MR THOMPSON, THE REVOLVER WAS INSPIRED BY THE COLT HANDGUN. IT COULD TAKE FOUR SHOTS IN RAPID SUCCESSION.

From time to time cameras have appeared that, either for novelty or disguise, have been designed to look like other objects. One of the earliest, rarest and without a doubt most unusual cameras of this type is Thompson's Revolver Camera.

By the 1860s, the idea of using a single glass plate for multiple exposures was already well established. *Cartes-de-visite*, a format recently introduced by the French photographer Disderi, were produced using cameras that took multiple exposures on repeating plate backs. The Revolver Camera took this concept a significant step further by adopting what was, quite literally, a revolutionary design.

The Revolver Camera was designed by a Mr Thompson, an Englishman about whom very little is known. Thompson undoubtedly took as his inspiration the

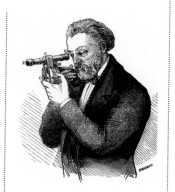

Colt revolver, invented by an American, Samuel Colt, who had acquired fame and fortune by supplying both sides in the American Civil War with guns. On 20 January 1862 Thompson took out a French patent for his *Revolver Photographique*. Coincidentally, Samuel Colt had died just ten days earlier.

Presumably, no British camera makers were interested in Thompson's design. Instead, the camera was manufactured by the Parisian instrument maker A. Briois. He demonstrated it before an appreciative audience at a meeting of the *Société Française de Photographie* in July 1862.

It is difficult to imagine a more conspicuous camera or one that would be more likely to cause unease in the mind of the person being photographed! True to its name, the Revolver Camera took the form of a handgun. However, instead of bullets, the brass cylinder that formed the body of the camera held a circular glass plate. After each exposure the back of this cylinder was rotated through 90 degrees. In this way, four successive 'shots' could be taken before having to reload. The camera's focusing mechanism was ingenious. The f/2, 40mm Petzval-type lens was mounted in a brass tube that slid up and down. In the 'up' position, the lens focused an image onto a ground glass screen that was in the same focal plane as the sensitized plate.

When a catch – the 'trigger'– was released, the lens tube dropped down into position in front of the plate. This, in turn, released the shutter. The whole process took only a fraction of a second. In good light, very brief 'instantaneous' exposures were possible.

'... the Revolver Camera took the form of a handgun. However, instead of bullets ... the body of the camera held a circular glass plate.'

The wooden pistol grip allowed the camera to be held steady with one hand, leaving the other free to operate the controls. Novel and ingenious as it was, Thompson's camera wasn't a commercial success. The exact number made is not known but serial numbers on surviving examples would suggest that fewer than one hundred were produced.

Piazzi Smyth's Camera

A CURIOUS TALE OF ANCIENT EGYPTIAN TOMBS, 'SACRED CUBITS', A MINIATURE EBONITE CAMERA AND THE SENSATIONAL MAGNESIUM-LIT IMAGES OF SCOTLAND'S ASTRONOMER ROYAL.

The pyramids have always held a peculiar fascination. In the 1850s, theories as to the real significance and purpose of the pyramids abounded. Unable to explain the complex geometric, mathematical and astronomical laws by which they had been constructed, some came to the conclusion that the only possible explanation lay in divine guidance. Charles Piazzi Smyth, the Astronomer Royal for Scotland, believed that the pyramids were built using a unit of measurement called the 'sacred cubit'. He thought that as well as the pyramids, the cubit was used by Noah to build his ark and was also the basis for the British inch. In November 1864, determined to find the evidence to prove his theory, Charles and his wife Jessie set off for Egypt.

In January 1865, after setting up residence in a tomb near the Great Pyramid, Piazzi Smyth began measuring and taking photographs. For his expedition, he had designed an ingenious miniature camera. A small box, 5 inches (127mm) square and 8 inches (203mm) long, it was fitted with a cylindrical shutter and a Dallmeyer f/5, 1.8in lens. Like its contemporary, the Dubroni camera (see page 36), it was an internal processing camera. The plate-holder was a watertight ebonite box – each side of which held a 3 by 1 inch (76 x 25mm) glass slide (facing page, bottom centre). These slides, previously coated with collodion, formed the inside of a container into which sensitizing and developing solutions could be introduced. A sliding shutter covered each slide until it was ready for exposure.

'... he asked a local camera maker to make him a camera so strong that it could be buried with him so that he could photograph the Day of Judgement.'

Four 1 inch (25mm) square negatives could be taken in succession. Not content with only photographing the exterior of the Great Pyramid, Piazzi Smyth also wanted to photograph the burial chamber at its heart. Candles and torches were enough to light the way for curious tourists, but for photography a much brighter light was required.

Using the brilliant light given off by burning magnesium wire had been suggested in the photographic journals as a theoretical possibility. Fortunately for Piazzi Smyth, the Magnesium Metal Company of Manchester had begun the commercial production of magnesium wire just a few months before he set off on his expedition. Piazzi Smyth's photographs of the King's Chamber, illuminated by the light of burning magnesium (facing page, bottom right), caused a sensation when they were shown on his return to Britain in the summer of 1865.

Piazzi Smyth made two cameras so that he could take stereoscopic pairs of photographs. Unfortunately, only one, incomplete, camera has survived. This is preserved in the Royal Observatory, Edinburgh. However, in about 1870 his design was briefly produced commercially by Bryson, a well-known Edinburgh scientific instrument maker.

In 1886 Smyth retired from his post as Astronomer Royal and moved to Ripon in North Yorkshire where he died in 1900. There is an anecdote that, as a last request, he asked a local camera maker to construct for him a camera so strong that it could be buried with him so that he could photograph the Day of Judgement. As it was, he wasn't buried with his reinforced camera. He was, however, very appropriately, buried under a tombstone in the shape of a pyramid.

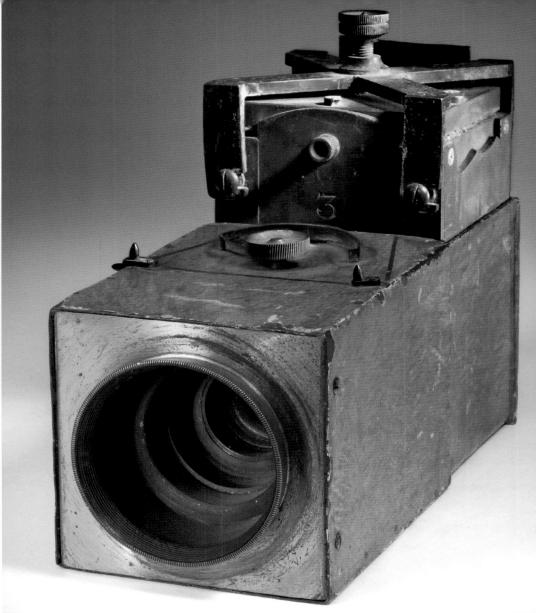
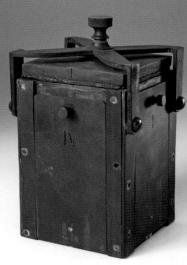

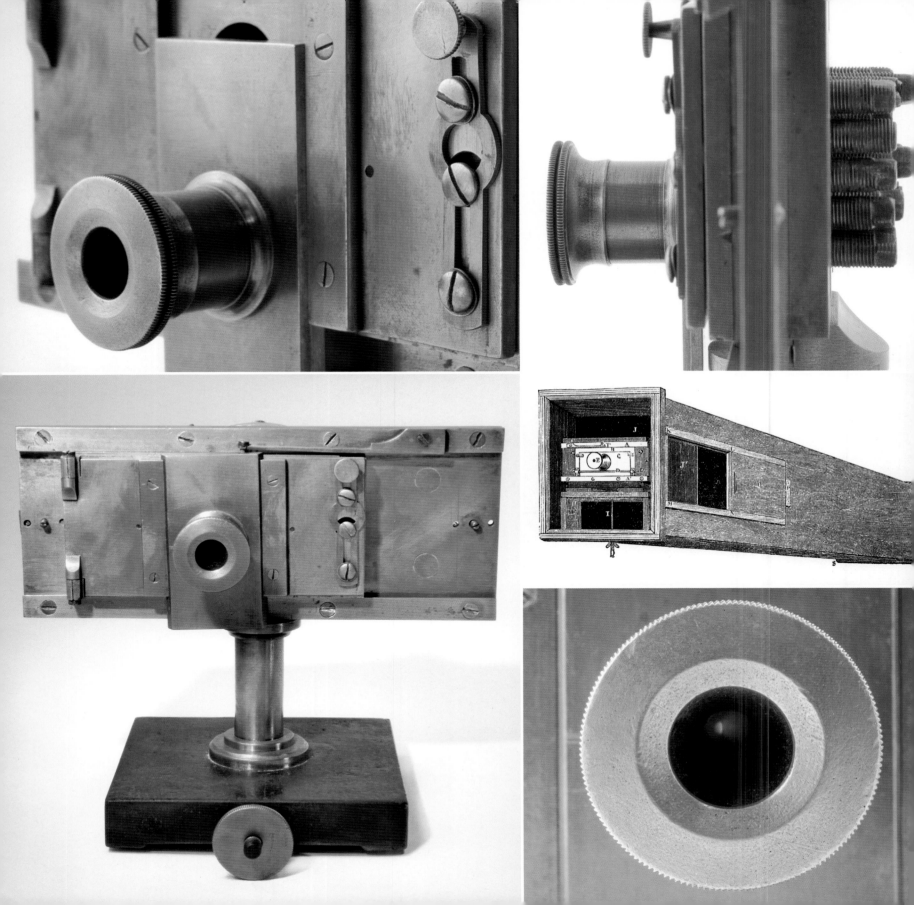

Dagron Camera

FROM THEIR HUMBLE BEGINNINGS AS NOVELTY SOUVENIRS, RENÉ DAGRON'S MICROPHOTOGRAPHS LATER GAINED ROYAL APPROVAL AND FOUND A PRACTICAL APPLICATION IN WARTIME.

During the 1840s, John Benjamin Dancer, a Manchester photographer, optician and scientific instrument maker, took the first microphotographs, mounted on slides for viewing in a microscope. In 1856, the same year that Dancer patented his twin lens stereoscopic camera (see page 42), he presented a number of his microphotographs to the distinguished Scottish physicist Sir David Brewster. Brewster was impressed and exhibited Dancer's work when he visited Paris the following year. Rather than using a microscope, Brewster suggested viewing these tiny images with small magnifying lenses called Stanhopes, named after their inventor Lord Stanhope.

After seeing Dancer's images, René Prudent Patrice Dagron, a French photographer, realised the commercial potential of microphotographs as novelty souvenirs. In 1859, Dagron was granted the first ever patent for microphotography for 'a novelty microscope for viewing miniature pictures'. Within three years his idea had grown into a business employing 150 people, busily turning out microphotographic novelties contained in every type of object imaginable. In 1860, Dagron, with a keen eye for publicity, sent a ring containing miniature portraits of Prince Albert and the Prince of Wales as a gift to Queen Victoria. In 1862, Dagron was awarded a Certificate of Honourable Mention at the International Exhibition, held in London. A popular souvenir of the exhibition were microphotographs of the impressive exhibition building, designed by Captain Francis Fowke of the Royal Engineers (see page 32).

'To make his microphotographs, Dagron designed a special reducing camera for the production of multiple images.'

To make his microphotographs, Dagron designed a special reducing camera for the production of multiple images. Constructed entirely of brass, versions were produced with 3, 6, 9, 15, or 25 lenses. Focusing was achieved using a microscope viewing lens. The sensitized wet collodion glass plate was held in a movable frame. After each exposure, this frame could be moved very precisely, either vertically or horizontally to expose a different section of the plate. The frame could be moved into six positions horizontally and three vertically, so it was possible to produce up to 450 identical images on a single plate (25 x 6 x 3).

In use, the camera was placed at one end of a large, box-shaped wooden tube or *chambre noir* (facing page, centre right). At the other end of the tube was placed the glass negative that was to be copied. The entire unit was positioned near a window to allow the maximum amount of daylight to pass through the negative. Dagron suggested exposure times of between one and three seconds, depending on the weather and time of year. After exposure and processing, the finished microphotographs were cut out of the plate using a diamond cutter.

During the Franco-Prussian war of 1870, Dagron's expertise was put to a more practical purpose when he was asked to make microphotographs of messages that were to be sent to the besieged city of Paris by carrier pigeons.

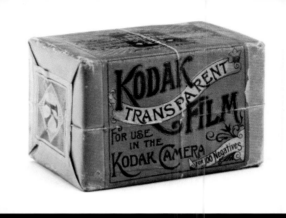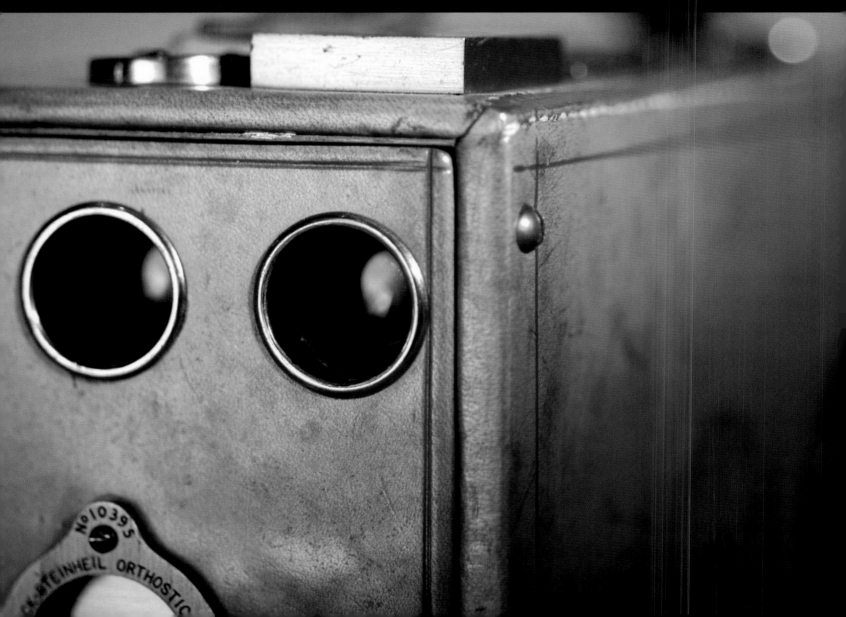

Dry Plates and Roll Film

WHILST A FEW CAMERAS DESIGNED TO BE HAND-HELD HAD

APPEARED AS EARLY AS THE 1850s, SUCH CAMERAS WERE

UNUSUAL IN THE WET-PLATE PERIOD. THE INTRODUCTION OF

MORE SENSITIVE GELATIN DRY PLATES IN THE LATE 1870s

MADE 'INSTANTANEOUS' EXPOSURES POSSIBLE FOR THE FIRST

TIME. DURING THE 1880s, THE FIRST HAND-HELD 'DETECTIVE'

CAMERAS FITTED WITH VIEWFINDERS AND SHUTTERS APPEARED.

THE SUCCESS OF THE KODAK CAMERA, WHICH FIRST APPEARED

IN 1888, ANTICIPATED THE FUTURE POPULARITY OF ROLL-FILM

CAMERAS, PARTICULARLY AMONG THE RAPIDLY GROWING

NUMBERS OF AMATEUR PHOTOGRAPHERS.

Top left: the Artist Hand camera (page 70)
Top right: the Kodak (page 60)
Below: the Frena (page 72)

The Facile

THE FACILE WAS ONE OF MANY 'DETECTIVE CAMERAS': QUICK TO USE, HAND-HELD AND INCONSPICUOUS, THEY WERE HARBINGERS OF A NEW ERA OF CANDID PHOTOJOURNALISM.

In 1881, Thomas Bolas took out a British patent for a box-form plate camera. Because it could be used in the hand, inconspicuously, he coined the name 'detective camera' for his invention. The term came to be applied to almost all hand cameras, up to the end of the century. A number of designs soon appeared for detective cameras that held a number of plates that could be exposed successively, thus doing away with the need to change plate holders after each exposure. Incorporating ingenious plate-changing arrangements, these were known as magazine plate cameras and enjoyed their greatest popularity in the 1890s.

In 1889, a Londoner, Frank Miall, took out a patent for one such plate-changing device. This was incorporated into a box-form camera sold by the well-known photographic retailers, Jonathan Fallowfield of Charing Cross Road. Originally named The Miall camera, it was soon rechristened 'The Facile' by Fallowfield, to suggest – somewhat misleadingly perhaps – its convenience and ease of operation.

'In use, the Facile was designed to be carried like a parcel, tucked under one arm. Its unobtrusive appearance was a major selling point.'

Indeed, in the politically incorrect 1890s, Fallowfield advertisements suggested that 'Faciles should be used by Ladies, as they are so simple and easy to work'.

The Facile's workings were concealed within a polished mahogany box, about the size of a large shoebox. When loaded with a dozen quarter-plate 4¼ by 3¼ (108 x 82mm) glass plates, the camera weighed about 5½ pounds (2.5kg). Unexposed plates were held in an upper, slotted compartment, whence they were dropped, one at a time, with a loud 'clunk', into a similar lower compartment ready for exposure. The Facile had a fixed-focus lens (nominally f/8 but actually nearer f/11) and a simple sector shutter, operated by pressing a plunger. Depending on the force applied, the shutter speed could vary from around 1/2sec to about 1/25sec.

In use, the Facile was designed to be carried like a parcel, tucked under one arm. Its unobtrusive appearance was a major selling point. To reinforce the illusion of concealment, different cases were available – brown waterproof paper, cloth or leather. Realizing its potential for candid 'instantaneous' photography, the pioneering photojournalist Paul Martin bought a Facile in 1892, and used it to record late Victorian Britain with a freshness and immediacy in total contrast to contemporary 'pictorial' photography. Martin's subjects included street scenes, children, holidaymakers on Hampstead Heath and courting couples cuddling on the beach at Great Yarmouth. His personally modified Facile camera, together with its leather case, specially made for it by a local harness maker, is now one of the treasures of the Royal Photographic Society Collection (facing page, bottom right).

At least three versions of the Facile were produced until around 1900. The cheapest, at just four guineas, had a fixed-focus, fixed-aperture lens, while for an extra guinea you could buy a model with a rapid rectilinear lens and four stops on a rotating wheel. In about 1897 a focusing version was introduced called, unsurprisingly, 'The Focussing Facile'.

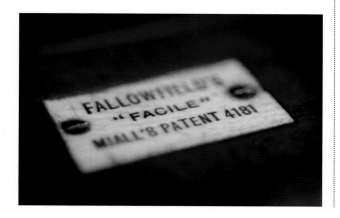

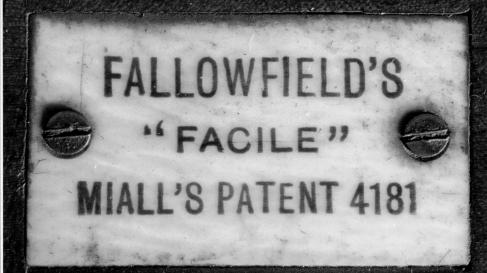

FALLOWFIELD'S "FACILE" MIALL'S PATENT 4181

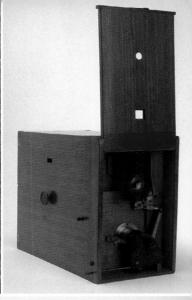

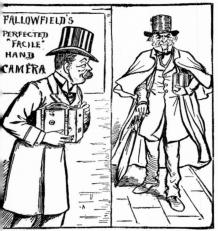

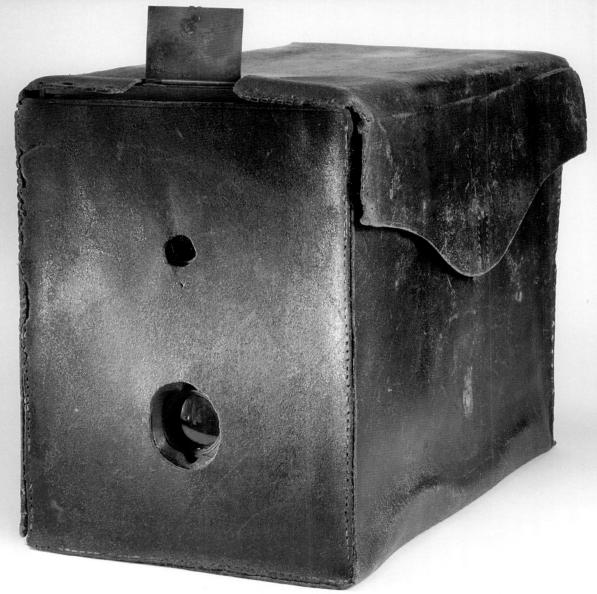

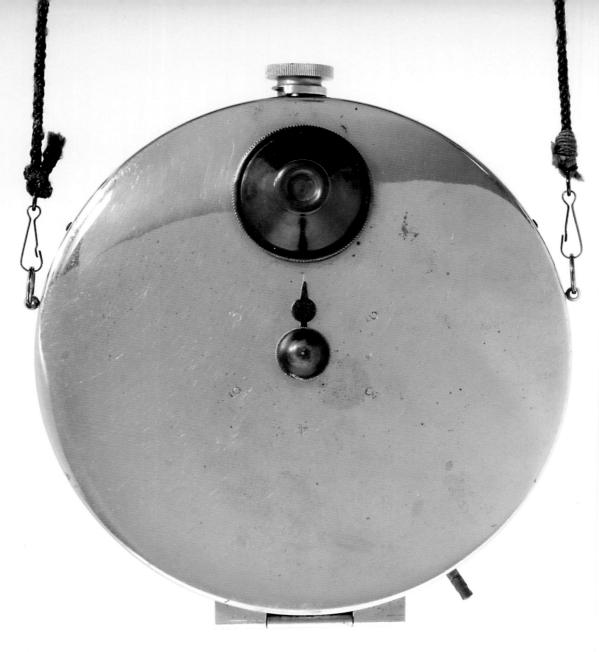

Stirn's Waistcoat Camera

WITH ITS NOVEL SHAPE, DESIGNED TO BE WORN UNDER CLOTHING, AND A LENS DISGUISED AS A BUTTON, THE 'CONCEALED VEST CAMERA' WAS A SURPRISING SUCCESS.

During the 1880s, the development of a satisfactory dry-plate process gave a fresh impetus to camera design. The shorter exposure times now required provided the stimulus for the appearance of a new generation of hand cameras. Inspired by the twin possibilities of portability and concealment, inventors came up with numerous disguised and concealed cameras, including such curiosities as the hat camera, cravat camera and walking stick camera. Probably the best-known of these concealed cameras is Stirn's waistcoat camera – invented by an American but turned into a commercial success by a German.

In December 1885, Robert Gray demonstrated a new camera of his own invention to a meeting of the Society of Amateur Photographers of New York. Gray's ingenious camera was designed 'to be carried concealed upon the person' and incorporated, as an integral part, a half-waistcoat or 'vest' – just like a false 'dicky' front worn for evening dress. The camera was hidden behind the waistcoat front with the lens poking through, disguised as a button (facing page, centre).

In 1886, after some minor modifications, Gray's camera was manufactured in America by the Western Electric Company and sold by the Scovill Manufacturing Company. Realizing the as yet untapped commercial possibilities of the camera, Carl Stirn of New York entered into negotiations to buy the patent rights from Gray. A deal was struck and in July 1886 Stirn was granted a German patent. Carl's brother, Rudolf, owned a camera factory in Berlin and by the end of the year had begun production of what was now officially known as 'C P Stirn's Patent Concealed Vest Camera'.

'... inventors came up with numerous disguised and concealed cameras, including such curiosities as the hat camera, cravat camera and walking stick camera.'

Disc-shaped and all-metal in construction, at first glance the camera resembles the offspring of a liaison between a frisbee and a hip flask. Thin enough to be worn unobtrusively beneath an ordinary waistcoat, it hung around the photographer's neck on a strap. The f/10, fixed-aperture lens poked through a buttonhole of the waistcoat and, as a further aid to concealment, was designed to look like a button. Exposures were made on a circular glass plate that was rotated after each exposure by turning a knob protruding from the front of the camera.

Six photographs, 40mm in diameter, could be taken on each plate. Rotating the knob also set the rotary shutter, which was released by pulling on a length of string that dangled from the bottom of the camera.

Considering its unusual design, the camera was surprisingly popular. By 1890, the manufacturers claimed that no fewer than 18,000 had been sold. Despite its novelty value, contemporary reviewers noted that it was capable of producing quite acceptable results. One, however, did point out a potential flaw – one that had more to do with the design of the photographer than with that of the camera: 'Persons with a tendency to obesity would have some trouble; they would have to make special arrangements, otherwise they would get nothing but "sky" pictures.'

Stirn's camera was sold in Britain by several different retailers, including J Robinson & Sons, Fallowfield's and Perken Son & Rayment, under a variety of names – 'The Secret Camera', 'The Waistcoat Detective' and 'Stirn's Secret Camera'. In France it was known as *'Le Cuirasse'* (the breastplate) and in Germany it was called the *'Geheim'* (secret). At least four different models were produced, in different sizes, but the original (known as the No 1) was by far the most popular.

Stirn's 'America' Detective Camera

THE SIMPLE, COMPACT 'AMERICA' WAS NAMED AFTER GEORGE EASTMAN'S ROLL-FILM SYSTEM. IT WAS THE FIRST CAMERA DESIGNED SOLELY TO EXPLOIT THIS NEW TECHNOLOGY.

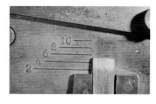

In 1885, an American entrepreneur, George Eastman, introduced his system of 'film' photography, where a roll of paper film was used as a support for light-sensitive chemicals instead of glass plates. This clearly had some obvious advantages regarding weight and fragility. Roll-holders – devices that held a strip of sensitized paper and that could be attached to the back of a plate camera – had been around since the 1850s; one of the first had been patented by A.J. Melhuish in 1854. However, Eastman's version, designed in partnership with William H. Walker, was the first to enjoy any real commercial success.

Although Eastman-Walker roll-holders were made in a range of sizes to fit different cameras, there was, at first, no camera made specifically to take Eastman's film or for which the roll-holder was designed as an integral part rather than an accessory. Encouraged by the favourable response to his roll-holder, Eastman explored the possibility of incorporating it into a simple camera. Eventually, in 1888, this was to result in the introduction of the Kodak camera. His first attempt, however, was a failure. In November 1886 Eastman, together with Franklin M. Cossitt, took out a patent for a box-form camera containing a roll-holder which was interchangeable with plate-holders. The Eastman-Cossitt Detective camera was a costly failure. The design was complicated and too expensive to manufacture. Consequently, only about fifty were made. Meanwhile, as Eastman and Cossitt worked on their detective camera, two other Americans, Robert Gray (the inventor of the waistcoat

'The camera's most unusual feature was its ingenious exposure counter.'

camera – see pages 56–7) and Henry Stammers, had also filed a patent application for a camera in which a roll-holder was an integral and non-removable part. Their patent was issued on 3 May, 1887, and Gray demonstrated the camera shortly afterwards at the annual meeting of the Society of Amateur Photographers of New York. It was the first camera designed solely to use Eastman's 'American' roll film, from which it derived its name, and pre-dates the Kodak by one year.

The rights to the design were acquired by Carl Stirn who patented it in Germany. In a similar arrangement to the earlier 'Waistcoat' camera, the camera was manufactured in Berlin by Carl's brother, Rudolf. Externally a plain wooden box, 5 by 6 by 7½ inches (127 x 152 x 190mm), the 'America' camera contained a roll-holder giving 25 exposures on Eastman's 3¼ inch (82mm) wide American stripping film. It was fitted with an f/17, 105mm lens, a fixed-speed sector shutter and a waist-level reflecting viewfinder. According to a contemporary review: 'It presented a very neat appearance (and) was compact and simple.' The camera's most unusual feature was its ingenious exposure counter. A lever, pointing to a scale marked from 1 to 25, was driven by a small pin at one end. The pin followed a spiral groove in a flat disc which was attached to the shaft of the take-up roller of the roll-holder. At appropriate intervals, this groove had small holes, into which the pin dropped to indicate that the correct amount of film had been wound on (facing page, bottom).

Despite its name, the 'America' camera was never marketed in the United States. For a few years it was sold in Germany, Sweden and Britain but it clearly wasn't a great commercial success. I know of only two surviving examples – one is in the collection of George Eastman House and the other at the National Media Museum in Bradford.

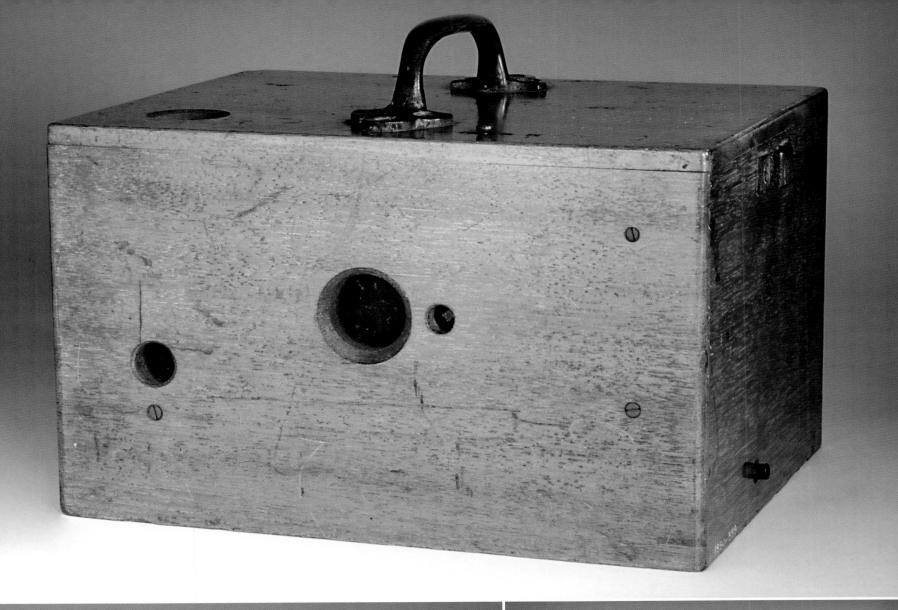

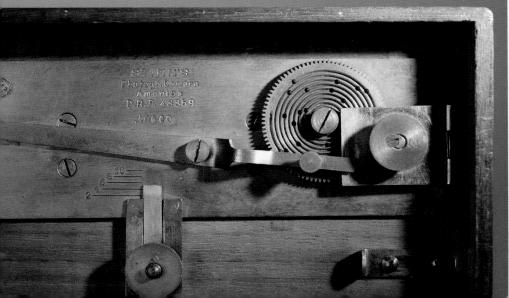

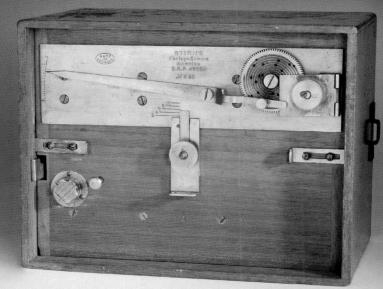

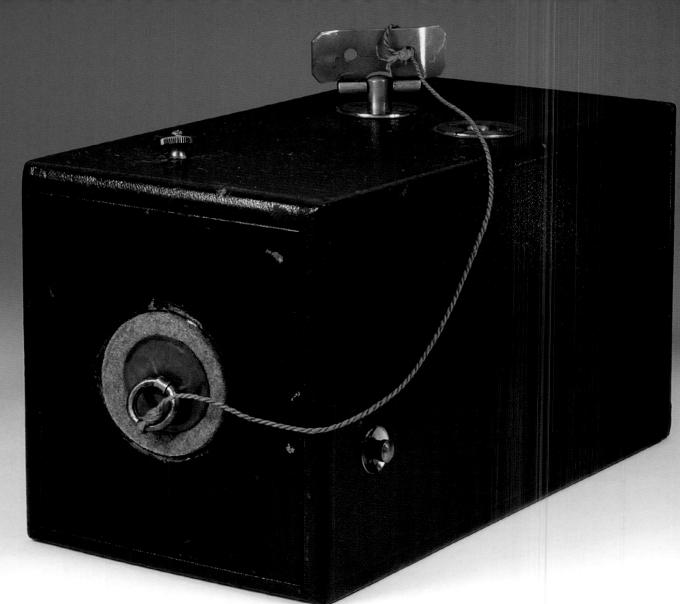

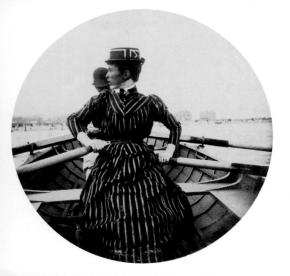

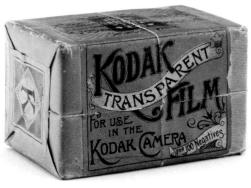

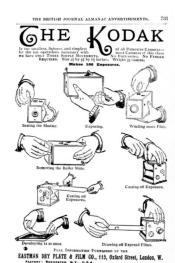

The Kodak

'YOU PRESS THE BUTTON, WE DO THE REST': THE KODAK
CAMERA WAS JUST ONE ELEMENT IN A COMPLETE DEVELOPING
AND PRINTING SYSTEM THAT FOUNDED AN ENTIRE INDUSTRY.

Popular photography can truly be said to have started with the introduction of the Kodak camera in 1888. Invented by an American, George Eastman (facing page, bottom right), it was the success of the Kodak which laid the foundations for Eastman to build an enormous business empire and make 'Kodak' a household word all over the world. He chose the name with great care: 'The letter "K" had been a favourite with me – it seems a strong incisive sort of letter. It became a question of trying out a great number of combinations of letters that made words starting and ending with "K". The word "Kodak" is the result.'

Advertised as 'the smallest, lightest and simplest of all Detective cameras' (a popular term of the time for a hand-held camera), the Kodak was a simple wooden, leather-covered box, 6½ inches long, 3¾ inches high and 3¼ inches wide (165 x 95 x 82mm). Inside was a roll-holder for 70mm wide 'film' – initially paper negative stripping film then, from late 1889, celluloid roll film (facing page, bottom centre). The Kodak was fitted with a fixed-aperture f/9 lens inside a horizontally-arranged cylindrical shutter with two opposing apertures. As the shutter rotated, the exposure was made when the lens came into alignment with the apertures. In Kodak cameras made after about May, 1889, this cylindrical shutter was replaced with a simpler sector shutter. The relatively small aperture and short focal length (about 60mm) of the lens gave a considerable depth of field so that anything more than about one metre away was in focus. Poor definition at the edge of the image area, however, meant that a circular exposing mask was placed in front of the film, explaining the distinctive round photographs that the Kodak produced (facing page, bottom left).

'The smallest, lightest and simplest of all Detective cameras.'

The lens covered an angle of 60 degrees which meant that no viewfinder was needed – the camera was simply pointed at the subject to be photographed. Taking a photograph with the Kodak was very easy, requiring just three simple actions: turning a key (to wind on the film); pulling the string (to set the shutter); and pressing the button (to release the shutter and make the exposure).

Ingenious, compact and simple to use though it was, the Kodak didn't embody any revolutionary technological innovations. It wasn't the first hand camera, nor indeed was it the first camera to be designed solely for roll film. The true significance of the Kodak lies in the fact that it was just the first element in a complete system of amateur photography.

The Kodak was sold already loaded with enough film for 100 exposures. After the film had been exposed, the entire camera was returned to the factory where the film was developed and printed. The camera, reloaded with fresh film, was then returned to its owner, together with the negatives and a set of prints. Eastman had founded the D & P industry. To promote his 'Kodak System', Eastman devised the brilliant advertising slogan: 'You press the button, we do the rest.'

This new convenience, however, didn't come cheap. In Britain, the Kodak cost five guineas – over a month's wages for most people. Through a combination of imaginative marketing and pioneering mass-production methods, Eastman was gradually able to reduce costs as he introduced new and improved versions of Kodak cameras. In October 1889, a larger model was introduced. This was named the No 2 Kodak and the original model was renamed the No 1 Kodak. Altogether, around 11,000 Kodak and No 1 Kodak cameras were produced before the model was discontinued in 1895.

The Luzo

A BRITISH COMPETITOR TO THE KODAK, THE LUZO WAS SUPERIOR IN SEVERAL RESPECTS: IT WAS SMALLER, CHEAPER, AND TOOK RECTANGULAR INSTEAD OF CIRCULAR PHOTOGRAPHS.

In October 1888, the first supplies of a revolutionary new American camera reached Britain. The name of this camera was to become synonymous with snapshot photography – The Kodak. Yet, while everyone has heard of that 'transatlantic emanation', few now remember the first British-made camera designed to take roll-film, which appeared just a few months later – the equally enigmatically named 'Luzo' camera.

The immediate success of the Kodak camera naturally encouraged other inventors and manufacturers to design roll-film cameras of their own. On 28 November 1888, an Englishman, H.J. Redding, was granted a British patent for a box-form roll-film camera which incorporated a design feature that was actually a distinct improvement on the Kodak. Redding placed the film spools at the front of the camera and took the film back through the focal plane and forward again. This arrangement meant that his camera design was much more compact than the Kodak, where the film spools were at the back of the camera and the film was carried forward.

From 1889, Redding's camera was made and sold by his employers, J. Robinson & Sons of Regent Street, London. Modestly, they advertised it as 'the most Compact, the Lightest, the Simplest and BEST hand camera in the world. A child can use it' – a cheeky reference, perhaps, to the Kodak's similar claim of being 'the smallest, lightest and simplest of all detective cameras.' In construction, however, the Luzo was very different to the Kodak.

'The first British-made camera designed to take roll film.'

Finely crafted from Spanish mahogany with brass fittings 'guaranteed to resist the most trying climates', the original model Luzo measured just 5½ by 3¼ by 3¼ inches (140 x 82 x 82mm). It was fitted with an f/11 rapid rectilinear lens, a circular waist-level reflecting viewfinder and a simple, external quadrant shutter, powered by a rubber band. The shutter speed was altered by changing the tension on the band. The film winder 'clicked' as it was turned to give an estimation of how much film had been wound on.

Just like the Kodak, the Luzo was sold ready-loaded with Eastman's 2¾ inch (70mm) roll film, sufficient for one hundred exposures. Unlike the Kodak, however, the rapid rectilinear lens meant that it took conventional rectangular prints – 'Photos taken with the "Luzo" are sharp to the extreme corners, avoiding the necessity of Circular Prints.' The Luzo sold for £4.14s.6d – slightly less than the 5 guineas that the Kodak cost.

The following year, several new, larger models of the Luzo were introduced for larger film formats – the Nos 2, 3 and 4 Luzo for negatives up to quarter-plate size (3¼ by 4¼ inches/82 x 108mm). In 1893, the Luzo range was completed with the introduction of versions for 5 by 4 inch (127 x 102mm) and half-plate film. Other changes included the replacement of the shutter rubber band with a spring and a rectangular instead of a circular viewfinder.

In 1896, Redding left J. Robinson & Sons, where he had worked for over 25 years, and set up his own business in partnership with another Robinson employee, E.T. Gyles. As Redding & Gyles they traded from Argyll Place, just around the corner from their old workplace. Redding took his patent with him, together with the rights to manufacture the Luzo. Redding & Gyles continued to produce some models of the Luzo until about 1899, after which date it stops being advertised.

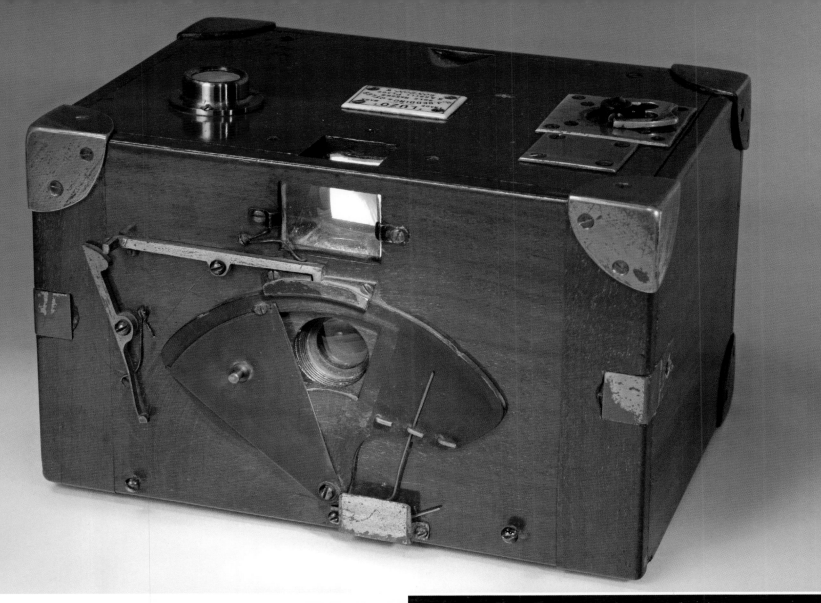

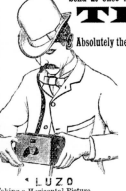
'LUZO
Taking a Horizontal Picture.

LUZO
A Timed Exposure.

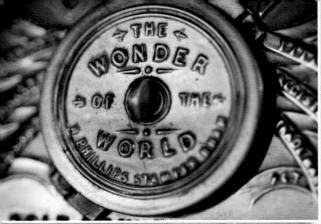

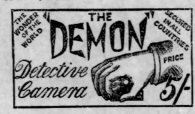

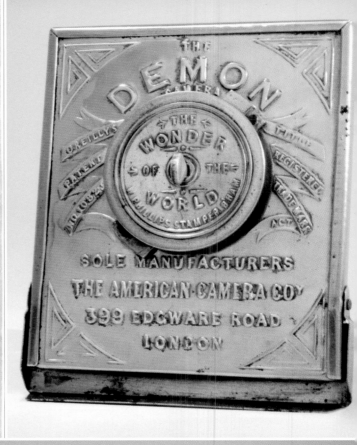

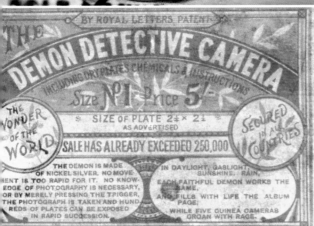

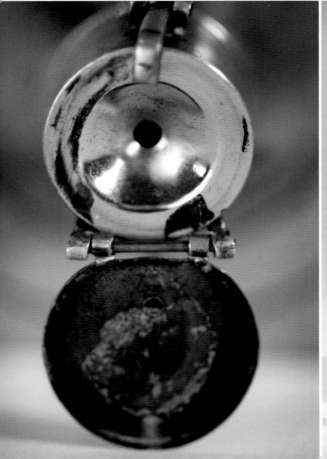

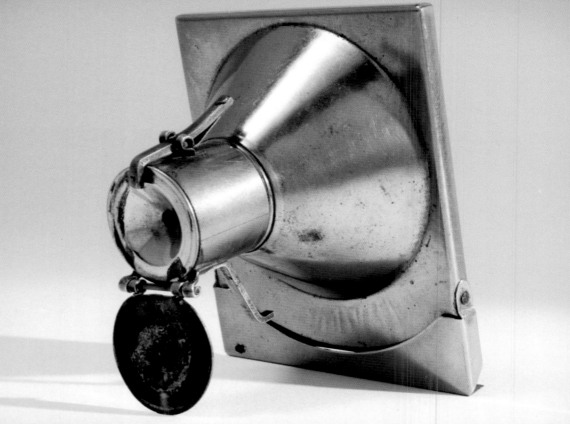

The Demon Detective

MADE IN BRITAIN BY THE 'AMERICAN CAMERA CO.' AND MARKETED AS 'THE WONDER OF THE WORLD', THE DEMON COULDN'T LIVE UP TO ITS HYPERBOLIC ADVERTISING.

In those innocent days before the formation of the Advertising Standards Authority, the creative imagination of the copywriter wasn't constrained by such trifling matters as having to tell the truth. Many camera manufacturers made what could, at best, be described as unverifiable claims about their products. Surely none of them, however, could match the astonishing claims made on behalf of a camera called The Demon, which first went on sale in 1889.

'... the Demon was small enough to be concealed and used inconspicuously ...'

The Demon Detective camera was based on an 1888 British patent taken out by Walter O'Reilly. It was sold by The American Camera Co of Edgware Road, London, but wasn't made in the United States. At the time, American products enjoyed a reputation for innovation and mechanical ingenuity, and the company undoubtedly chose their name to make the most of this. In fact, The Demon was made in Birmingham by W. Phillips.

Described as 'The Wonder of the World', The Demon was small enough to be concealed and used inconspicuously. Made of nickel-plated brass, it consisted of a conical lens tube attached to a square, flat plate-holder with a hinged cover. The simple lens was covered by a flap shutter powered by an elastic band. There was no viewfinder – the camera simply being pointed in the general direction of the subject. Two sizes were produced – the No 1 for 2¼ inch (57mm) square plates, and a second, larger model, the No 2, for 3¾ inch (95mm) square plates, introduced in 1890.

Priced at 5s and 12s.6d respectively, the Demon cameras were cheap – particularly when one considers that they were sold complete with plates, chemicals and an instruction sheet.

Considering the camera's basic specification, the claims made for its performance were extravagant, to say the least: 'No movement is too rapid for it – the racehorse at greatest speed, the flight of birds, even the lightning flash itself. By merely pressing the trigger, the photograph is taken, therefore any person can use it, no knowledge of photography being necessary.' 'The Demon Camera can be used on the promenade, in law courts, churches and railway carriages, also in breach of promise and divorce cases – in fact, at all awkward moments when least expected.'

The reality was somewhat different. A letter to *The Amateur Photographer* in March 1892 asked: 'Will any reader who has tried the Demon tell me if you can get a fair picture with them?' Two replies, published the following week, were honest in their appraisal: 'I had one for a month or two, but could not by any manner of means get a negative at all.' and 'I have tried the Demon and have never succeeded in getting a picture fit to be seen with it.'

An aggressive advertising campaign, combined with the camera's low price, undoubtedly resulted in a large number of them being sold. It is extremely doubtful, however, whether sales were remotely as high as the astonishing figures quoted by the makers. The American Camera Co claimed that sales averaged over 2,000 every week and that by 1892 over a quarter of a million Demons had been sold worldwide. Such healthy sales figures, however, are difficult to reconcile with the fact that the company ceased trading in 1894.

L'Escopette

NAMED AFTER A BLUNDERBUSS USED BY THE FRENCH CAVALRY, L'ESCOPETTE WAS A SWISS DESIGN THAT USED THE SAME EASTMAN ROLL FILM AS THE ORIGINAL KODAK.

The success of the Kodak camera prompted other inventors and manufacturers to come up with their own designs of roll film cameras. One of the first, designed to take standard rolls of 70mm wide Eastman film, was L'Escopette, invented by Albert Darier of Geneva, Switzerland. In November 1888, Darier was granted a Swiss patent for a roll film camera with a wooden pistol grip, giving it the general appearance of a handgun. Pistol cameras were, of course, nothing new – both Skaife and Thompson had come up with the same idea some thirty years earlier.

From 1889, Darier's camera was manufactured by Edmond-Victor Boissonnas of Geneva (left) under the name L'Escopette.

Like the Kodak camera, there was no viewfinder, but sighting lines were inscribed on the top to show the angle of view. The camera, with its pistol grip, was primarily intended for hand-held 'instantaneous' exposures. However, it was also fitted with a pair of hinged telescopic legs mounted on the bottom front of the camera body which, when combined with the pistol grip, formed a tripod. The camera could then be rested on a flat surface for time exposures. L'Escopette took 110 exposures on a roll of Eastman film – the same film that was supplied for use in the original Kodak camera.

In August 1889, the Genevese photographer Frederic Boissonnas (facing page, centre left), the brother of Edmond-Victor Boissonnas, used an Escopette camera to record the spectacular *Fête des Vignerons* (Festival of the Vine Growers) in Vevey, on Lake Geneva, Switzerland. Held only once a generation, this is the world's most important wine festival. Frederic used the camera to make a series of candid instantaneous photographs of the celebrations and colourful processions. Edmond-Victor died from typhus in January 1890, aged just 27.

'The camera, with its pistol grip, was primarily intended for hand-held "instantaneous" exposures.'

An *escopette* was an early form of firearm used by French cavalry during the seventeenth century and the word can be roughly translated as 'blunderbuss'. A roll-holder was contained in a roughly cubical wooden box, to which was attached a bell-shaped brass lens housing which also held the shutter.

The camera was fitted with a Steinheil f/6, 90mm periscopic lens and a revolving hemispherical shutter. The shutter speed could be varied by adjusting spring tension. It was set by turning a wing nut beneath the lens housing and released by squeezing a trigger.

L'ESCOPETTE
Alb. DARIER Inv.
Pat appl for. Brev. ✠ No 17
D.R.P. ang. Breveté S.G.D.G.
BOISSONNAS Phot.
GENEVE No 64

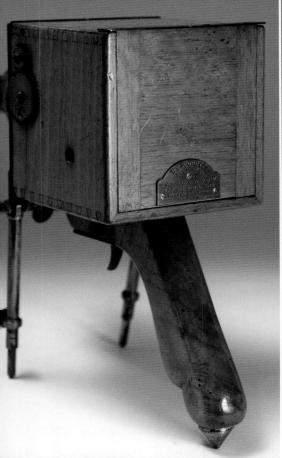

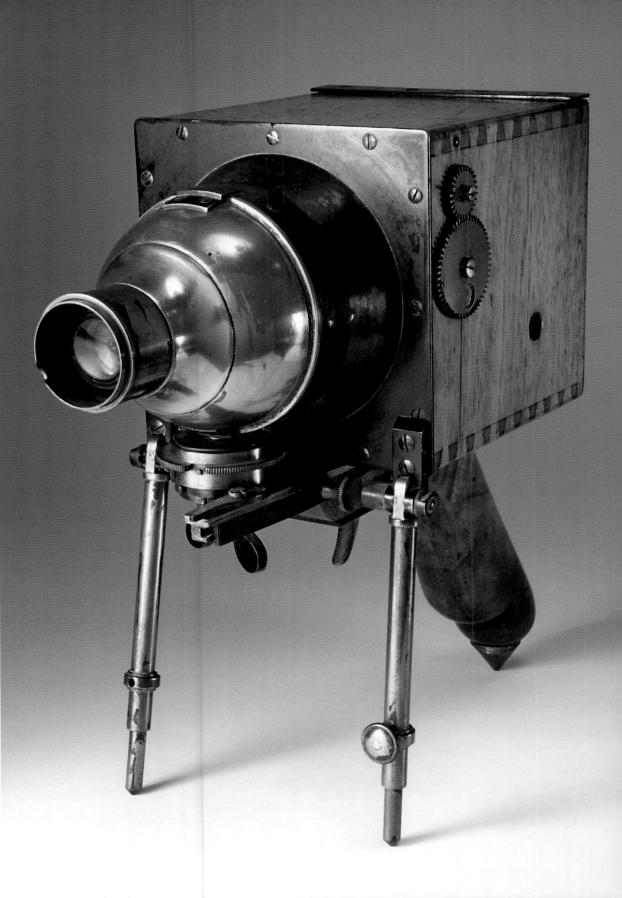

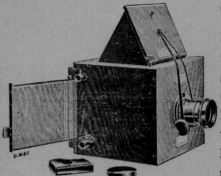
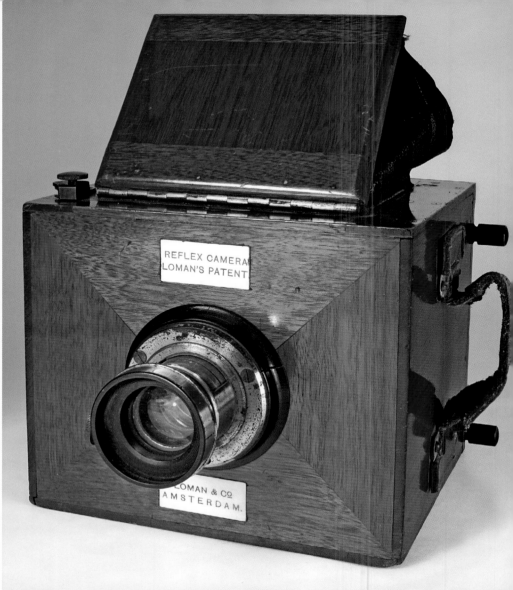

Loman's Patent Reflex Camera

AN EARLY SINGLE-LENS REFLEX CAMERA WITH AN INNOVATIVE FOCAL-PLANE SHUTTER, LOMAN'S CAMERA, BUILT IN HOLLAND, WAS 'AN EXTREMELY NATTY LITTLE INSTRUMENT'.

The concept of the single-lens reflex camera pre-dates photography. Some portable camera obscuras had a mirror placed at 45 degrees behind the lens so as to produce an image on a horizontal glass screen.

The first reflex photographic camera was invented by Thomas Sutton in 1861, just one year after he introduced his ingenious panoramic camera fitted with his spherical water-filled lens (see page 39). However, very few of Sutton's reflex cameras were made.

'This was the first camera fitted with a focal plane shutter to achieve commercial success .'

The first single-lens reflex camera to be sold in any numbers was the Monocular Duplex camera, introduced in 1884 and designed by an American, Calvin Rae Smith. This had an internal movable mirror, reflecting an image onto a ground glass screen on the top. Gradually, this principle was adopted by others. A popular model, introduced a few years later, was invented by a Dutchman, A.D. Loman. This was also the first camera fitted with a focal-plane shutter to achieve commercial success and is probably Holland's only notable contribution to the development of the camera.

In 1889, Loman, who had studied photography under Hermann Vogel in Berlin, took out a patent in Germany and Britain for a single-lens reflex camera. That same year, Loman together with a friend, Chris Shuver, founded a company, Loman & Co, in Amsterdam to produce his cameras.

Earlier reflex cameras had the drawback that the shutter had to be opened for focusing, closed when the mirror was moved out of position, and then opened and closed again to make the exposure. Loman solved this problem by placing a roller blind shutter in the focal plane, behind the mirror, rather than in front of the lens. The image could therefore be viewed in the focusing screen right up to the moment of making the exposure. The shutter release first raised the mirror before activating the shutter. Variable shutter speeds from about 1/2sec to 1/250sec were possible by altering the tension of a spring. The camera lens had rack and pinion focusing for distances from 5 feet (1.5m) to infinity.

From 1891, Loman's camera was sold in Britain by Mawson & Swan of Newcastle-upon-Tyne and London. A contemporary review in *The Amateur Photographer* described it as 'an extremely natty little instrument ... an excellent practical form of hand-camera.' Two sizes were available – quarter-plate priced at £10 and half-plate at £18. A 'Special Reflex' version was also available, covered in black leather.

In 1893, Loman sold his company to L.J.R. Holst. Holst subsequently took the patents for the Loman Reflex camera and focal plane shutter with him when he later became technical director of the Huttig factory in Dresden, Germany.

The Artist
Hand Camera

ENDORSED BY THE PRINCESS OF WALES, THE 'ARTIST' WAS A TWIN-LENS REFLEX CAMERA THAT 'SHOWS ON THE FINDER AN EXACT REPRODUCTION OF THE PICTURE BEING PHOTOGRAPHED'.

Twin-lens cameras, in which one lens is used for viewing and the other for taking the photograph, first appeared in the 1860s. However, the first true twin-lens reflex, or TLR, camera, in which a reflex viewing system was also used to focus the camera, didn't appear until the 1880s. The first TLR was probably made by R. & J. Beck for G.M. Whipple, the Superintendent of the Kew Observatory in 1880. This was a two-compartment box camera with two lenses, fitted one above the other and coupled for focusing. The lower compartment was fitted with a plate-holder and the upper was fitted with a mirror which reflected an image onto a ground glass screen, with a viewing hood, at the top of the camera. This was to become the standard design for all subsequent TLRs.

In January 1887, E. Français of Paris patented his Kinégraphe camera. This was a wooden box-form camera with a small viewing lens above a larger taking lens. A mirror and a ground glass screen gave reflex viewing but, technically, this wasn't a TLR camera since the viewing lens wasn't coupled to the taking lens. In Britain, the Kinégraphe was sold by the London Stereoscopic & Photographic Co Ltd as the Artist Hand Camera. The Artist was available in three sizes – quarter-plate, half-plate and 5 x 4. The quarter-plate version was described as 'particularly handy for artists and cyclists on tour, who, not having the necessary time to take sketches and details, can thus bring away with them faithful reproductions of the scenes visited.'

'... particularly handy for artists and cyclists on tour ... '

A stereo version was also produced, The Stereoscopic Artist, with the viewing lens and hood in the centre of a pair of taking lenses – very similar to the arrangement that was later to be adopted by the Heidoscop camera.

In 1889, Français introduced an improved version of their Kinégraphe, called the Cosmopolite. This incorporated a number of changes. In The Cosmopolite, the matched viewing and taking lenses were mounted on the same panel and focused by a rack-and-pinion mechanism. The reflex focusing screen, protected by a viewing hood, gave an image the same size as the negative.

At first, the camera was fitted with a rotary shutter but from 1892 this was replaced by a roller-blind shutter. Like the earlier model, The Cosmopolite was also imported into Britain and sold by the London Stereoscopic Co as The Twin Lens Artist Hand Camera. This was available in four sizes, from 5 by 4 to whole-plate. The most famous owner of one of these cameras was Alexandra, The Princess of Wales, who was an enthusiastic amateur photographer. The London Stereoscopic Co made frequent use of her celebrity endorsement in their advertisements (facing page, centre right).

During the 1890s, several manufacturers introduced their own TLR cameras, including Ross, Adams & Co and Newman & Guardia, all of which followed the same basic design. Despite their initial success, by the outbreak of the First World War TLR cameras were largely replaced by SLR cameras, which were just as versatile but far less bulky. The twin-lens reflex principle, however, was still used for several stereoscopic camera designs, including the Heidoscop. This was the direct precursor of the camera that was to bring about a revival of interest in the TLR – the Rolleiflex (see page 108).

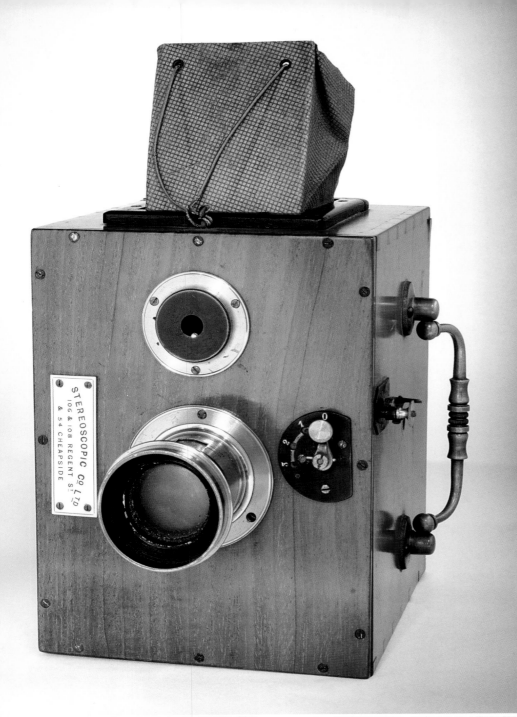

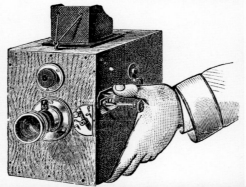

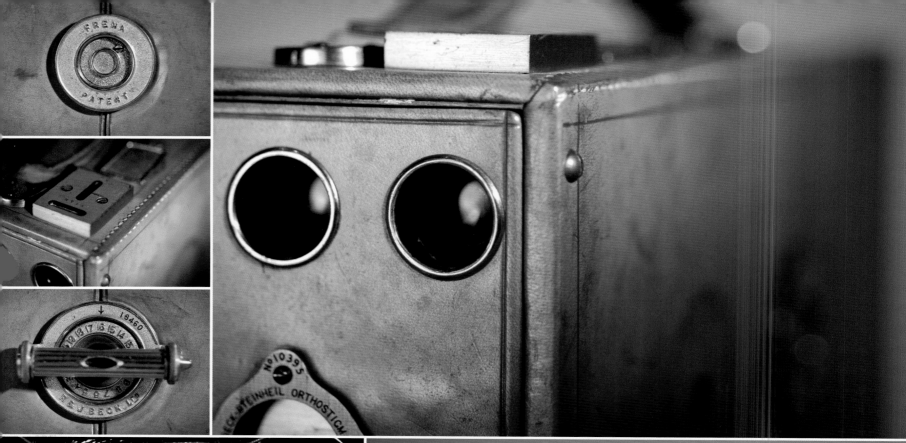

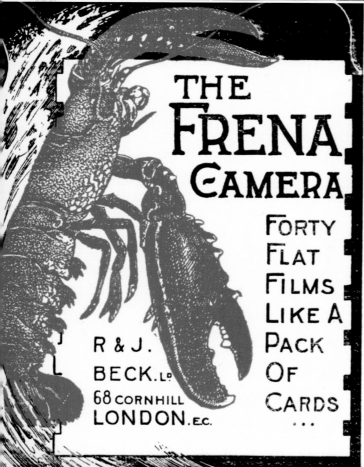

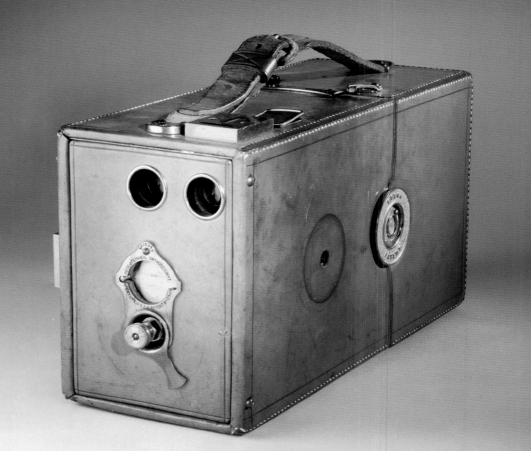

THE
FRENA
CAMERA

FORTY
FLAT
FILMS
LIKE A
PACK
OF
CARDS
...

R & J.
BECK. LD
68 CORNHILL
LONDON. E.C.

The Frena

HIGHLY POPULAR UNTIL THE FIRST WORLD WAR, THE FRENA

USED CUT CELLULOID FILM IN PLACE OF BULKY GLASS PLATES.

THE DELUXE VERSION WAS COVERED IN TAN PIGSKIN.

The weight of the glass plates they held set a practical limit to the number of plates that could be carried by magazine cameras such as the Facile (see pages 54–5) – usually a maximum of twelve. To increase the number of exposures available, an alternative was to use cut celluloid film in place of glass plates. The first and most popular camera to use packs of cut film was the Frena.

The Frena was based on a series of patents taken out between 1890 and 1892 by Joseph Thatcher Clarke. Clarke proposed the use of a frame holding a pack of sheets of celluloid cut film. The edges of the film were notched, or crenellated, and each sheet was interleaved with similarly cut opaque, thin card. The films were stacked so that the notches in successive sheets alternated and were not in line.

Frena cameras were very popular and were made in many different sizes and versions until around the First World War. *The Amateur Photographer* magazine even ran a regular Frena column. One notable Frena user was the author Virginia Woolf who, as a young girl, carried her Frena camera everywhere she went, referring to it in her diary as her 'frend' (sic). Ordinary models were covered in black leather but there was also a deluxe version covered in tan pigskin with gilt fittings (facing page, bottom right). From 1900, a range of Folding Frena cameras was produced and it was also possible to use Frena films with an ordinary plate camera by attaching a Frena Film Holder. Despite these variations, all Frena cameras used the same film-changing method and were designed to hold up to 40 films, supplied in packs of 20.

'One notable Frena user was the author Virginia Woolf who, as a young girl, carried her Frena camera everywhere she went ...'

The films were pressed by a spring against a series of pins on the front of the frame. After each exposure, the frame was rotated until it was horizontal by turning a handle on the side of the camera. This action also moved the pins sideways, allowing the exposed film, together with its interleaving card, to fall from the frame, leaving the next film in place, ready for exposure. From 1892, Clarke's design was incorporated into a series of box cameras named 'The Frena', made by R. & J. Beck of London.

There are differing explanations as to the origins of the name 'Frena'. One suggestion is that it is an acronym of 'For Rapidly Exposing Negatives Automatically' – a phrase often used in Beck's advertisements. In one of their instruction booklets, however, they suggest a much more plausible etymology, claiming that the name is actually derived from a combination of 'Faro' (a popular card game where the pack of cards is dealt from a metal box fitted with a spring) and 'crena', the Latin word for notch.

Folding Pocket Kodak

ALWAYS AN ASTUTE BUSINESSMAN, GEORGE EASTMAN BOUGHT

THE PATENT FOR DAYLIGHT-LOADING CARTRIDGE FILM AND

INSTALLED IT IN A RANGE OF COMPACT FOLDING CAMERAS.

The first Kodak roll film cameras had to be loaded and unloaded in the darkroom. In 1892, Samuel N. Turner applied for an American patent for a system of 'cartridge' daylight loading in which film was attached at one end to a black paper backing strip. When the film and paper were wound together tightly on a flanged spool, the black paper protected the film from being exposed to light during loading and unloading. To indicate each exposure, the backing paper was printed with numbers that could be viewed through a little red window in the back of the camera. Turner manufactured a camera called the Bull's Eye which used his cartridge film.

'The Folding Pocket Kodak was the first of what was to become a long line of popular folding cameras.'

George Eastman had already experimented with one, ultimately unsatisfactory, method of daylight film loading. In 1895, he used Turner's cartridge-loading system for a new, small camera called, appropriately, the Pocket Kodak. Shortly afterwards, Turner's outstanding patent application was finally granted. Eastman, realizing its commercial importance, quickly bought both Turner's company and patent outright so that Kodak cameras could continue to use cartridge film.

The Pocket Kodak was the most popular Kodak camera produced up to that time – 100,000 were sold in the first year. People liked the fact that it was small but were disappointed with the small pictures that it produced (just 1½ by 2 inches/38 x 51mm). Eastman subsequently asked his camera designer, Frank Brownell, to come up with a folding camera that was very compact when closed but that could also take a larger size film. The result, introduced in 1897, was the Folding Pocket Kodak.

The Folding Pocket Kodak was launched in November 1897 at the Eastman Exhibition held in London. This, the first public exhibition of snapshot photography, also included a section devoted to the latest products of the Eastman Photographic Materials Company. Pride of place was given to their new folding camera.

The Amateur Photographer was impressed: 'Of Kodaks there are apparently no end … the present exhibition introduces at an opportune moment still another Kodak. This enjoys the name of the folding pocket Kodak. When closed it looks rather like a book with rounded ends (and) it fully justifies the specific name of 'pocket' … For this very ingenious instrument it is surely safe to predict a large demand at the popular price of two guineas.' When closed, the Folding Pocket Kodak was only just over 1½ inches (38mm) thick. In its review, *The Photogram* described it as 'no larger than a small pocket sandwich tin or a spirit-flask'.

For use, the lens panel popped out on spring-loaded struts. The lens panel had a built-in rotary shutter for time and instantaneous (about 1/20sec) exposures, and an achromatic lens with three f stops on a sliding metal bar giving, roughly, f/11, f/16 and f/22. There were two reflecting viewfinders, for horizontal and vertical pictures. The Folding Pocket Kodak took 2¼ by 3¼ inch (56 x 82mm) pictures on what was later designated 105 roll film.

The Folding Pocket Kodak was the first of what was to become a long line of popular folding cameras. The last folding Kodak, the Kodak 66, was discontinued over 60 years later, in 1960. After the introduction of larger roll film models in 1899, this first model was redesignated the No 1 Folding Pocket Kodak. It subsequently underwent a number of design changes – from 1905 it incorporated one of the earliest self-erecting mechanisms – before being discontinued in 1915.

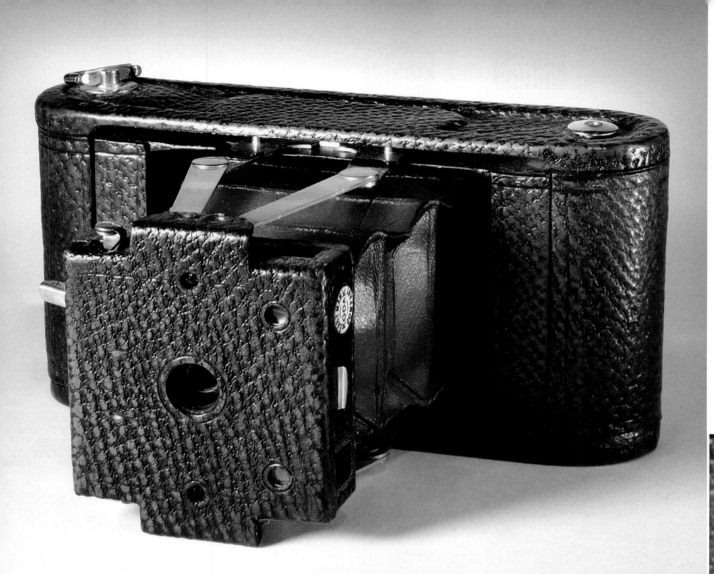

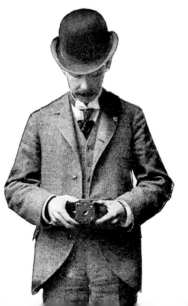

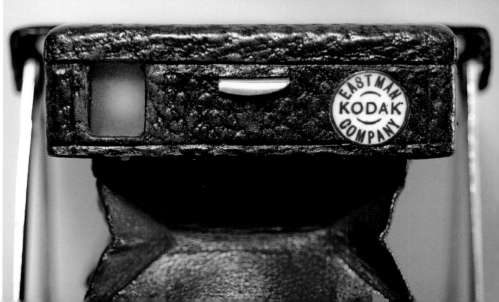

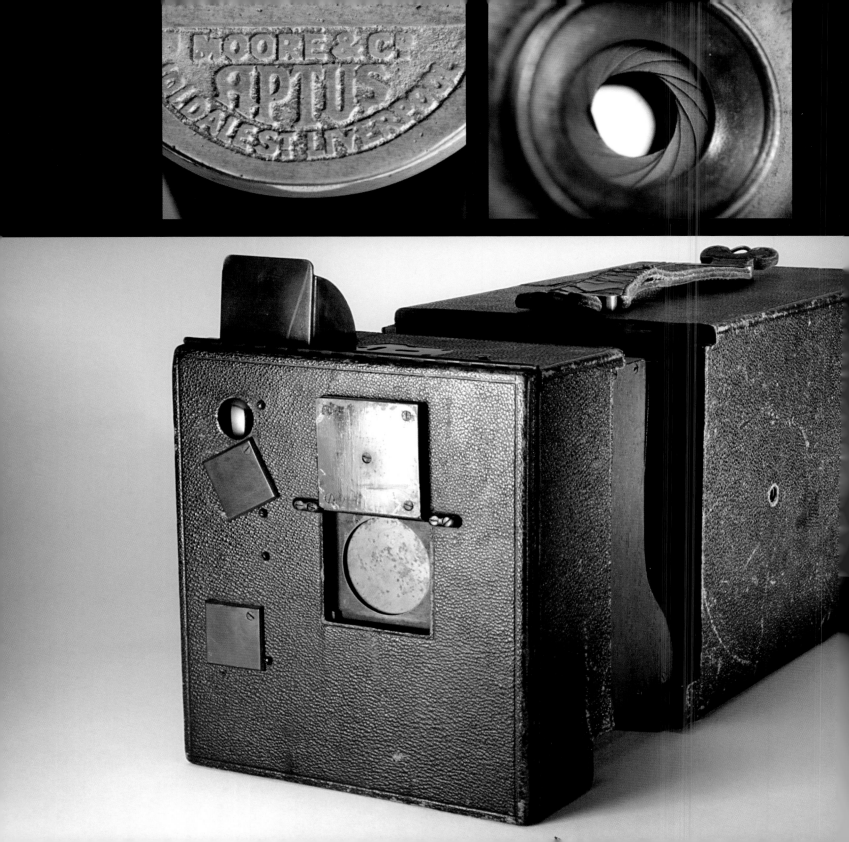

A New Century

THE BEGINNING OF THE TWENTIETH CENTURY WITNESSED

A PROFUSION OF CAMERA DESIGNS. LONG-ESTABLISHED

BUSINESSES USING CRAFT TECHNIQUES COMPETED WITH

INTERNATIONAL CORPORATIONS EXPLOITING THE ECONOMICS

OF MASS PRODUCTION. THE USE OF TRADITIONAL MATERIALS

SUCH AS MAHOGANY CONTINUED, BUT METAL BECAME

INCREASINGLY USED FOR CAMERA CONSTRUCTION. FIELD

CAMERAS RUBBED SHOULDERS WITH HAND CAMERAS;

PLATE CAMERAS COMPETED WITH ROLL-FILM MODELS. THERE

WERE SPECIALIZED CAMERAS FOR SPECIFIC FORMATS AND

APPLICATIONS SUCH AS STEREO, PANORAMIC AND STUDIO

PHOTOGRAPHY. CAMERA DESIGN HAD UNDERGONE A RADICAL

TRANSFORMATION, FROM HAND-MADE WOODEN BOXES TO

MASS-PRODUCED PRECISION-ENGINEERING PRODUCTS.

Top left: the Aptus
(page 90)
Top right: the Midg
(page 82)
Below: Universal
Special B (page 92)

The Brownie

WITH SALES OF OVER 100,000 IN ITS FIRST YEAR, THE BROWNIE WAS THE FIRST TRUE MASS-MARKET CAMERA. IT RAPIDLY BECAME SYNONYMOUS WITH POPULAR PHOTOGRAPHY.

Throughout the 1890s the cost of roll-film cameras gradually fell, from five guineas for the first Kodak camera to just one guinea for the Pocket Kodak, introduced in 1895. Even this, however, represented over a week's wages for most people. George Eastman was determined to bring photography within reach of everyone — not through altruism but for sound business reasons. All those who could be persuaded to take up photography were potential users of Kodak film, already identified as the major source of Kodak's profits.

In 1898, Eastman asked his camera designer Frank Brownell to design a camera that would be as cheap as possible whilst still being reliable and capable of taking successful photographs. Brownell designed most of the early Kodak cameras and his company manufactured all of them until 1902. Brownell didn't disappoint, coming up with his simplest but most influential design and keeping costs to an absolute minimum through the use of cheap materials and mass-production techniques.

The new camera was launched in February 1900. It was a small box camera, measuring just 5 inches long, 3 inches high and 3 inches wide (127 x 76 x 76mm), made from jute-board reinforced with wood and covered with imitation leather. There was a simple rotary shutter for time and instantaneous exposures and an f/14 meniscus lens. Like the first Kodak camera, there was no viewfinder but a clip-on viewfinder was available after July 1900 as an optional extra. Six 2¼ inch (57mm) square negatives could be taken on what was later designated 117 roll film.

'Good value, reliable and capable of perfectly satisfactory results in the right conditions, the Brownie was an instant success .'

The first production batch of about 15,000 cameras had a push-on box-lid back but this proved to be unreliable and was soon replaced by a hinged back, secured by a sliding catch.

Eastman called his new camera 'The Brownie' — not after Frank Brownell, but after characters created by the popular Canadian children's author and illustrator, Palmer Cox. Eastman, always the shrewd businessman, wanted to cash in on their popularity and make the camera more appealing to children. At first, Brownie packaging carried illustrations of the little, pixie-like characters. It soon became clear, however, that the cameras were not being bought by parents for their children, but for them to use themselves. The Brownie characters soon disappeared but the name stuck. The Brownie was aimed at people who had not previously owned a camera and it was advertised widely in the popular press. In Britain it cost just 5 shillings ($1 in the US), bringing it within the reach of practically every family. Indeed, it was so cheap that advertisements had to reinforce the fact that it wasn't a toy: 'Despite its low price and small size, the Brownie is not a toy but a thoroughly efficient instrument.'

The Amateur Photographer was quick to grasp the camera's potential: 'Not least the wonderful part of this camera, to be known as the "Brownie", is the marvellously explicit pamphlet of instructions which is issued with it and, on sunny days, with no very adverse circumstances, anyone with a little commonsense should be able to secure a snapshot or two, though he has never thought of photography before.'

Good value, reliable and capable of perfectly satisfactory results in the right conditions, the Brownie was an instant success. Within a year, over 100,000 had been sold. Other Brownies soon followed — both box and folding models. The name 'Brownie' became synonymous with popular photography. All box cameras, whether they were made by Kodak or not, were described as Brownies. By the time the last Brownie camera appeared in 1980, nearly 100 different cameras had carried the famous name.

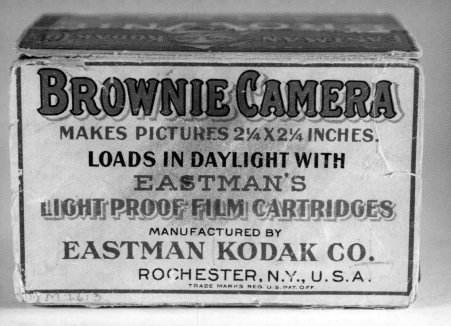

BROWNIE CAMERA
MAKES PICTURES 2¼ X 2¼ INCHES.
LOADS IN DAYLIGHT WITH
EASTMAN'S
LIGHT PROOF FILM CARTRIDGES
MANUFACTURED BY
EASTMAN KODAK CO.
ROCHESTER, N.Y., U.S.A.
TRADE MARKS REG. U.S. PAT. OFF.

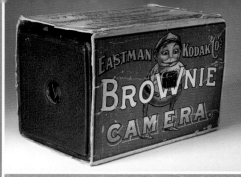

EASTMAN KODAK Co's
No 2
BROWNIE
CAMERA

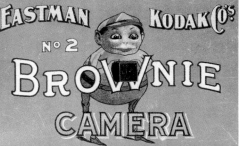

AN EFFICIENT
5/-
FILM CAMERA.

THE BROWNIE.

Not a Toy. Takes splendid Photographs,
2¼ by 2¼ inches. Complete with Hand-
book of Instructions. Price only 5/-

Of all Photographic Dealers, or from—

KODAK, Limited,
43, Clerkenwell Road, E.C.;
60, Cheapside, E.C.;
115, Oxford Street, W.;
and 171-3, Regent Street, W.

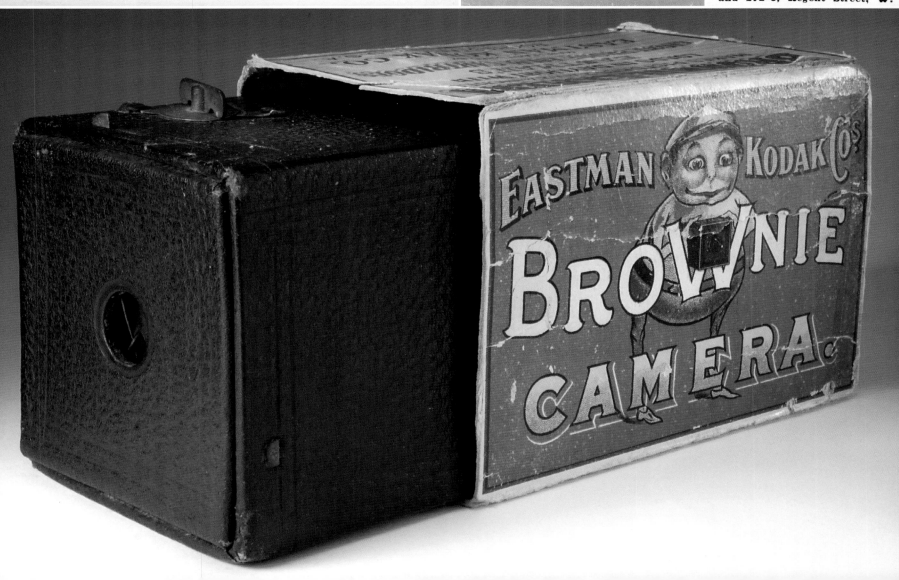

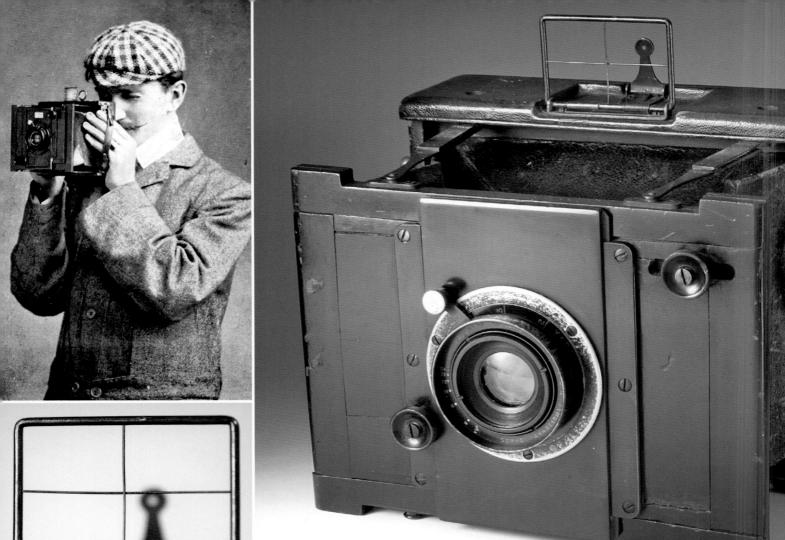

Goerz Anschütz Camera

THE SHUTTER DEVISED BY OTTOMAR ANSCHUTZ WAS CAPABLE OF EXPOSURES AS BRIEF AS 1/1000SEC. HUGELY INFLUENTIAL, IT WAS USED BY THE EUROPEAN PRESS FOR THREE DECADES.

'The focal-plane shutter's ability to "freeze" movement was the camera's major selling point.'

Like many other photographic innovations, the focal-plane shutter (placed behind the lens, just in front of the plate or film) has been around for a lot longer than you might imagine. William England, the chief photographer of the London Stereoscopic Company renowned for his 'instantaneous' street scenes, proposed such a shutter in the early 1860s. However, the most famous and influential design of the focal-plane shutter was devised during the 1880s by a German, Ottomar Anschütz.

Anschütz designed his first shutter in 1883. He used it, just like his more famous contemporary, Eadweard Muybridge, to take photographs of moving subjects, such as birds in flight. His photographs of storks in flight were a direct inspiration for aviation pioneer Otto Lilienthal's experimental gliders. Anschütz patented his shutter in 1888. It consisted of a fabric roller-blind working at a fixed tension, but with a slit whose width could be adjusted to give exposures as brief as 1/1000sec – much faster than any other shutter in use at the time.

From 1890 onwards, Anschütz's shutter was incorporated into a camera made commercially by the Berlin firm of C.P. Goerz, founded just four years earlier by Carl Paul Goerz.

The first model, known as 'Anschütz's Moment-Apparat', was in the form of a truncated pyramid with a square back containing the focal-plane shutter and fitted with a large eye-level wire-frame viewfinder (facing page, bottom left). In 1892, a new model was introduced with a similar specification but of more conventional square, box-form construction.

In 1896, the third and most famous version of the Goerz Anschütz camera appeared. This was a collapsing camera with the lens panel supported at each corner by a strut, hinged in the middle and folding inwards, so that the camera would collapse flat.

The Goerz Anschütz *klapp* or folding camera was enormously influential and its design was imitated by a number of other manufacturers. In Britain, for example, the design was copied by Peeling and Van Neck for their VN Press Camera, introduced in the early 1930s. The focal-plane shutter's ability to 'freeze' movement was the camera's major selling point. The review in the *British Journal Photographic Almanac* in 1900 said: 'This is a very portable and at the same time efficient apparatus for photographing rapidly moving objects at a close range, such as horse, foot or cycle races etc.'

The Goerz Anschütz and its imitators soon became the standard press camera, used by newspaper photographers in continental Europe and Britain for over thirty years. It was produced by C.P. Goerz right up until 1926 when they, together with a number of other German companies, merged with Carl Zeiss to form Zeiss Ikon.

The Midg

THE MIDG WAS TYPICAL OF A NEW BREED OF MAGAZINE-PLATE CAMERAS. IN 1917, HOWEVER, IT WAS USED TO PERPETRATE THE MOST FAMOUS PHOTOGRAPHIC HOAX IN HISTORY.

The 1890s saw the appearance of a type of camera that remained very popular until around the First World War. Known as 'magazine falling-plate cameras', these were a response to the growing popularity of box-form roll-film cameras. Falling-plate cameras allowed photographers to take a series of exposures (usually about twelve) on glass plates without having to carry around separate plate holders.

They did away with the time-consuming routine: remove the dark slide, take the exposure, replace the dark slide, remove the plate-holder, replace with a fresh plate-holder, remove the dark slide and so on. Magazine cameras were loaded with a 'magazine' of plates held in thin metal sheaths. A spring on the camera back pushed the plates forward so that the front plate was in position ready for exposure. When the exposure had been made, a catch was released, allowing the plate to fall forward and lie horizontally on the bottom of the camera. The next plate was then automatically pushed into position ready for exposure. Theoretically, if the plate-changing mechanism worked properly, you could take up to two photographs a second in rapid succession. In practice, however, the mechanism frequently jammed and had to be freed by the time-honoured method of giving the camera a good thump.

'In practice, however, the mechanism frequently jammed and had to be freed by the time-honoured method of giving the camera a good thump.'

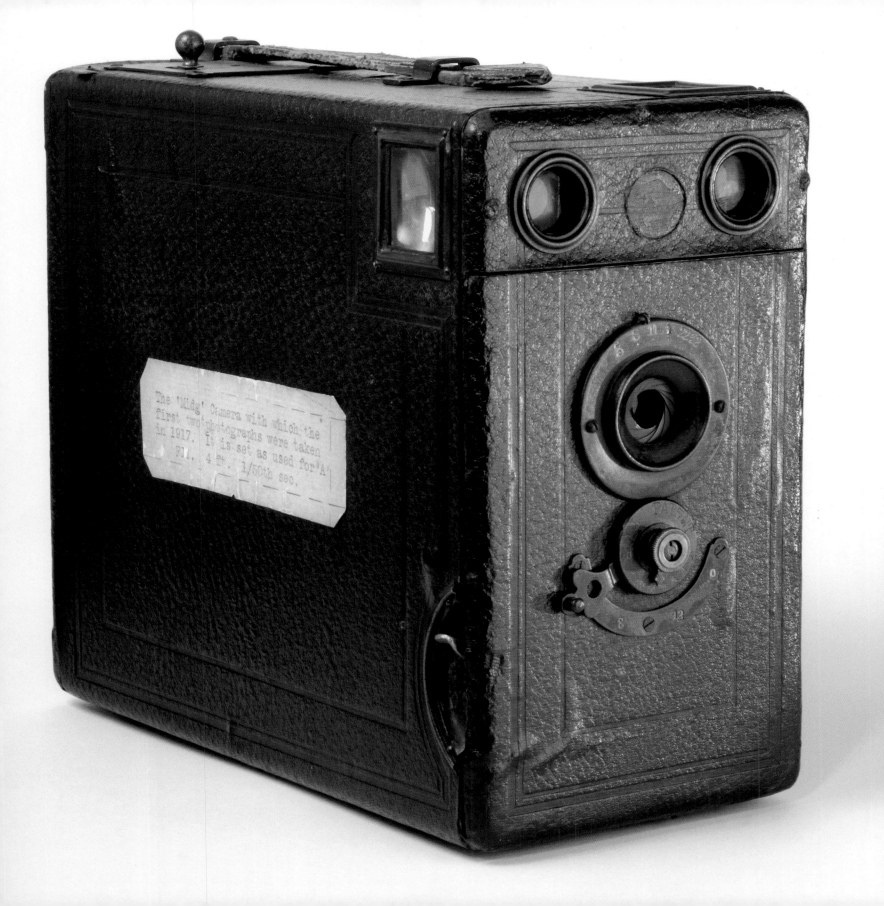

The 'Midg' Camera with which the
first two photographs were taken
in 1917. It is set as used for 'A'
F11. 4 ft. 1/50th sec.

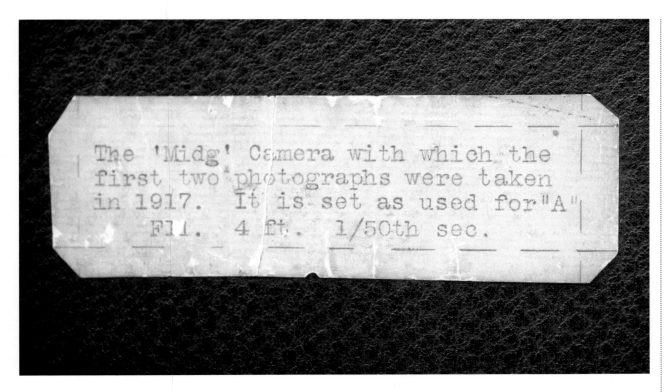

The 'Midg' Camera with which the
first two photographs were taken
in 1917. It is set as used for "A"
F11. 4 ft. 1/50th sec.

Magazine plate cameras had other disadvantages. They tended to be bulky and, when fully loaded, they were very heavy. Also, unlike roll-film cameras, they had to be loaded and unloaded in a darkroom.

However, despite their drawbacks, magazine plate cameras, were very popular and were produced in large numbers by a range of manufacturers. Most were very similar in design and differed only in the details of their plate-changing mechanisms.

Typical of this type of camera were 'Midg' cameras, sold by W. Butcher & Sons of London. Introduced around 1901, Midg cameras were produced until the early 1920s in a range of different models with various features. The cheapest of the range was the No 0 Midg which cost just one guinea (£1.05) and was advertised as 'The King of Guinea Cameras'.

This particular Midg camera is an unremarkable example of one of the simplest of the range. It has an achromat doublet meniscus lens and, since there is no focusing

movement, supplementary lenses which can be swung into position to give focused distances of 12, 8 and 4 feet (3.65, 2.43 and 1.21m). An external iris diaphragm offers apertures of f/8, f/11, f/16, f/22 and f/32 and a guillotine shutter gives speeds of 1 to 1/100sec. However, what makes this particular camera so special are the extraordinary photographs it took during the summer of 1917.

This Midg belonged to Arthur Wright who lived in Cottingley, near Bradford, Yorkshire. In 1917, his daughter Elsie, then aged 15, and her cousin, Frances Griffiths, aged 10, borrowed this camera to take a photograph whilst playing beside a stream near their house. When Arthur developed their photograph he was amazed to see that it appeared to show a group of dancing fairies. What had started as a childish practical joke, intended simply to tease their parents, was destined to become the world's most famous and long-running photographic hoax. Only in 1983 did the 'girls' (now old women) finally admit that the 'fairies' they photographed were in fact cardboard cutouts.

Fig. 2.—Magazine Camera

Sanderson Cameras

SANDERSON'S 'UNIVERSAL SWING FRONT' ALLOWED AN UNPRECENDENTED DEGREE OF CAMERA MOVEMENT AND RESULTED IN A POPULAR AND VERSATILE RANGE OF CAMERAS.

Frederick H. Sanderson was born in Cambridge in 1856. A wood and stone carver by profession, he was naturally interested in church architecture. Sanderson was also a keen photographer but when he tried to combine his two interests he ran up against a problem. In order to take accurate photographs of buildings, without distortions and without converging verticals, a camera with a high degree of rise and fall and swing and tilt movements was needed. However, field cameras of the time only had limited movements. Sanderson came up with his own solution to this problem. Patented in 1895, Sanderson's Universal Swing Front used four slotted arms to support the lens panel, two on either side. All four arms could be moved independently and the lens panel locked in position as the image was viewed on the ground glass focusing screen. With Sanderson's system a tremendous range of movements was possible.

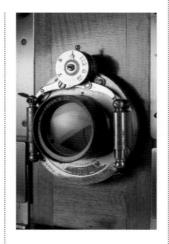

In 1895, Sanderson's Universal Swing Front was incorporated into a field camera made by Holmes Brothers of Islington, London, and sold by George Houghton & Son who held the sole licence for Sanderson's patent. In 1904 Holmes Brothers were incorporated into G. Houghton & Son Ltd but continued to manufacture cameras at their Sanderson Camera Works.

In 1899, Houghton & Son introduced a version of the Sanderson that could either be used on a tripod or hand-held. The baseboard could be dropped below the horizontal so that very wide-angle lenses could be used, and the top of the camera body was hinged to allow the maximum amount of rise. A viewfinder was fitted to the baseboard and rack-and-pinion focusing was provided, along with a focusing scale. The Sanderson hand camera was advertised as 'The most perfect universal camera known ... adapted alike to any kind of hand or stand work. Perfect for snap shots, portraiture and groups, landscape and seascape, architectural work.' Sanderson cameras were, rightly, very popular and they were produced in a huge range of different models and sizes. Before the First World War there were at least ten different models, all available in three different versions and four different sizes.

'Sanderson cameras were, rightly, very popular and they were produced in a huge range of different models and sizes.'

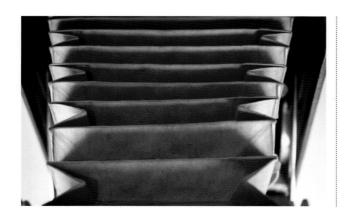

There were Junior Sandersons, Tourist Sandersons, De Luxe Sandersons and Tropical Sandersons made from polished teak. As the decades passed, Sanderson cameras remained on the market, their design virtually unchanged from the time they first went on sale and all of them sharing the unifying feature of Frederick Sanderson's Universal Swing Front. The last models were still on sale in 1939.

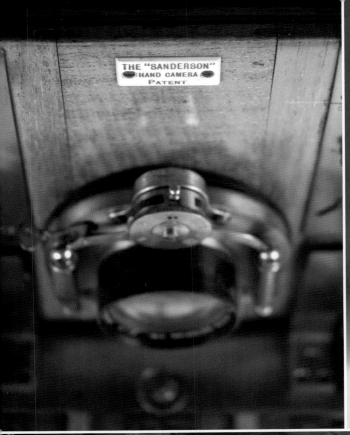

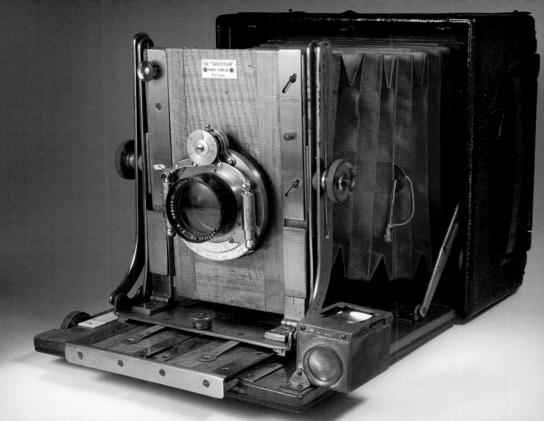

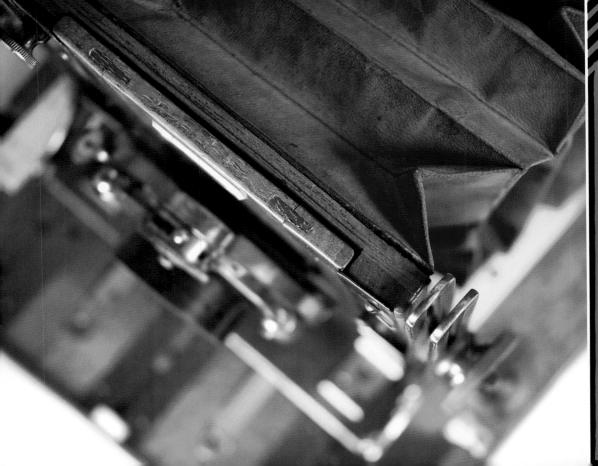

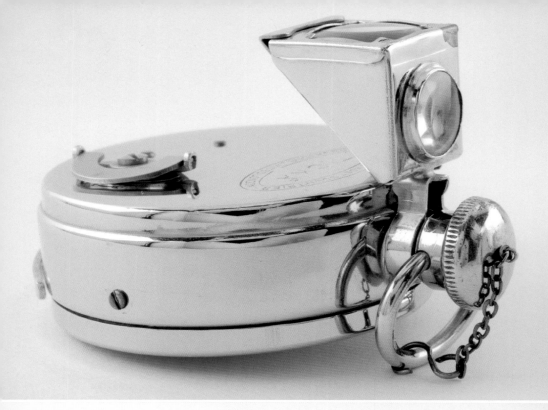
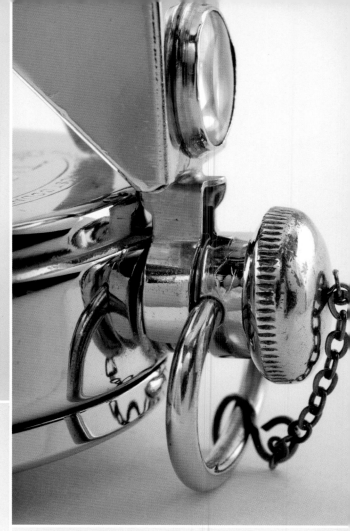
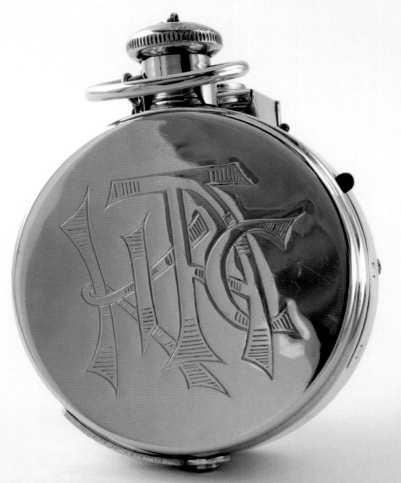

The Ticka

MUCH MORE THAN JUST A PRETTY FACE, THE TICKA FEATURED A DAYLIGHT-LOADING FILM CASSETTE THAT ANTICIPATED THE KODAK INSTAMATIC RANGE BY ALMOST SIX DECADES.

Over the years, there have been a surprising number of cameras designed to resemble watches but, of all the watch-form cameras made, the most popular and commercially successful was the aptly-named 'Ticka'.

In 1904, Magnus Niell, a Swedish engineer living in New York, took out a patent for a compact roll-film camera designed in the shape of a pocket watch. Niell sold the American manufacturing rights to the Expo Camera Co of New York who produced their Expo watch camera for over thirty years. In Britain, the camera was made by Houghtons Ltd, probably the largest photographic manufacturer in the country at the time. Houghtons named it the Ticka watch pocket camera and first advertised it for sale in 1906.

Made from nickel-plated metal, the Ticka had the outward appearance of a fat pocket watch. The f/16 meniscus lens was contained in the 'winding-stem' and had to be covered by a screw-on cap when cocking the shutter between exposures. To prevent this small but vital part from getting lost it was attached to the fob ring by a small chain. The guillotine shutter had two settings – Time and Instantaneous (about 1/25sec). No viewfinder was fitted, but a clip-on reflecting viewfinder could be bought as an optional extra. A range of other accessories were also available, including a tripod, developing outfit and printing frame. One of the most innovative features of the camera was the system of film loading. Roll film was carried in a daylight loading cassette which was simply dropped into the camera body 'as easily as putting a pellet into an air gun' and engaged with the winding key, anticipating

'Made from nickel-plated metal, the Ticka had the outward appearance of a fat pocket watch.'

Kodak's 1963 Kodapak cartridge for their Instamatic range of cameras by nearly 60 years. Each film produced 25 postage-stamp sized negatives that could be enlarged using a special printing box to give 3 x 2 inch (76 x 51mm) prints.

The Ticka was immediately popular and Houghtons claimed that they had sold over 10,000 within the first three months. Part of this success was undoubtedly due to Houghtons' advertising campaign and their use of celebrity endorsement. Queen Alexandra, an enthusiastic and accomplished amateur photographer, bought one. Houghtons' advertisements boasted: 'Her Majesty the Queen uses a Ticka and has written to say she is very pleased with the pictures she has taken with it.' As a mark of their appreciation, Houghtons presented the Queen with a special Ticka with a case made from solid silver and engraved with her monogram.

In 1908, Houghtons introduced two new Ticka models. The Watch Face Ticka had a dummy enamelled watch face, so the camera was more likely to be mistaken for a watch. The hands of the watch were fixed permanently at seven minutes past ten, indicating the angle of view of the lens and acting as a simple yet effective viewfinder. That same year, the company also introduced a Focal-plane model fitted with a better-quality, Cooke f/6.5, lens and an adjustable focal-plane shutter giving speeds from 1/70 to 1/400sec. The Focal-plane Ticka cost £2.10s (£2.50) – over five times the price of the standard model. Watch Face and Focal-plane Tickas are rare, being produced in much smaller numbers than the standard Ticka, and are sought after by collectors.

Despite its commercial success, the Ticka was only made for a comparatively short time. Production ceased during the First World War and the camera stopped being listed in the Houghtons catalogue after 1918 – although Ticka film spools were still being sold well into the 1920s. In America the camera was to enjoy greater longevity. One New York dealer was still advertising the Expo watch camera for sale as late as July 1939, 35 years after it first went on the market.

The Aptus

BELOVED BY 'SMUDGERS' — STREET PHOTOGRAPHERS OUT TO MAKE A QUICK BUCK — THE APTUS'S BUILT-IN PROCESSING MEANT IT COULD PRODUCE UP TO 100 PHOTOS PER HOUR.

From the 1860s onwards, itinerant street photographers, or 'smudgers' as they were popularly known, were a familiar sight wherever people gathered to have a good time — the fairground, the park, the racecourse and, most commonly, the seaside. At first, smudgers used the wet-plate process to take direct positive ambrotype photographs on glass or ferrotypes (tintypes) on thin sheets of metal. Using mobile darkrooms on wheels for sensitizing and developing their plates, they could produce cheap, while-you-wait portraits in a couple of minutes. The introduction of 'dry' ferrotype plates in the 1890s did away with the need for mobile darkrooms and heralded the appearance of several ingenious 'instant' cameras which incorporated processing tanks. These included the wonderfully named 'Nodark', 'Takuquick' and, my personal favourite, the 'Automatic Wonder Photo Cannon'. However, of all the various automatic ferrotype cameras produced, the most popular and long-lived was the 'Aptus'.

'... of all the various automatic ferrotype cameras produced, the most popular and long-lived was the "Aptus".'

In 1912, H.C. Moore of Liverpool took out a British patent for a magazine plate camera with a built-in processing tank. The camera, named the Aptus, went on sale the following year. In use, the Aptus was loaded with a magazine containing one hundred sensitized ferrotype plates. These plates were picked up, one at a time, from the bottom of the camera using a pivoted plate holder fitted with a suction pad attached to a rubber bulb. To make an exposure, the photographer pushed down a lever on the side of the camera and squeezed the bulb. The lever was then brought back to the upright position, bringing the plate into position ready for exposure. After making the exposure, the bulb was squeezed again, releasing the suction, and allowing the plate to fall into a processing tank fitted underneath the camera. This characteristic action of lowering and raising the lever earned the Aptus its nickname. Smudgers affectionately referred to their cameras as 'choppers'. There was a direct-vision viewfinder and the focus was altered by pulling out a small lever on the front of the camera, marked with set distances of 2, 3 and 6 yards (1.8, 2.7 and 5.5m), corresponding to head and shoulder, three-quarter length and group portraits. Approximate exposure times were ¼sec in bright sunshine (very unusual on British beaches!) to three seconds in dull weather.

After exposure, plates required only about 30 seconds in the combined developer and fixer solution before being removed from the tank — a magnet was provided for just this purpose — and rinsed in cold water before being presented to the sitter. It was claimed that even an inexperienced operator could turn out 100 photographs every hour. The money-making potential was obvious, as advertisements for the Aptus stressed: 'All that it is necessary to do is to set the camera up in any place where there is a crowd ... and the money flows in just as fast as you can handle it. Where can you find another business with so large a profit, and so small an investment?' Indeed, if you could keep one step ahead of the police who were always on the lookout for unlicensed street traders, it was possible to earn £3 or £4 on a good day. Getting the right 'pitch' was critical and it was by no means unknown for smudgers to fight over the most lucrative spots. Trafalgar Square was the street photographer's ultimate goal.

The Aptus camera enjoyed a long and successful commercial career. A number of models in different sizes were produced, including, in 1927, a new version that used positive cards instead of ferrotype plates. Following the Second World War, the fortunes of the itinerant photographers went into swift decline, challenged by growing consumer affluence and camera ownership. Moore & Co discontinued production of Aptus cameras in the mid-1950s.

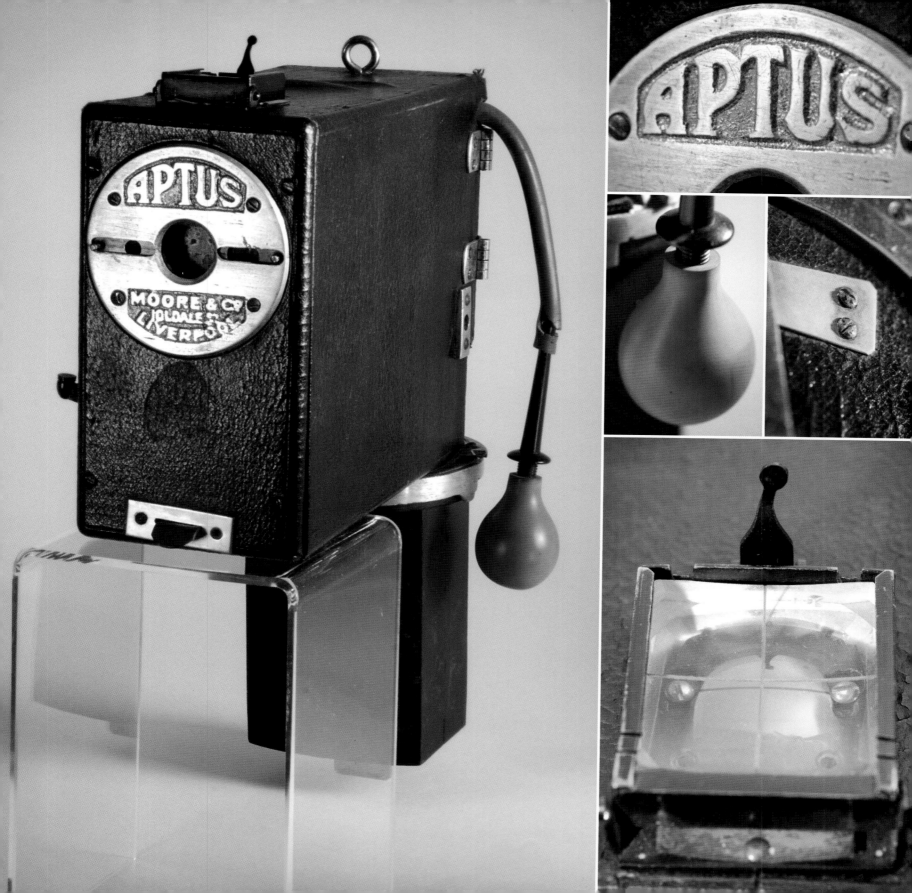

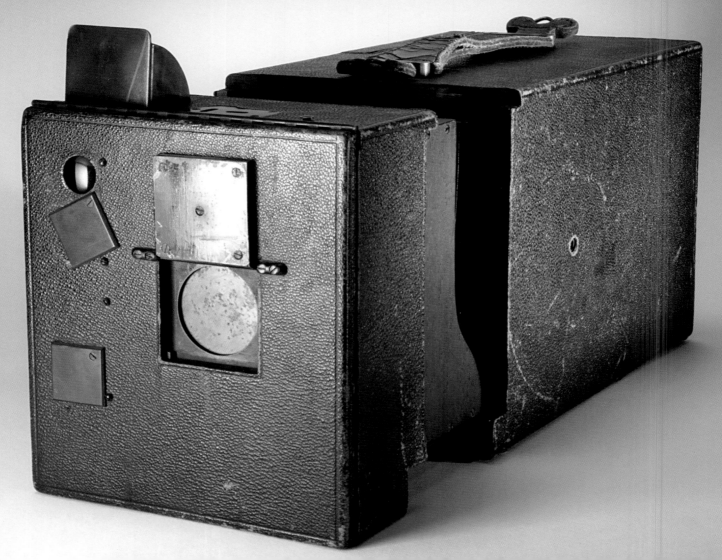

Universal Special B

RELIABLE PRECISION INSTRUMENTS PACKED WITH HIGH-QUALITY FEATURES, NEWMAN & GUARDIA'S 'UNIVERSAL' CAMERAS EVEN ACCOMPANIED CAPTAIN SCOTT TO THE ANTARCTIC.

Magazine cameras such as the Facile (see page 54) and the Midg (see page 82) used mechanical plate-changing devices. Whilst ingenious, these were not always reliable and often jammed. An alternative plate-changing method was the so-called bag changer, based on an 1886 British patent issued to Arthur Samuel Newman. Newman's bag changer consisted of a wooden box which held a number of plates in thin metal sheaths. Attached to the top of this box was a flexible light-tight bag. By turning an external crank, the front plate was pushed up into the bag, far enough for the photographer to grip it between their fingers, withdraw it and move it to the back of the pack.

In 1890, Newman went into partnership with Julio Guardia, Spanish by birth and a naturalized Briton. The firm of Newman & Guardia was to become one of the most respected of British camera makers with a reputation for high-quality, no-expense-spared photographic equipment for those who wanted, and could afford, the very best. N & G, as it was usually known, remained in business right up until 1970. However, by 1910 Guardia had died and Newman had moved on to form another successful photographic partnership, this time with James Sinclair.

In 1892, Newman & Guardia launched their first camera, named 'The Universal'. This box-form magazine camera incorporated an improved version of Newman's bag changer and a pneumatic shutter, also designed by Newman.

'The Universal was received with universal acclaim and secured N & G's lasting reputation.'

The Universal was produced in several different formats and versions. Even the most basic model, however, was still a precision instrument, far removed from the popular perception of a 'box camera'.

The Universal was received with universal acclaim and secured N & G's lasting reputation. Their advertisement in the 1904 *British Journal Photographic Almanac* neatly sums up its many features: 'Self-contained box-form camera. Any lens or several lenses. Self-capped, high-efficiency metal shutter. Pneumatic regulation for automatic exposures from 1/2 to 1/100sec and "time". Finger and pneumatic releases. N & G changing box, roll-holder or dark slides – interchangeable. Two T-levels. Two real-image finders. Focussing screen for tripod work. Double rising front. Double extension. Finest workmanship and materials.'

Some idea of the quality and reliability of N & G cameras can be gleaned from the fact that Herbert Ponting used them when he was official photographer to Captain Scott's ill-fated Antarctic expedition of 1912. N & G claimed that their cameras could withstand 'years of work in the most trying climates.' This claim was to be tested to the extreme. As Ponting later recalled in his book *The Great White South*: 'Often when my fingers touched metal they became frostbitten. Such a frostbite feels exactly like a burn. Once, thoughtlessly, I held a camera screw for a moment in my mouth. It froze instantly to my lips, and took skin off when I removed it. On another occasion, my tongue came into contact with a metal part of one of my cameras, whilst moistening my lips as I was focusing. It froze instantaneously; and to release myself I had to jerk it away, leaving the skin of the end of my tongue sticking to the camera ...'.

Soho Tropical Reflex

LAVISHLY RENDERED IN TEAK, LACQUERED BRASS AND RUSSIAN LEATHER, THE SOHO WAS AIMED AT 'SPORTSMEN, SCIENTISTS AND EXPLORERS' — WITH A PRICE TAG TO MATCH.

'The result was a camera that was very robust but also very beautiful.'

Introduced in 1905, Soho cameras were made by Abram Kershaw of Leeds and incorporated Kershaw's patented design for a focal-plane shutter and a reflex mirror mechanism. Kershaw supplied cameras to a number of retailers but they are most popularly associated with the firm of Marion & Co. One of the oldest British photographic suppliers, Marion & Co were based in London's Soho Square — from which the camera gets its name. The Soho Reflex remained on the market for a surprisingly long time and was still being sold after the Second World War, unchanged except in minor details.

Advertisements proclaimed: 'The "Soho" reflex IS the best camera in the world. This is a bold assertion: but it is one of fact. A camera hand made in which quality of material and workmanship have received first consideration. Sportsmen who have only one opportunity of photographing an event — Scientists whose research work must be reproduced in many cases urgently — Explorers and those who travel in places where it is not possible to get repairs effected, and all others, whose first consideration is reliability — in short, all who are primarily concerned in possessing a camera which may be relied upon for the finest possible work under the most exacting conditions, will find in the British-made Soho Reflex an instrument which will prove equal to every demand.'

The standard version of the Soho Reflex was covered in black leather. However, Marion & Co also produced a tropical model 'designed and constructed to withstand the severely trying conditions experienced in Tropical Countries'. This was recommended 'for the use of Officers, Scientists and experts in the most trying parts of the world'. The leather covering was abandoned since it would be prone to mildew and the camera body was made from teak, one of the most resistant of woods, rather than mahogany. All fittings were made of lacquered brass to avoid rusting. The bellows and viewing hood were made from the finest quality Russian red leather. The result was a camera that was very robust but also very beautiful.

For the photographer who wanted the best, the Soho Tropical Reflex was an obvious choice. It was by no means cheap. The standard half-plate model cost £24 (without lens), increasing to £36 for the tropical model. A wide range of lenses were available by Goerz, Ross, Dallmeyer and Zeiss, which added up to another £10 to the price.

ROBBINS MANISTRE & Cº Lᵀᴰ
The London Camera Exchange,
2, POULTRY, CHEAPSIDE, LONDON, E.C.2.

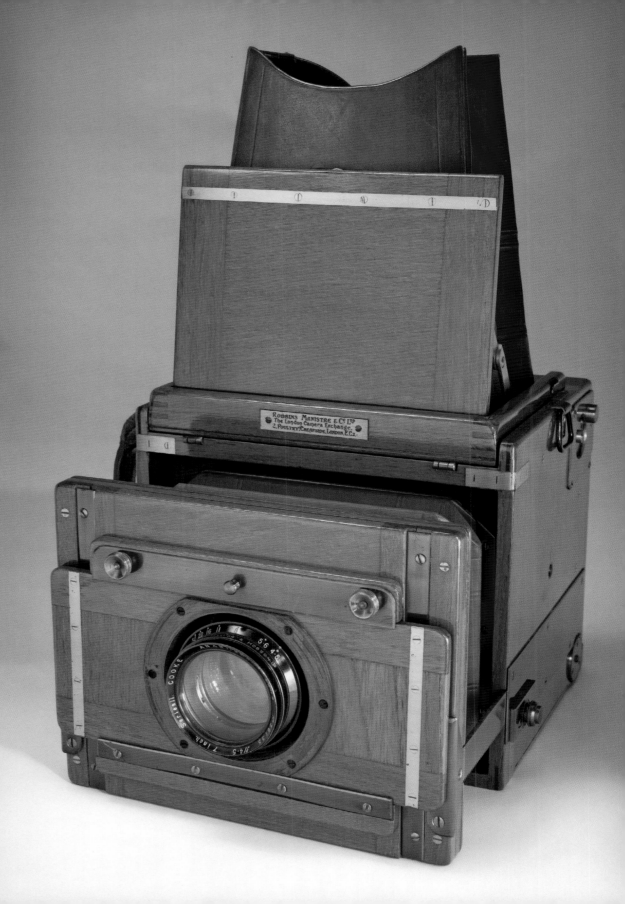

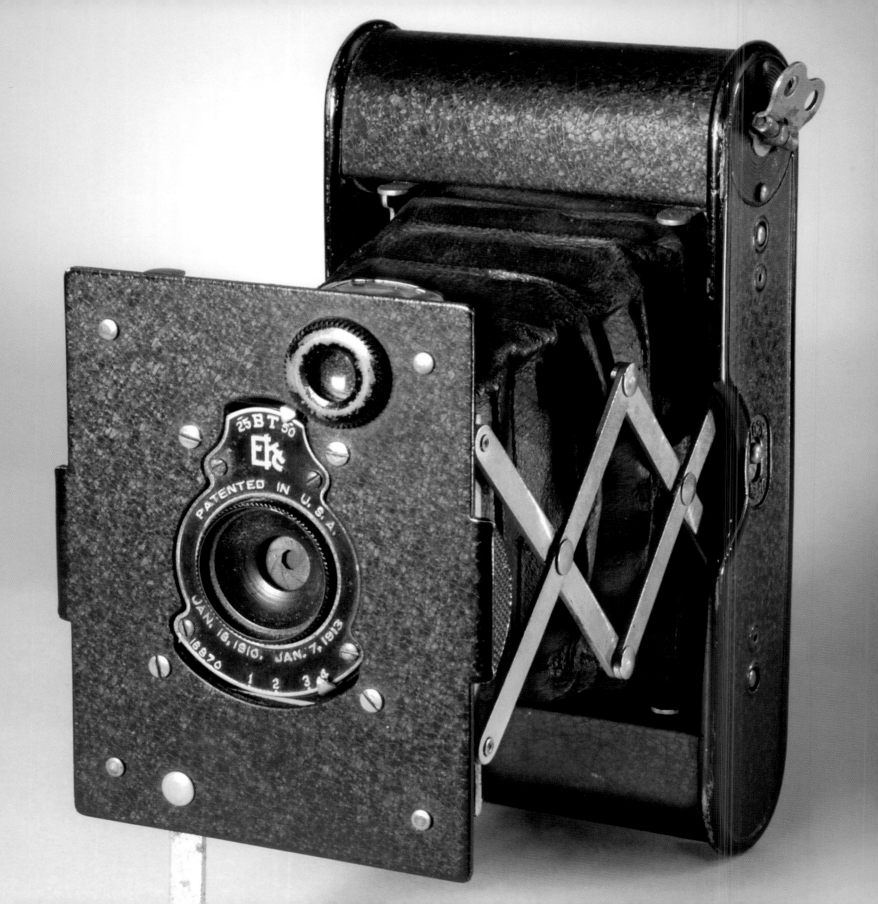

Vest Pocket Kodak

OF THE TWO MILLION 'VPK' CAMERAS SOLD, THOUSANDS WERE
TAKEN TO THE FRONT LINE IN THE FIRST WORLD WAR. IN 1924,
ONE MAY EVEN HAVE REACHED THE SUMMIT OF EVEREST.

The concept of an extremely compact camera, small enough to slip into your pocket, may seem like a fairly recent innovation. However, like most things in photography, the idea has been around for a lot longer than you might think. One of the first and most successful 'compact' cameras first appeared nearly one hundred years ago. The Vest Pocket Kodak, or VPK, as it was usually known, was one of the most popular hand cameras of its day and was to break all records for sales with around two million of these little cameras eventually being sold.

'... one of the most popular hand cameras of its day ...'

Nothing to do with men's underwear, the Vest Pocket Kodak took its name from the American word for a waistcoat. It wasn't the first camera to adopt this unusual name.

In 1897 the Monroe Camera Co, also of Rochester, New York, had introduced their 'Vest Pocket' camera which took single exposures on plates or sheet film. During the first decade of the twentieth century, as roll film increased in popularity, there emerged a trend toward more convenient, pocket-sized cameras. In 1909, the British firm Houghtons Ltd launched their Ensignette camera, a small roll-film camera based on a collapsing strut design. The success of the Ensignette may well have been the inspiration behind Kodak's decision to introduce the Vest Pocket Kodak in 1912.

The VPK took pictures $1^5/_8$ by $2^1/_2$ inches (40 x 64mm). This was the same size as the earlier No 0 Folding Pocket Kodak. However, since a metal spool was used, the film was much smaller and consequently the camera could be greatly reduced in size. When closed, the camera measured just 1 by $2^1/_2$ by $4^3/_4$ inches (25 x 64 x 120mm) — small enough to slip conveniently into a waistcoat pocket.

In use, the lens panel pulled out on a pair of lazy-tongs struts. The basic VPK was fitted with a two-speed ball-bearing shutter – 1/25 and 1/50sec – and a meniscus achromat lens. Many variants were also produced.

In 1913, the year after the VPK first appeared, Kodak decided that it needed to simplify how the many different film formats that were then available were identified. Up to this time, films had been identified by the type of camera they fitted. A consecutive numbering system, starting from 101, was adopted, with numbers allocated in the order in which the various film sizes first appeared. VPK film was the twenty-seventh roll-film format to be produced and therefore became known as 127 film.

'In 1924, when George Mallory and Andrew Irvine set off for the summit of Everest, they took along a Vest Pocket Kodak camera to record their triumph.'

In 1915, a new model VPK was introduced – the 'Autographic' Vest Pocket Kodak. In 1913, an American inventor, Henry Gaisman, had taken out a patent for a roll film with a thin carbon-paper-like tissue between the film and the backing paper. A small window in the back of the camera could be opened to uncover the backing paper. Pressure from a metal stylus caused the backing paper to become transparent, exposing the film. Using autographic film, photographers could 'write' information that would then appear on their finished prints – the first databack. George Eastman paid Gaisman the then enormous sum of $300,000 for his patent rights and the entire range of folding Kodak cameras, including the VPK, were re-designed to use autographic film.

The introduction of the Autographic VPK coincided with a boom in camera sales linked with the outbreak of the First World War. Despite the fact that using a camera in the front line was prohibited, many soldiers bought cameras to record their experiences. The VPK was by far the most popular choice, particularly with American 'doughboys'. It was widely advertised as 'The Soldier's Kodak' and owners were encouraged to 'Make your own picture record of the War'. Sales figures rocketed. In 1914 about 5,500 VPKs were sold in Britain. The following year, over 28,000 were sold.

It was not only soldiers who were attracted by the compact and convenient design of the VPK. In 1924, when George Mallory and Andrew Irvine set off for the summit of Everest, they took along a Vest Pocket Kodak camera to record their triumph. Tragically, Mallory and Irvine died in their attempt on the world's highest peak. Many believe, however, that they were in fact successful and perished on their way back down.

In 1999 an expedition discovered Mallory's body near the summit but Irvine's body and the camera remain missing. If found, this VPK camera may yet hold the key as to whether Mallory and Irvine did in fact reach the top of Everest nearly 30 years before Hillary and Tensing, making it one of the most sought-after cameras in the world, as well as one of the highest.

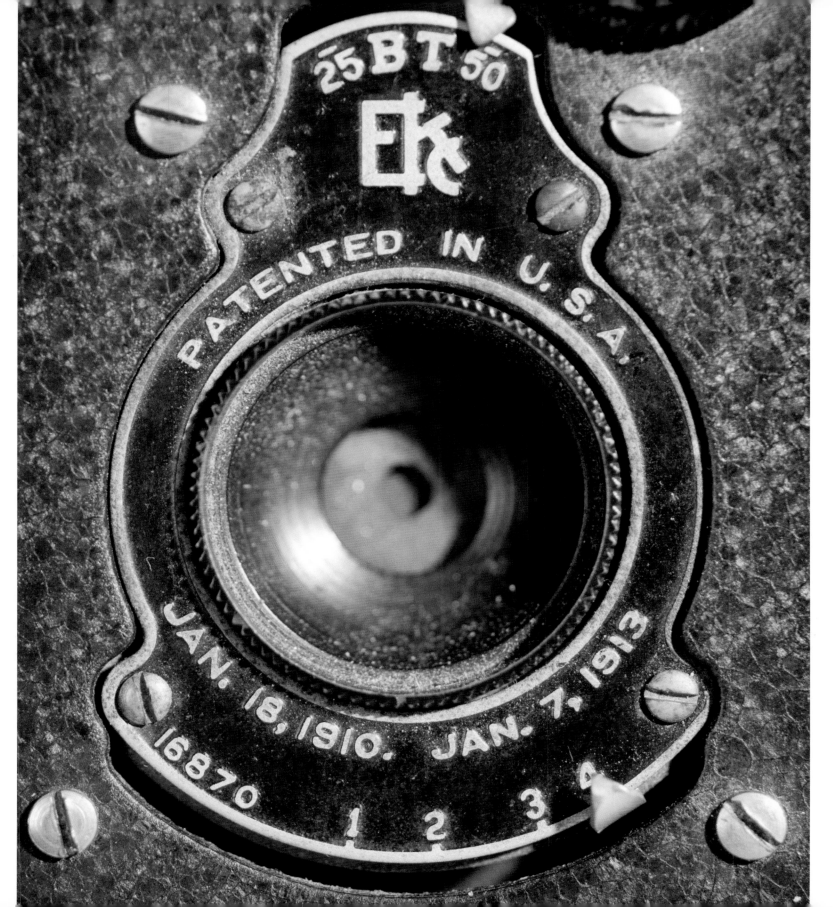

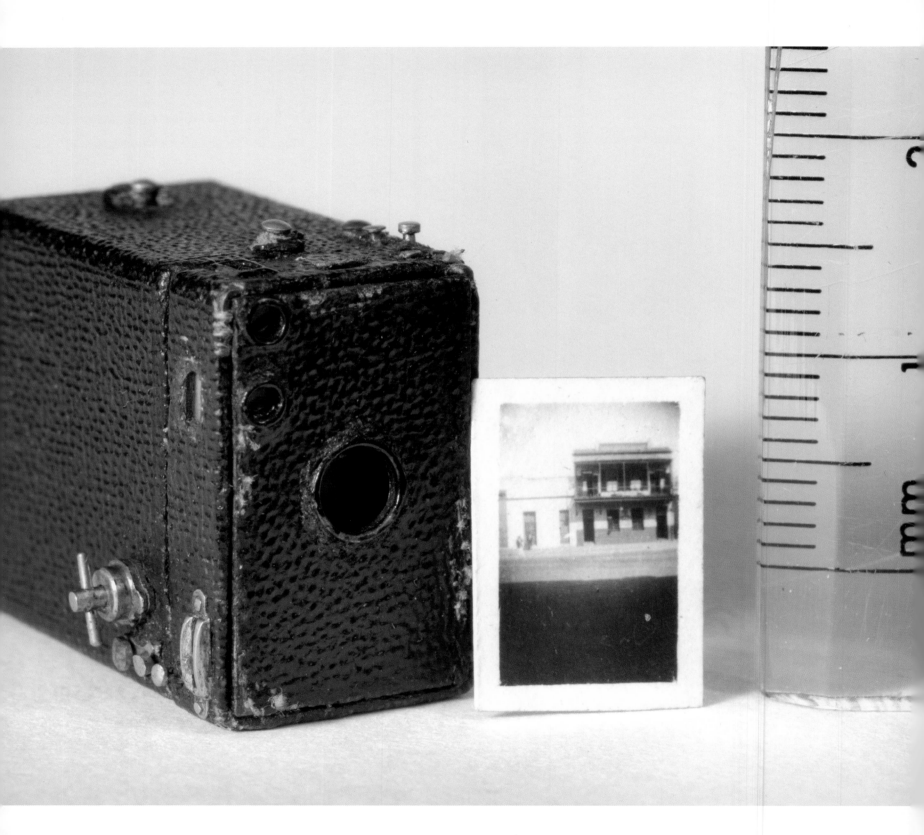

Queen Mary's Dolls' House Camera

PRODUCED BY ROYAL APPOINTMENT FOR THE BRITISH EMPIRE EXHIBITION OF 1924, THIS EXTRAORDINARY ONE-EIGHTH SCALE BOX BROWNIE WAS REJECTED BY KODAK BOSSES.

'Not only did the camera look just like the real thing, it was even capable of taking photographs on small pieces of cut film.'

The idea for a dolls' house, specially made for Queen Mary, the wife of King George V, came from Princess Marie Louise, a granddaughter of Queen Victoria. In 1920, knowing of Queen Mary's enthusiasm for collecting miniature objects, she asked a personal friend, the eminent architect Sir Edwin Lutyens, to design a magnificent dolls' house for the Queen's personal pleasure. Lutyens had recently become a household name through his distinctive design for the Cenotaph in London's Whitehall. After some initial surprise, Lutyens accepted the commission and began to develop the concept further.

In 1924 the British Empire Exhibition was to be held at Wembley. Lutyens realized that the dolls' house could be included as a novel advertisement for the work of British manufacturers, designers, artists and craftsmen. When the suggestion was put to the Queen she agreed enthusiastically, suggesting that a small fee could be charged for viewing the house, all the proceeds from which would go to charity.

Work on the house began in 1921. Lutyens took personal charge of every detail, designing not only the house but also coordinating all the decoration. To furnish the house, prominent manufacturers were invited to donate miniature versions of their products. Kodak Limited, as suppliers of photographic materials 'by Royal Appointment' were asked to provide a miniature camera.

Technicians from the Kodak repair works in Kilburn, North London, were given the challenge of making a tiny, working model of a camera, complete in every detail. Four of them, named Abbott, Bartlett, Cross and Le Frank, worked on the project for six weeks. The result was a one-eighth scale version of a No 2C Brownie box camera. Not only did the camera look just like the real thing, it was even capable of taking photographs on small pieces of cut film. A photograph taken with the camera shows its four makers grouped together, posing proudly in their workshop.

The miniature Brownie camera was sent to the Kodak company directors for approval. Unfortunately, they were not impressed. Surely, they felt, such a grand household would have something rather more sophisticated than a humble box camera.

The camera was returned to the workshops with instructions to make a second, folding camera. The response of the technicians is, unfortunately, not recorded. In due course, however, a second camera was made – a perfect scale model of a No 3A Autographic Kodak.

The dolls' house was exhibited at the British Empire Exhibition between April and November 1924, where it was seen by over one and a half million people. It is now on show in Windsor Castle.

The unwanted box Brownie was taken home by one of its makers, Charlie Abbott. In 1930, Abbott donated the camera to the recently formed Kodak Museum. Today it is on display as part of the Kodak Gallery at the National Media Museum in Bradford.

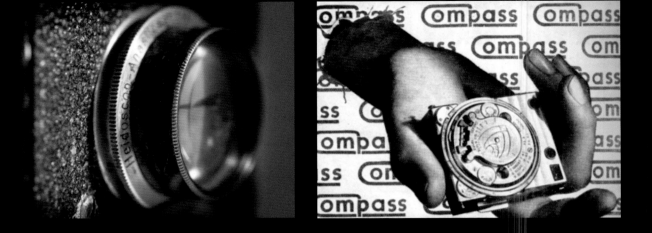
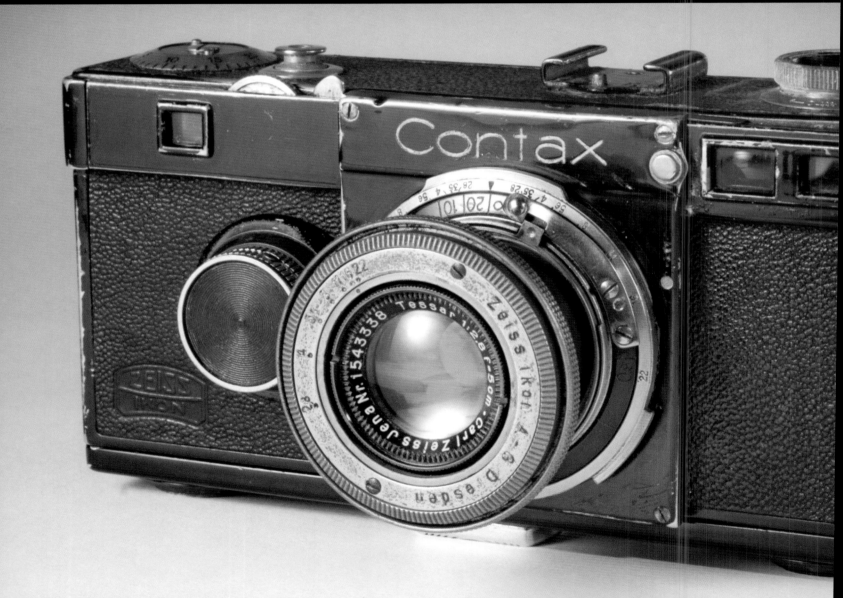

BETWEEN THE WARS

AFTER THE FIRST WORLD WAR THERE WAS A NOTICEABLE TREND FROM WOODEN TO PRECISION-MADE METAL 'MINIATURE' CAMERAS. WHILST KODAK DOMINATED THE MARKET FOR POPULAR SNAPSHOT CAMERAS, AT THE HIGHER END OF THE MARKET, THE GERMAN CAMERA INDUSTRY REINFORCED ITS REPUTATION FOR QUALITY AND INNOVATION THROUGH THE PRODUCTS OF MANUFACTURERS SUCH AS ZEISS IKON, ERNEMANN AND LEITZ. THE SUCCESS OF THE LEICA AND ROLLEIFLEX MADE MEDIUM-FORMAT AND 35MM PHOTOGRAPHY ACCEPTABLE AND THE KINE EXAKTA, INTRODUCED IN 1936, WAS THE FIRST 35MM SLR CAMERA.

Top left: the Rolleiflex (page 108)
Top right: Compass camera (page 128)
Left: the Contax (page 116).

The Ermanox

THE ERMANOX COULD TAKE PICTURES IN LOW LIGHT, INDOORS OR AT NIGHT. PRESS PHOTOGRAPHERS WERE QUICK TO EXPLOIT THESE NEW POSSIBILITIES AND 'CANDID PHOTOGRAPHY' WAS BORN.

There are very few cameras that can claim to have created an entire genre of photography. A remarkable camera, the Ermanox is one of this select group. Innovative in both design and application it has earned its place in photographic history as the first 'candid camera'.

Announced in July 1924, the Ermanox was manufactured in Germany by the respected Dresden-based company, Ernemann. The camera was basically a development of one of their earlier successful designs for a compact camera taking the then popular 'vest-pocket' size glass plates (4.5 by 6cm). The Ermanox, however, incorporated a lens that was revolutionary in its specification and picture-taking potential.

The Ermanox was fitted with an Ernostar lens with, for that time, a phenomenally wide aperture of f/2. In 1925, an even faster f/1.8 lens was to appear. This lens was the work of Ernemann's gifted young optical designer, Ludwig Bertele, who later went on to develop the famous Zeiss Sonnar range of lenses in the 1930s. With the Ernostar, the Ermanox possessed the widest aperture lens of any miniature camera.

The concept of fitting large aperture lenses to small format cameras was not, of course, a new one. The idea is, quite literally, as old as photography itself. Way back in 1835, William Henry Fox Talbot made his earliest negatives using tiny 'mousetrap' cameras (see page 16) constructed from cigar boxes fitted with relatively large telescope eyepieces. Talbot found that this meant he could reduce his exposure times to around 30 minutes!

'... the Ermanox possessed the widest aperture lens of any miniature camera.'

Some 90 years later, the combination of Ermanox camera and Ernostar lens meant that photographs could be taken with 'instantaneous' exposures in low light conditions, indoors or at night, without having to use artificial lighting.

The camera itself was a compact, well-made and robust piece of equipment, constructed from solid aluminium covered in black leather. There was a focusing screen together with a folding optical viewfinder and a focal-plane shutter giving speeds of 1/20 to 1/1000sec. It was the Ernostar lens, however, in its helical focusing mount that dominated the camera, appearing to be out of proportion to the camera body.

In their advertisements Ernemann claimed: 'This camera opens out a new era in photography, instantaneous exposures being obtainable in any light, however poor.' As *The British Journal Photographic Almanac* noted in its review: '... the camera has its special uses for indoor shutter exposures under conditions of lighting which would be impossible with lenses of smaller aperture.' The camera's capability was summed up in the memorable slogan – 'What you can see, you can photograph'. The Ermanox was aimed primarily at professional and press photographers. Among those who quickly saw the opportunities presented by it for available light photography were a number of pioneering photojournalists including Felix Man, Alfred Eisenstadt and Erich Salomon. Salomon used his Ermanox to take photographs of Europe's rich and powerful in private, unguarded moments. His work was published in magazines all over the world and caused a sensation. In Britain, the *Graphic* magazine came up with a new phrase to describe Salomon's groundbreaking photography – 'candid camera'.

In 1926, Ernemann merged with Contessa-Nettel, Goerz and Ica to form Zeiss-Ikon, who continued to manufacture the Ermanox until 1931. As well as the standard 'vest pocket' model, a reflex model was produced for larger plate sizes up to 13 by 18cms. These larger models were produced in very small numbers and are very rare.

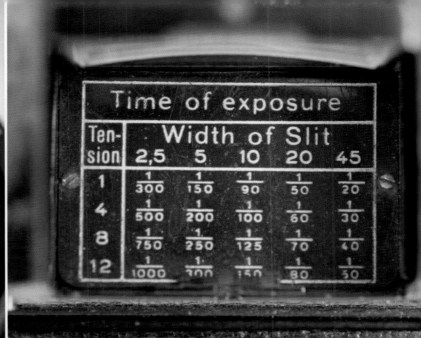

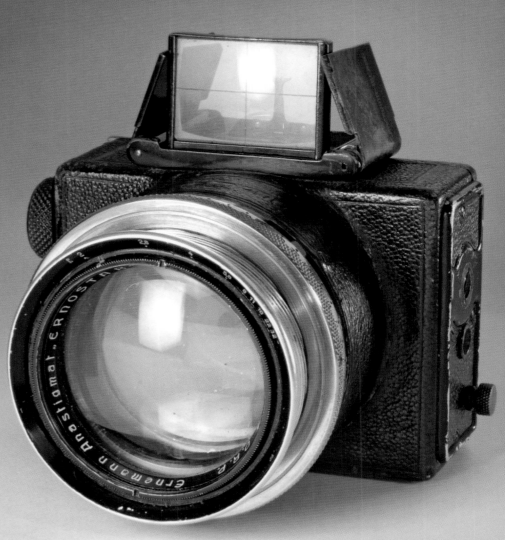

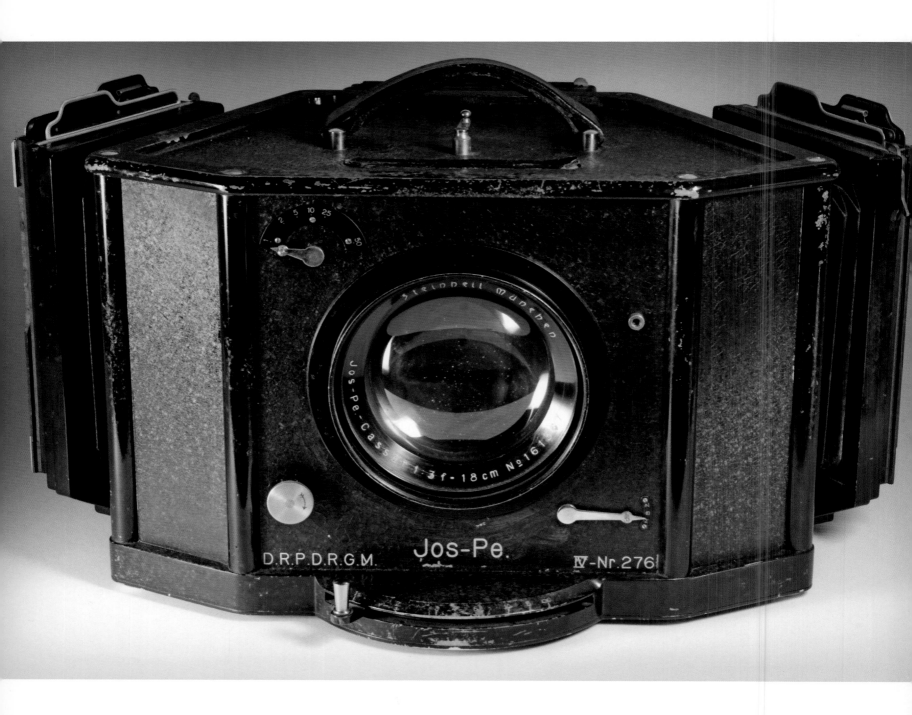

The Jos-Pe

THE JOS-PE CREATED THREE NEGATIVES FROM A SINGLE EXPOSURE DIRECTED THROUGH RED, GREEN AND BLUE FILTERS. TOGETHER, THEY PRODUCED A COLOUR PRINT.

'... the first one-shot camera to be constructed of metal rather than wood ...'

The theory of subtractive colour reproduction can be traced back to the 1860s when the Frenchman Louis Ducos du Hauron explained the principle in his book *Les Couleurs en Photographie*. Du Hauron proposed that colour-separation negatives, made through red, green and blue filters, be used to produce three positive images which could then be dyed the complementary colours of cyan (blue-green), magenta (blue-red) and yellow, and superimposed to produce a colour photograph. When taking colour-separation negatives of subjects that didn't move – for example, a vase of flowers – a conventional camera could be used. All you had to do was change the colour filter after each exposure. If a great deal of colour work was being done, this procedure could be made simpler through the use of repeating backs. A number of different devices of this sort were marketed. The simplest type were long plate-holders, fitted with three filters, which could be slid along the camera back in three steps. The most complex were fitted with clockwork motors, enabling three negatives to be exposed in rapid succession in as little as two or three seconds.

When photographing subjects where movement was likely to occur – such as portraits – even automatic repeating backs were not fast enough. For these, a camera that could expose all three negatives simultaneously was needed. Over the years, many designs for such 'one-shot' cameras were patented and a number were produced commercially. These used various arrangements of mirrors and prisms to split the light entering the camera into three separate beams, each of which went to a plate-holder fitted with a different coloured filter.

One of the most successful one-shot cameras was the Jos-Pe, produced in Germany in the 1920s. The Jos-Pe camera was patented in 1924 and manufactured commercially from 1925. The name is an abbreviation of JOSef-PEter Welker, a German financier who in 1924 founded the Jos-Pe Farbenphoto Gesellschaft in Hamburg. This was the first company to offer a complete system of colour photography – a one-shot camera and a printmaking process. The process was basically a development of earlier patents but the camera, the first one-shot camera to be constructed of metal rather than wood, incorporated several innovations.

Seen from above, the camera is in the shape of a half hexagon. The three equal sides are fitted with plate-holders and the lens is on the opposite side. The lens is fixed, focusing being done by rotating a knob on the top of the camera which moves all three plate-holders simultaneously. Two small mirrors are fitted behind the lens, reflecting light to the holders on either side of the camera. Light passing between the mirrors reaches the plate-holder at the back of the camera. Immediately in front of each plate is a red, green or blue filter. The Jos-Pe is fitted with a large aperture f/3 Steinheil Cassar or f/2.5 Steinheil Quinar lens. When the effects of splitting the light beam, together with the colour filters, is taken into account, these correspond to a conventional camera operating at about f/12.

The makers claimed that instantaneous 'snapshot' exposures could be made in summer sunshine at 1/25sec. In its review of the Jos-Pe process, *The British Journal of Photography* noted: 'ingeniously contrived cameras of patented design allow the making of all three negatives simultaneously with a single exposure. We use the plural "cameras" for the reason that two models are being produced, for professional and amateur use respectively.'

Two models of the Jos-Pe were produced – the 'Uka', a professional studio camera for 9 by 12cm plates, and the 'Liliput', an amateur version for 4.5 by 6cm plates.

The Rolleiflex

IN THE HALF CENTURY BETWEEN THE LAUNCH OF ITS FIRST AND FINAL MODELS, THE ROLLEIFLEX CAME TO EPITOMIZE PROFESSIONAL MEDIUM-FORMAT PHOTOGRAPHY.

I n 1920, Paul Franke and Reinhold Heidecke set up in partnership as camera manufacturers in Braunschweig, Germany. Heidecke, who had previously worked for Voigtländer, was the camera designer and Franke provided the business acumen. Their first camera, launched the following year, was a stereo camera, similar in appearance, unsurprisingly, to the Stereflektoscop camera introduced by Voigtlander in 1913. Named after its designer, the Heidoscop was a 'triple lens reflex' with a large reflex viewfinder lens between a pair of taking lenses.

In 1926, a roll-film version of the Heidoscop was launched, called the Rolleidoscop. This was the first use of the prefix that was soon to find lasting fame as part of the name of the first 'modern' Twin Lens Reflex camera.

This camera was to have a huge influence on future design and bring about a revival of interest in TLR cameras that was to last for the next 50 years. That camera was the Rolleiflex.

'... the first "modern"

Twin Lens

Reflex camera.'

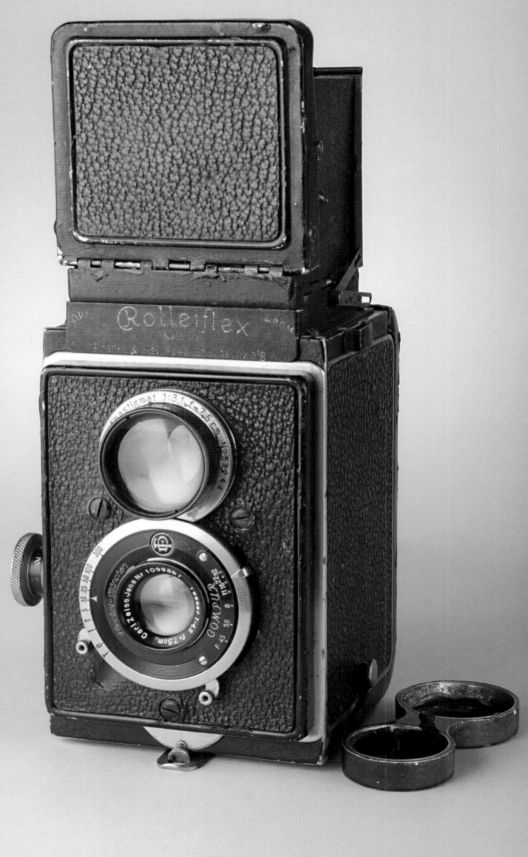

Franke & Heidecke launched the Rolleiflex in December 1928 and the first cameras reached the shops in January 1929. The experience gained in their construction of the Rolleidoscop is evident and some of its components, most obviously the folding focusing hood with its built-in magnifier, are identical. By using a comparatively small roll-film format and all-metal construction, the camera could be made very compact – very different to earlier, bulky, wooden TLR cameras. The Rolleiflex has a leather-covered, diecast aluminium body, which makes it both light and strong. Both taking and viewing lenses are mounted on the same panel, which is moved backwards and forwards by a focusing knob and a rack-and-pinion mechanism. The first Rolleiflexes were fitted with an f/4.5 Tessar lens but this was soon replaced by an f/3.8 Tessar. The viewing lens is an f/3 Heidoscop. A rim-set Compur shutter, introduced by Zeiss the previous year, gives speeds between 1 and 1/300sec. The first model, like the Rolleidoscop, was designed to take 117 film, giving 6 x 6cm negatives. This film size, introduced by George Eastman in 1900 for the Brownie camera, was obsolescent by the late 1920s. Soon Rolleiflexes appeared that were designed to take 127 and, later, 120 film.

Altogether, around 28,000 original Rolleiflexes were sold between 1929 and 1932. In 1932, an improved version, the Rolleiflex Standard, was introduced. This incorporated several new features for which the Rolleiflex was to become noted – it took 120 film, the film wind knob was replaced by a crank and the aperture and shutter speed settings were visible in a window on top of the viewing lens. In 1933, Franke & Heidecke introduced a less expensive version of the Rolleiflex, called the Rolleicord.

Throughout its long life – the very last Rolleiflex TLR, the 2.8GX, was introduced in 1987 – the Rolleiflex was produced in many different models, incorporating many technical innovations. However, its basic design remained unchanged and was copied by many other manufacturers all over the world. For many years the medium-format TLR, epitomized by the Rolleiflex, was the favourite tool of many professional photographers.

The Leica

THE CAMERA THAT TRULY REALIZED THE POTENTIAL OF THE

35MM FORMAT, OSCAR BARNACK'S LEICA IS ALSO LEGENDARY

FOR ITS ALL-METAL BODY AND SUPERB BUILD QUALITY.

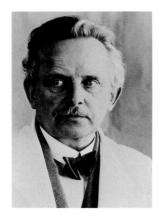

No book about classic cameras could possibly be complete without the Leica. From the beginning of the twentieth century, a number of camera designers had toyed with the idea of using 35mm cine film for still photography. One of the earliest patents for a 35mm still camera dates from 1908 and a few 35mm cameras, such as the Tourist Multiple of 1913 and the Simplex, which appeared the following year, actually made it on to the market.

Although it was not, as is sometimes mistakenly thought, the first 35mm camera, the Leica was the camera that undoubtedly did more than any other to popularize 35mm photography. A classic example of industrial design, it is one of the most significant cameras ever produced.

The Leica was designed by Oscar Barnack (left), an engineer who had joined the E. Leitz Optische Werke in Wetzlar, Germany, in 1911.

The outbreak of the First World War delayed further development, but after the war, in 1923, a further 31 pre-production 'Model 0' Leica prototypes were made. The Leitz directors had serious misgivings about going into full-scale production, but eventually decided to take the plunge. The camera's first public appearance was at the Leipzig Spring Fair in 1925 and it went on sale that summer. During that first year, 870 cameras were produced.

The Leica I, as it became known, was the first commercially available Leica. It had a self-capping focal-plane shutter, with a range of speeds from 1/25 to 1/500sec, and was fitted with a non-interchangeable f/3.5, 50mm Elmar lens in a telescoping focusing mount. The camera had a direct-vision optical viewfinder. It took 36 exposures, 36mm by 24mm, on 35mm film.

In Britain, the Leica Cine Film Camera, as it was initially known, was sold from 1926 by Ogilvy & Co of London, for £22 (plus £2 for an accessory range-finder). It was advertised as 'A unique camera for use at eye level, unequalled for strength, compactness and rapidity in use.' Other than shutter blind and optics, this instrument is entirely of metal, and will withstand all climatic conditions and hard wear. In its review, *The British Journal Photographic Almanac* reported:

'A classic example of industrial design, it is one of the most significant cameras ever produced.'

A keen mountaineer and hiker as well as a photographer, Barnack hated having to carry around a bulky and heavy camera. Employed by Leitz to develop a cine camera, he realized the potential of short lengths of 35mm film for use in a still camera.

An expert machinist, in 1913 Barnack made himself a compact, metal prototype camera, known as the Ur-Leica, or original Leica, for 50 exposures on 35mm film.

'Quite an innovation in pocket cameras is one just issued by the well-known firm of Leitz, designed to take about 5 feet (1.5m) of ordinary standard perforated cinematograph film, which is mounted in a special triple spool allowing daylight loading and unloading In design and workmanship the camera is of the highest description.' Due to the excellence of its design, the precision of its construction and the quality of its lenses, the Leica was a success right from the start. The legend had begun.

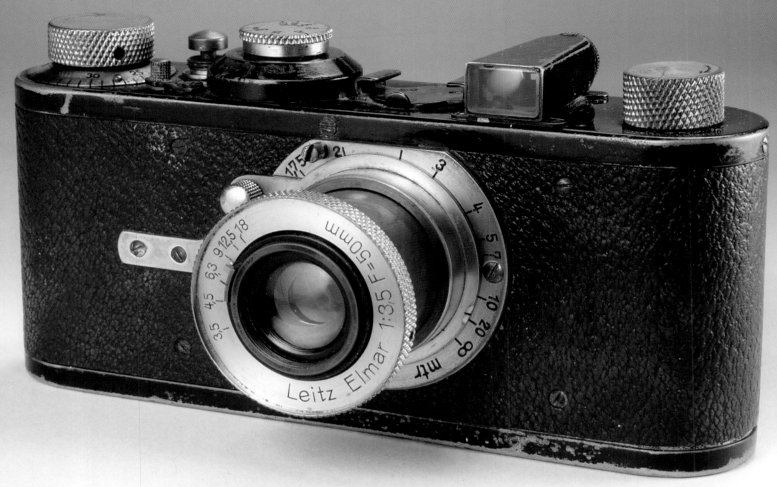

LEICA CAMERA.

A Real Pocket Camera. Focal Plane Shutter. F/3·5 Lens.

Gives 36 Exposures without Reloading.

—

Illustration is only a little over ½ scale.

A unique camera for use at eye level, unequalled for strength, compactness and rapidity in use. Takes pictures 36 × 24 mm. on standard ciné film which can be enlarged to 10″ × 8″. The turning of one milled head sets shutter and winds film simultaneously. Other than shutter blind and optics, this instrument is entirely of metal, and will withstand all climatic conditions and hard wear.

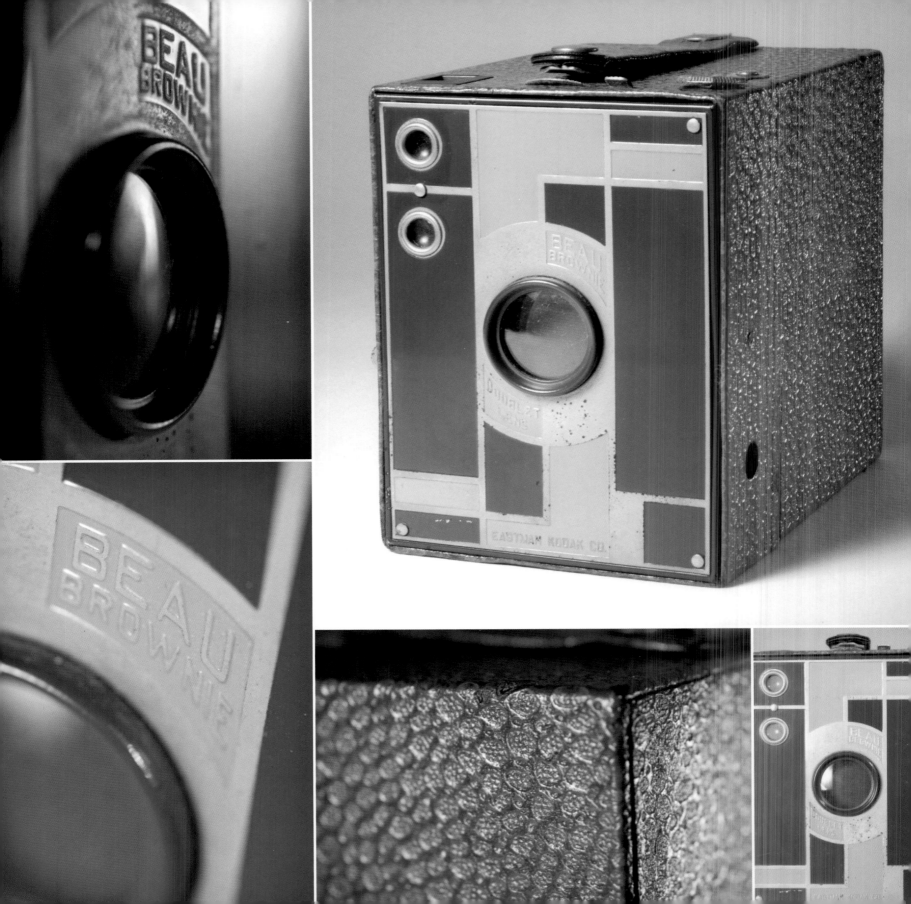

Beau Brownie

AVAILABLE IN FIVE COLOURS WITH A DISTINCTIVE GEOMETRIC ART DECO PATTERN, THE BEAU BROWNIE'S DOUBLET LENS ALSO MARKED IT OUT FROM ITS PLAINER PREDECESSORS.

The Beau Brownie camera was styled by the foremost industrial designer of the day, Walter Dorwin Teague. A pioneering figure in industrial design, Teague was contracted to Kodak from 1928 onwards and brought his design flair to a range of cameras. Teague's initial design brief from Kodak was a comparatively simple one – to take existing camera models and transform them through the addition of colour and decoration – a sort of 'pimp my camera'.

In 1928 the plain, black, Vest Pocket Kodak emerged, butterfly-like, as the Vanity Kodak. Sold in a range of five striking colours – Cockatoo (green), Sea Gull (grey), Redbreast (red), Jenny Wren (brown) and Bluebird (deep blue) – Vanity Kodaks had matching coloured bellows and all metal parts were enameled in matching colours.

Two years later, Teague turned his attention to the humble box Brownie and came up with the Beau Brownie, again produced in five different colours – black, blue, rose, green and tan. This time, as well as being covered in coloured leatherette, the cameras also sported a decorative enameled front panel with a modernistic 'Art Deco' geometric pattern in two complementary colours. Beau Brownies were produced between 1930 and 1933 (the green and rose versions were discontinued in 1931) in two different sizes – the No 2 Beau Brownie for 120 film and the larger No 2A Beau Brownie for 116 film. Beau Brownies were fitted with a fixed-focus doublet lens with three stops, a single-action shutter for 'Instantaneous' and 'Brief Time' exposures and two viewfinders for vertical and horizontal pictures.

The doublet lens had a larger aperture and shorter focus than the single lens fitted to standard Brownies. This meant that the No 2 Beau Brownie was a full inch shorter than the ordinary No 2 Brownie which took the same size film. In Britain, the No2 Beau Brownie cost £1.1s, compared to 12s.6d for the No 2 Brownie.

According to the 1931 Kodak Ltd catalogue: 'It has that simplicity of working characteristic of all "Brownie" cameras'. The following year, *The British Journal Photographic Almanac* described it as: '... far gayer and more handsome than any of its predecessors ... Altogether the newcomer well merits its title of the "Beau Brownie".'

'... far gayer and more handsome than any of its predecessors Altogether the newcomer well merits its title of the "Beau Brownie".'

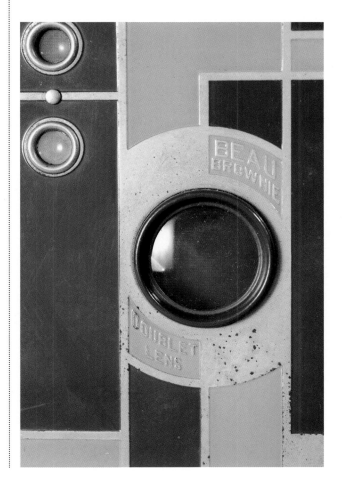

The Contax

A 35MM CAMERA SUPERIOR IN MANY RESPECTS TO ITS COMPETITORS, THE CONTAX SUFFERED FROM AN OVERCOMPLICATED AND UNRELIABLE SHUTTER SYSTEM.

Dresden-based Zeiss Ikon launched their Contax camera in 1932 – partly in recognition of the growing popularity and importance of the 35mm film format but also as a response to the success of the Leica. They can hardly be accused of rushing into production. The first Leicas had gone on the market some seven years earlier and by 1932 the improved Leica II, fitted with a coupled rangefinder, had appeared. This delay in entering the 35mm market was caused in part by the fact that Leitz had patented many important design elements. Equally important, however, was Zeiss Ikon's desire to 'get it right' and to produce a camera worthy of their hard-won reputation for quality.

Although the Contax shared many of the features of the Leica II, such as a focal-plane shutter, coupled rangefinder and interchangeable lenses, it was by no means simply an imitation of its rival. It was a distinctive camera that was markedly different from and, in some respects, superior to its competitor.

'The Contax was bigger and slightly heavier than the Leica.'

The Contax was bigger and slightly heavier than the Leica, with an angular body compared to the Leica's classic slim, rounded design. Another key difference was that the camera back was detachable, making loading far easier. Rather than having a separate film-advance and shutter-speed dial, the Contax combined both in one knob sited, unusually, on the front of the camera. Setting the shutter automatically wound on the film, preventing accidental double exposures. The design of the focal-plane shutter was incredibly complex.

In contrast to other 35mm shutters, it ran vertically rather than horizontally. Also, instead of being made from rubberized fabric it was built up from brass slats – a bit like a roll-top desk. The first Contax models had shutter speeds of 1/25 to 1/1000sec (in 1933 this range was extended down to 1/2sec).

Ingenious as it was, the shutter design was notoriously unreliable and soon proved to be the camera's Achilles heel. Many early cameras had to be sent back to the factory for repair. An extra letter was added to the serial number to indicate that the camera had been repaired.

Today, it is almost impossible to find examples that do not carry this repair code. Much more practical and successful was the rangefinder. This extended to virtually the entire length of the camera and enabled very accurate coupling. Focusing was achieved by turning a knurled wheel near the shutter release.

The Contax was advertised as 'the modern universal roll-film miniature camera of unsurpassed efficiency and all-round versatility'. A wide variety of accessories were produced. This, together with the availability of high-quality interchangeable Zeiss lenses was one of its strongest selling points. A full range of bayonet-fit (as opposed to the Leica's screw-fit) lenses was offered, from the 28mm f/8 Tessar to the 180mm f/6.3 Tele-Tessar.

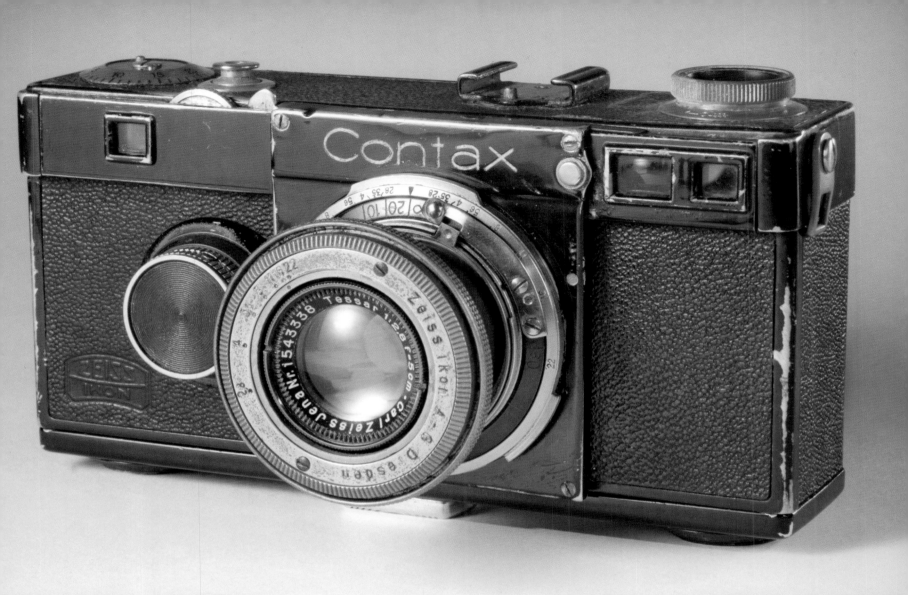

The Universal Camera

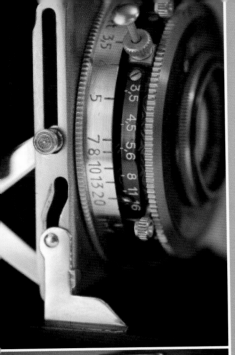

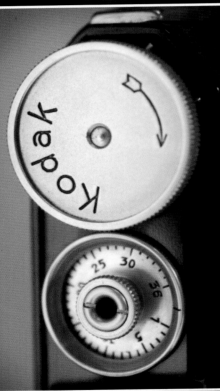

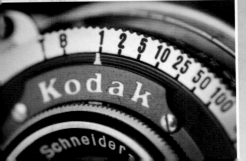

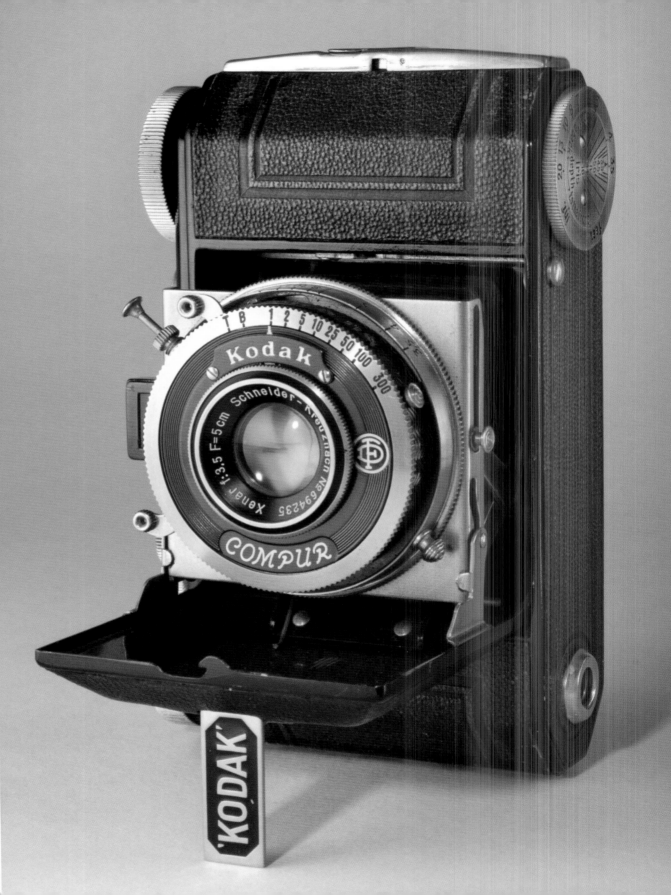

The Retina

WITH BOTH EYES FIXED ON THE LUCRATIVE AMATEUR MARKET, KODAK ACQUIRED THE NAGEL CAMERAWERK FACTORY AND MANUFACTURED A SIMPLE BUT STURDY 35MM COMPACT.

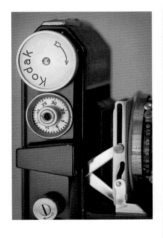

Cameras such as the Leica and Contax had demonstrated the enormous potential of 35mm photography. However, their cost put them way beyond the reach of the average amateur photographer. There was clearly a big potential market for a well-made 35mm camera that could be produced in large numbers and sold at an affordable price. Kodak had precisely this market in mind when they introduced their first 35mm miniature camera, the Retina.

The Retina was designed in Germany by Dr August Nagel. In 1928, Nagel left the employment of Zeiss Ikon and set up his own factory, Nagel Camerawerk, in Stuttgart. Nagel cameras such as the Pupille and Vollenda soon gained a good reputation for their high quality. Meanwhile, seeking to expand production in Europe, Eastman Kodak had decided to acquire an existing camera factory whose products could be sold under the Kodak brand. In 1931 Kodak bought Nagel Camerawerk, which became Kodak AG (*Aktiengesellschaft*). Dr Nagel remained in charge of the factory and was encouraged to develop a new range of cameras. As a company report later described, 'Dr Nagel set himself the goal of creating a miniature camera that would not only incorporate the current state of the art, but whose simple and sturdy mechanical design would make it economical to fabricate, so that it could be afforded by a great number of amateurs.'

'There was clearly a big potential for a well-made 35mm camera that could be produced in large numbers and sold at an affordable price.'

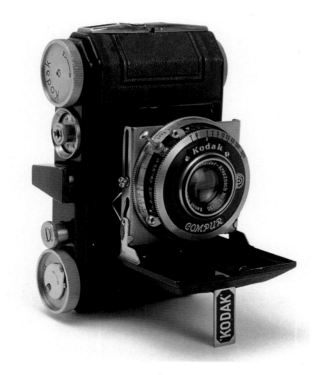

By 1939 over a quarter of a million Retinas had been sold. During the war, camera production was stopped and the factory was requisitioned by the German government to make time-fuses for 88mm anti-aircraft ammunition. Dr Nagel died in October 1943 and was spared witnessing the destruction of his factory by an Allied bombing raid in March 1944. Remarkably, however, Retina production was resumed at the end of 1945. The range of Kodak Retina cameras evolved through many more models, including an SLR, before it was finally discontinued in the late 1960s.

In 1953, Sir Edmund Hillary used a second-hand Retina, then at least 15 years old, to record his ascent of Mount Everest – a glowing testament indeed to the camera's quality of manufacture and performance.

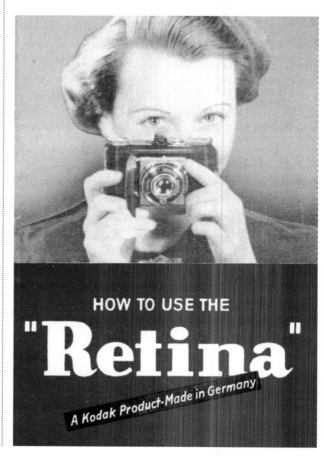

'The combination of good performance, convenience and relatively low cost made the Retina very popular.'

The result, introduced in 1934, was the Retina. The Retina was a compact, self-erecting folding camera for 35mm film. In many respects, the design was simply a scaled-down version of a standard folding roll-film camera of the day. When closed, the Retina was small enough to slip into a jacket pocket. The Retina had black enamelled bodywork and a leather covering. It was fitted with a Schneider Xenar f/3.5, 50mm lens and a Compur shutter giving speeds from 1 to 1/300sec. The Leica and Contax cameras used special reloadable film cassettes which, somewhat inconveniently, had to be loaded in the darkroom. In contrast, the Retina used a disposable ready-loaded Daylight Loading Cartridge (DLC). These disposable cassettes helped to simplify 35mm photography.

The combination of good performance, convenience and relatively low cost made the Retina very popular. A contemporary German review, with perhaps unfortunate echoes of the Volkswagen, called it 'The People's Camera'. Before the outbreak of the Second World War, eight variants of the Retina were produced, differing in only minor details.

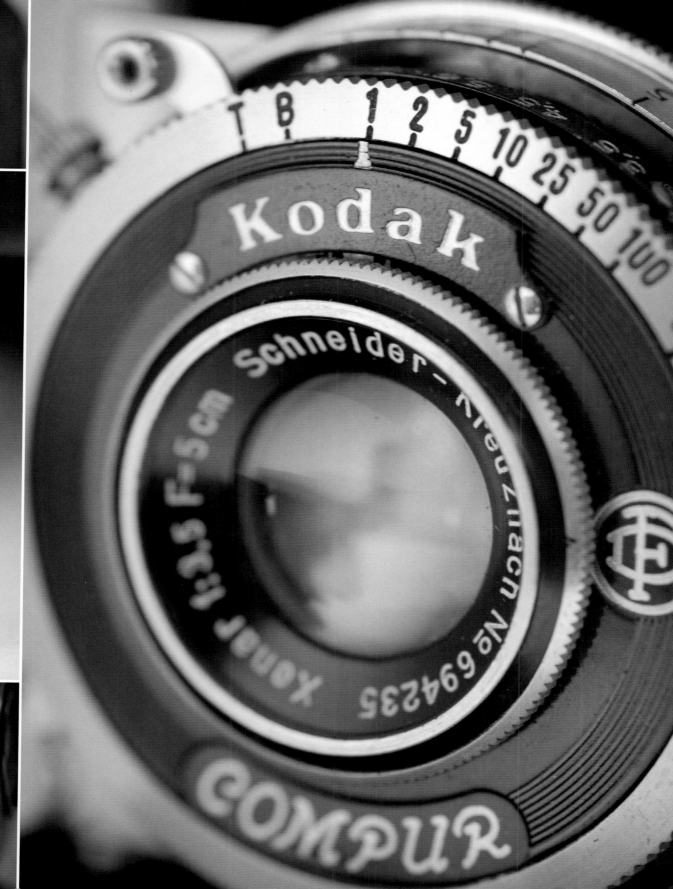

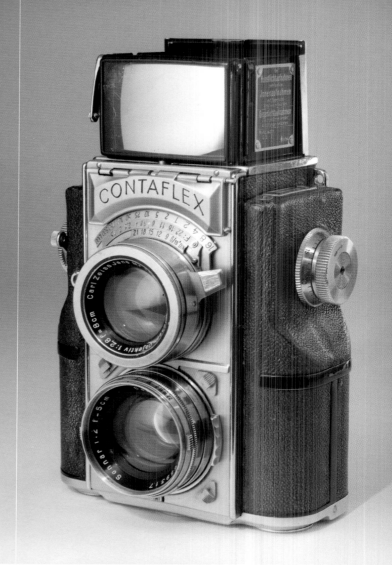
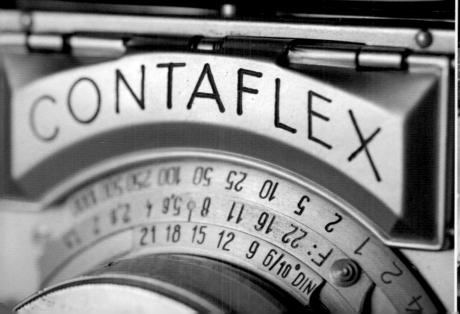

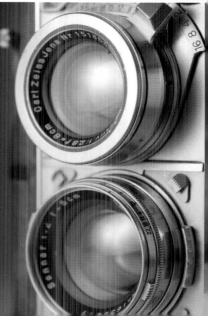

The Contaflex

WITH ITS FUTURISTIC LOOK AND HIGH SPECIFICATIONS, THE CONTAFLEX WAS THE MOST SOPHISTICATED 35MM TWIN-LENS REFLEX EVER PRODUCED — AND THE MOST EXPENSIVE.

'... the Contaflex was a remarkable camera with a very advanced specification for its day.'

Twin-lens reflex cameras are normally associated with medium format. Similarly, the vast majority of single-lens reflex cameras were designed to use 35mm film. Occasionally, however, cameras have appeared that are hybrids of both the miniature and medium-format worlds. There are, of course, medium-format SLRs, but there are also, and much less commonly, 35mm TLR cameras. The first of these few — a 35mm TLR produced by Zeiss Ikon and intended to combine the advantages of the Contax with reflex viewfinding – hence the name, was the Contaflex (not to be confused with the 35mm SLR cameras of the same name produced by Zeiss after the Second World War).

Introduced in 1935, the Contaflex was a remarkable camera with a very advanced specification for its day. In some respects it can be regarded as a sort of 'double-decker' Contax, with the bottom camera taking the pictures and the one on top acting as the viewfinder. As *The Amateur Photographer* reported: 'It possesses all, or nearly all, the features of its well-known sister camera the Contax, but in addition offers the attraction of focussing by screen instead of by range-finder, and shows on the screen a full-size version of the subject being taken.'

The Contaflex took standard, 24 x 36mm exposures on 35mm film. One of the drawbacks of the 35mm format was that the viewfinder image was deemed to be too small for accurate focusing. Zeiss came up with an ingenious solution.

The taking and viewing lenses used in the Contaflex are of different focal lengths. A choice of standard 50mm taking lenses was available from f/1.5 Sonnar to f/3.5 Tessar. The viewing lens gave the same angle of view but had a longer focal length – 80mm – which meant that the image in the viewfinder was twice the negative area. This, combined with a shallower depth of field, made focusing easier and more exact. For action photography, the focusing-screen hood also incorporated a direct-vision optical viewfinder. A range of interchangeable lenses in bayonet mounts were also available – from f/4 35mm Biogon to f/4 135mm Sonnar. These lenses were not compatible with the Contax. Today they are extremely rare and, consequently, more sought after than examples of the camera itself. The metal, focal-plane shutter was similar in design to that used in the Contax and gave a range of speeds from ½ to 1/1000sec.

As befitted its futuristic, chrome-plated appearance, the Contaflex was ahead of its time. It was the first camera in the world to have a built-in photo-electric exposure meter. This was fitted above the viewing lens, with a read-out dial next to the focusing-screen hood, but was not coupled to the exposure settings. The distinction of having the first coupled exposure meter goes to the Super Kodak Six-20 (see page 136) which appeared three years later, in 1938.

As well as being the first, the Contaflex was also the most complex and sophisticated 35mm TLR ever made. It was a remarkable piece of engineering and in many ways represents the climax of pre-war German camera design and construction. It was, however, not without its drawbacks. It was extremely heavy – weighing nearly 3lbs (1.36kg) – and had an equally hefty price tag. It was the most expensive camera on the market, costing as much as £87, depending on which standard lens you chose. For that you could have bought a car, or, should you be so inclined, no fewer than 350 Baby Brownie cameras.

Speed Graphic

IMMORTALIZED IN FICTION AND AN UBIQUITOUS PRESENCE ON THE REAL-LIFE CRIME SCENE, THE SPEED GRAPHIC WAS THE REPORTER'S FAVOURITE — A TRUE PHOTOGRAPHIC ICON.

Some camera names transcend their association with a particular model or manufacturer and become generic terms for a whole family of cameras. The word 'Brownie', for example, was soon being used to describe any simple box camera. Similarly, such was the ubiquity of the Speed Graphic – the press camera of the twentieth century – that all press cameras were thought to be Speed Graphics.

The Speed Graphic was the brainchild of an American, William F. Folmer. In 1887, Folmer went into partnership with William E. Schwing to form the Folmer & Schwing Manufacturing Co of New York. The company began as bicycle-makers but moved into making cameras in 1897. One of their first products was the Graflex – the first of what was to be a long and successful line of SLR plate cameras fitted with focal-plane shutters. In 1905, the company was bought by George Eastman who moved it to Rochester where, in 1907, it became part of the Kodak empire as the Folmer & Schwing Division of Eastman Kodak.

In 1912, Folmer & Schwing introduced their first model of the Speed Graphic – a folding bellows plate camera, fitted with a focal-plane shutter patented by Folmer in 1907. This shutter operated from 1/10 right up to 1/1000sec – the reason for including 'Speed' in the camera name.

The company set out to produce a camera that would appeal to an emerging photographic market – press photographers. The cameras were spectacularly successful. The Speed Graphic was intended for general commercial

'By the 1940s, the Speed Graphic had become famous as the tool of the newspaper photographer...'

photography – weddings, advertising and so on – but soon became the camera of choice for press photographers not only in America but throughout the world.

The Speed Graphic enjoyed a remarkably long life, with the last models still being made as late as the 1970s. There were many modifications and improvements over the years, and many variants and sizes were produced. These include the Anniversary, Miniature and Pacemaker Speed Graphic. However, the basic design remained practically unchanged. The secret of the camera's success lay in its reliability and versatility. Later models were fitted with a range of features that made them adaptable to any job. The camera had two shutters – focal plane and between-the-lens, three viewfinders – optical, frame and ground glass, a coupled rangefinder, interchangeable lenses and a range of different movements.

By the 1940s, the Speed Graphic had become famous as the tool of the newspaper photographer – immortalized in fiction and on the radio as *Casey, Crime Photographer* (facing page, centre right) and in reality by that larger-than-life character, Arthur Fellig, better known as Weegee. Weegee, who prowled the streets of New York with his Speed Graphic, wrote in 1945: 'If you are puzzled about the kind of camera to buy, get a Speed Graphic ... for two reasons ... it is a good camera, and moreover ... with a camera like that the cops will assume that you belong on the scene and will let you get behind police lines.'

Weegee used flash for many of his photographs. From the late 1930s onwards, Speed Graphics were fitted with flash-synchronized shutters and a Graflex flash-gun attachment. In the 1970s, a Graflex flash gun was used as the basis for Luke Skywalker's lightsaber for the film *Star Wars*. As a result, these are now eagerly sought after by *Star Wars* enthusiasts who convert them into lightsaber props. Ironically, these now cost more than you would have to pay for a good example of a Speed Graphic camera.

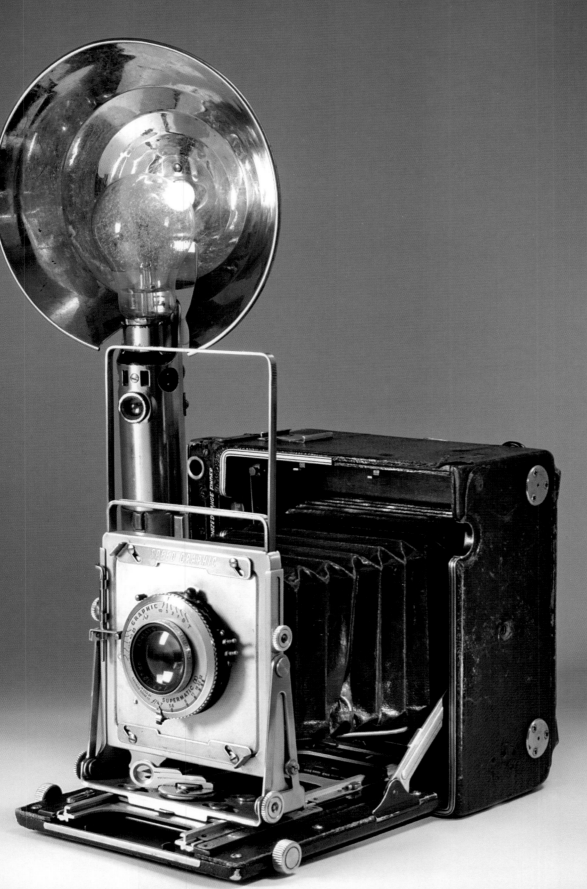

CASEY **CRIME** NO.1 **10c**
CAN. ED.
PHOTOGRAPHER

THE MYSTERY OF THE
GIRL on the DOCKS!
From the Files of the Famous
C.B.S. RADIO THRILLER

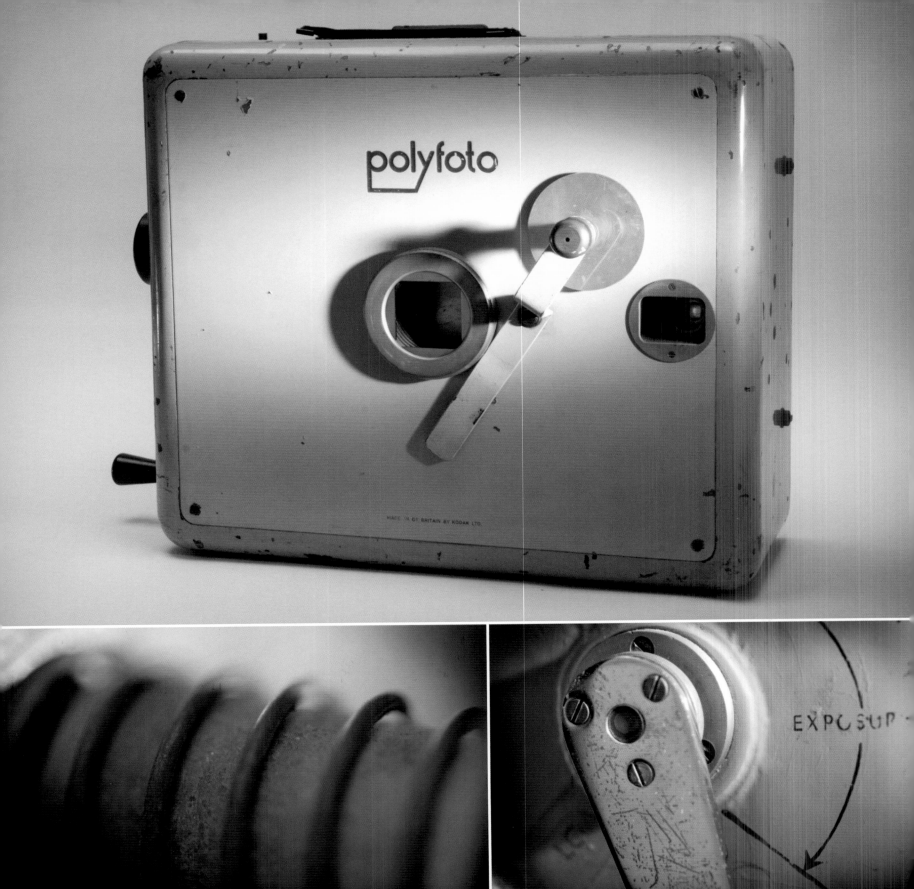

Polyfoto Camera

THE POLYFOTO PORTRAIT STUDIO WAS ONCE A FAMILIAR SIGHT
IN HIGH-STREET DEPARTMENT STORES. THE CAMERA TOOK 48
SUCCESSIVE SHOTS WITH A SIMPLE TURN OF THE HANDLE.

In July 1933, in an article entitled 'The New Portrait Photography', *The British Journal of Photography* announced 'an important innovation in portrait photography, a thing that portrait photographers cannot afford to ignore … in "polyfoto" there has arrived a system of portrait photography which challenges time-honoured methods … we are bound to come to the conclusion that "polyfoto" constitutes a formidable new element in the present business of photographic portraiture, and it will never do for the established photographer in almost any place to treat it otherwise than very seriously.'

However, this new, radically different approach to portraiture actually had its origins in an idea that can be traced back to the Victorian portrait studio and the *carte-de-visite* – capturing several different poses on one glass plate by using a camera with a repeating back. The trade name for this new form of portraiture was both simple and descriptive – Polyfoto, meaning, literally, 'many photographs'. For over 30 years, Polyfoto studios were a common sight. The distinctive photographs they produced – 48 different poses, each little bigger than a postage stamp – found their way into millions of wallets and handbags.

Polyfoto originated in Denmark. The first British studio was opened in Selfridge's in London in 1933. An immediate success, it was followed by others in most cities and larger towns, usually located in department stores. By 1939, there were over 60 Polyfoto studios – 20 of them in London alone. The studios were very simple. A floor space about 12 feet by 6 (3.65 x 1.82m) housed the camera, lights, sitter's chair

'All the operator had to do was centre the sitter in the viewfinder and turn the handle.'

and background. Everything was arranged so that relatively unskilled labour could be used. At most studios there was usually a manageress (very rarely a manager) and one or two assistants.

At the heart of the system was the Polyfoto camera itself. It was designed and built to cope with very heavy use. Many of them were in operation six days a week for over 25 years. The first British Polyfoto cameras were made by the Williamson Manufacuring Co of Willesden Green, better known as makers of aerial cameras for the RAF. Later, Kodak Ltd made about 50 Polyfoto cameras to the same internal specification but with a more streamlined cover (facing page). The camera worked by turning a handle on the right-hand side. Each complete revolution activated the shutter and moved the glass plate so that 48 successive photographs could be taken – eight rows of six negatives – on a 7 by 5 inch (178 x 127mm) plate. The camera lens had a fixed focus and aperture. All the operator had to do was centre the sitter in the viewfinder and turn the handle.

Every day, each studio sent their exposed plates to a central factory in Stanmore, Middlesex, to be developed and printed. After receiving their proof sheet, customers were then invited to select the pose that they would like enlarged. As the company slogan said – 'one of them must be good!' A wide range of print sizes were available, as well as vignetted combinations and hand-coloured prints. All negatives were kept for three years. At any given time there could be up to one million plates in storage. Each had a code from which the time and place that it was taken could be identified, and Scotland Yard was given access to the negatives to help locate and identify missing persons. In 1969, Polyfoto went into liquidation. *The Sunday Times* commented 'How can a company with a household name like that fail to make money?' Today, it is no longer a household name but it remains a fascinating example of mass-portrait photography and a source of nostalgia and personal memories for millions of people.

Compass Camera

A COMPLETE CAMERA SYSTEM THAT FITS INTO A CIGARETTE PACKET, DESIGNED BY AN INVETERATE GAMBLER AND BUILT BY SWISS WATCHMAKERS. YOU COULDN'T MAKE IT UP.

'... a remarkable camera designed by a truly remarkable man.'

In an age when miniaturization seems to be regarded as the epitome of progress, it is refreshing to discover that one of the finest compact cameras ever made appeared on the market nearly 70 years ago. A masterpiece in miniature, the Compass camera was a remarkable camera designed by a truly remarkable man.

The Compass camera was the ultimate compact 35mm camera, with more features packed into its finely-machined aluminium body than any other camera of comparable size. Intended to be a complete system of photography, its specifications included a 35mm, f/3.5 lens, a 22 speed shutter (4.5–1/500sec), a coupled rangefinder, direct vision and right-angle viewfinders, an extinction exposure meter, spirit level, built-in filters, ground glass focusing screen with magnifier, and panoramic and stereo tripod heads – all in a body just 30 x 50 x 70mm. The Compass was designed to take 24mm by 36mm, Leica-size negatives on glass plates but accessory roll-film backs were also available for 35mm and 828 film.

The Compass was the brainchild of Noel Pemberton Billing, a true British eccentric whose life could form the subject of a Hollywood blockbuster. After fighting in the Boer War, Billing took up a stage career and wrote several plays. He then trained as a barrister and, after a spell as a professional gambler in Monte Carlo, was elected as Member of Parliament for East Hertfordshire in 1916. In 1917 Billing founded the Vigilante Society to promote purity in public life and became notorious for his extreme right-wing views. In 1921 he resigned as an MP and turned his attention to playwriting and sailing his yacht.

In the 1930s he moved briefly to Mexico where he opened a casino with the boxer Jack Dempsey. After returning to Britain Billing became manager of the Royal Court Theatre in London. All the while, Billing continued to indulge his two major passions – aeronautics and inventing.

The Compass was the result of a bet that Billing made that he could design a high-quality camera that would be small enough to fit into a cigarette packet. Billing was no stranger to betting. Before the First World War he had learnt to fly and gained his pilot's licence in less than twenty-four hours – winning a £500 bet in the process. Losing was not in his nature. Moreover, despite his eccentricities and extreme political views, Billing was an extremely accomplished and innovative engineer. He claimed to have taken out over 2,000 patents for a bewildering range of inventions – from self-lighting cigarettes to a golf-practising device. On a less frivolous note, he was also the founder of the Supermarine aircraft factory that later went on to develop and manufacture the Spitfire fighter. Although the Compass was his first excursion into camera design, the task took him less than a fortnight and he was granted a British patent on 16 May 1936. Having designed the camera, however, Billing was faced with a slight problem. Such was the intricacy of his design, no British camera manufacturers were up to the task of making it. Instead, Billing turned to the only people who had the necessary experience of making such a precision instrument – Swiss watchmakers. The legendary firm of LeCoultre et Cie, producers of some of the world's finest watches, worked with Billing to improve and perfect his design. The Compass camera was finally released onto the market in March 1937, priced at £30 – roughly the same price as a Leica or Rolleiflex at the time. Advertisements stressed that it was the 'Complete Camera': 'It can be carried in a man's vest pocket, is smaller than a packet of 20 cigarettes and weighs less than 8 ounces (227g). A miniature camera in the true sense of the word – and complete!'

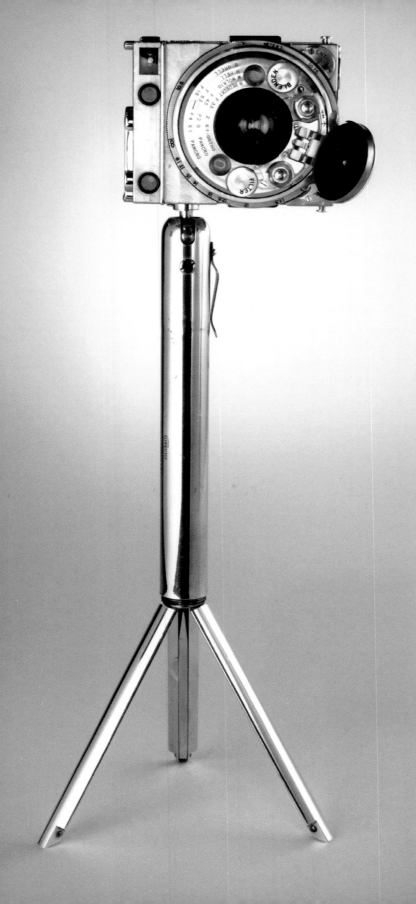

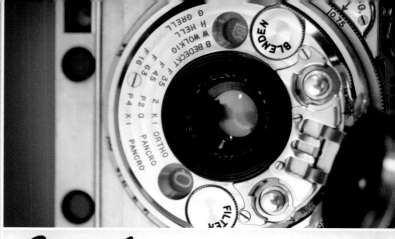

Your specification?
of the Complete Camera?

You would like to include so many essentials in your ideal camera that you are afraid it would be too cumbersome and heavy.

Read the accompanying Compass Specification and consider if this does not tally very closely with your own conception of the *complete* camera. Then consider the portability of Compass. It can be carried in a man's vest pocket, is smaller than a packet of 20 cigarettes and weighs less than 8 ozs. A miniature camera in the true sense of the word—and complete !

The Compass Camera may be examined at any Appointed Compass Dealer or at the Company's Showrooms.

SPECIFICATION

Exposure meter ; range-finder ; focusing scale ; right angle and direct vision viewfinders ; depth-of-focus indicator ; screen and magnifier for composition and focusing ; specially designed high-speed, wide-angle (f/3.5) lens by Kern ; lens cover and hood ; set of three filters ; spirit level ; panoramic and stereoscopic fitments. The Compass standard back for use with glass-plates is interchangeable with the new roll-film back. All within a space less than a packet of 20 cigarettes and weighing less than 8 ozs.

● *You are invited to write for the free explanatory 48 pp. illustrated booklet*

BUILT LIKE A WATCH—AS SIMPLE TO USE

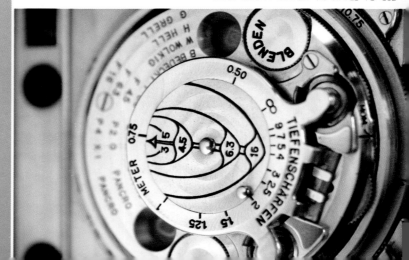

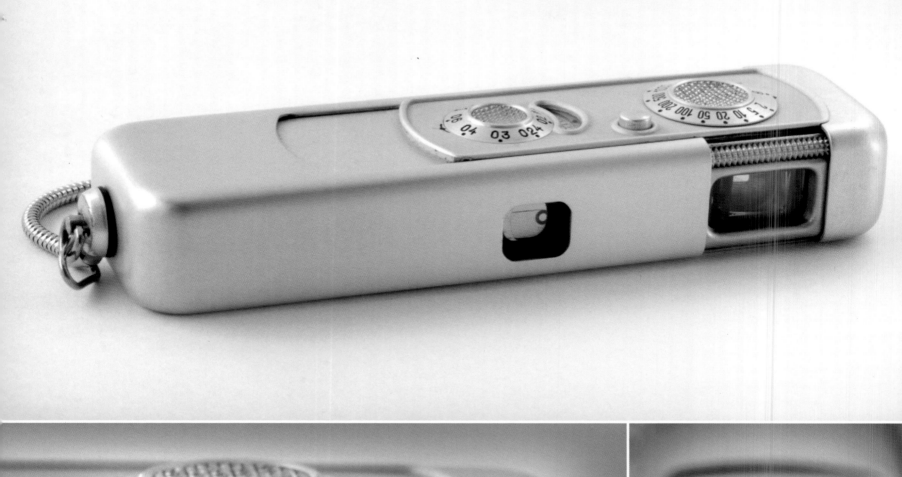
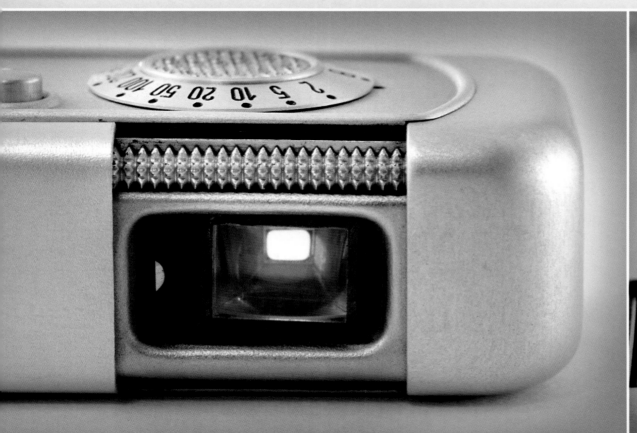
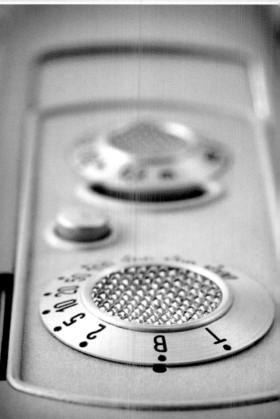

The Minox

A GENUINE DESIGN CLASSIC, WALTER ZAPP'S MINIATURE

MASTERPIECE PACKED AN IMPRESSIVE ARRAY OF FEATURES

INTO A STAINLESS STEEL BODY THE SIZE OF A MIDDLE FINGER.

If awards were given to cameras for the best supporting role in a film, then the winner would undoubtedly be the Minox. The camera of choice of any self-respecting spy, this little camera has appeared in countless films and television programmes. Yet there is much more to this, the most famous sub-miniature camera, than the clichéd description 'Spy Camera'. A masterpiece of design and precision engineering, it has one of the longest production histories of any camera.

The Minox was the brainchild of a Latvian, Walter Zapp, who produced the first hand-made prototype in 1936. The camera was patented in Britain in December 1936 and production began at the Valsts Electrotechniska Fabrika (VEF) factory in Riga, Latvia, in 1937. Because of their place of manufacture, these early cameras are known as Riga Minox.

The film was advanced by pushing together and then pulling apart the two parts of the sliding camera body. When closed, the camera was only about 3 inches (76mm) long – about the size of someone's middle finger. Made from stainless steel, it weighed about 4 ounces (113g).

For foreign distribution, VEF set up sales offices in London and New York. A British advertisement in *The Miniature Camera Magazine*, November 1939, called the camera a 'Miniature Masterpiece … . Small enough to seem a toy – nevertheless an apparatus of the finest precision.' A review of the camera which had appeared in the same magazine the previous month described it as 'an exceptionally clever and interesting camera – revolutionary in many respects, daring in design, but certainly efficient in performance … . We had no end of fun trying this camera, as it can be whipped out of the pocket in a moment and a picture taken before anybody knows what you are doing.'

Given the international situation at the time, it was stressed that the camera wasn't German, but was made in a neutral country. Unfortunately, Latvia soon found itself embroiled in the Second World War, occupied successively by Soviet and then German troops.

'Small enough to seem a toy – nevertheless an apparatus of the finest precision.'

The Minox took unperforated 9.5mm-wide film in special drop-in cassettes, giving 50 exposures. The negative size was just 8mm by 11mm – about one ninth the size of a standard 35mm negative. The Minostigmat fixed f/3.5, 15mm lens could be focused from as close as 8 inches (203mm) to infinity. Shutter speeds ranged from 1/2 to 1/1000sec. Perhaps the most characteristic aspect of the design was the film-advance mechanism.

Minox camera production continued, however, during the war. After the war the Minox factory was re-established in Wetzlar, Germany. New models appeared, such as the Minox B in 1958 and the Minox C of 1969, embodying refinements and improvements, such as built-in exposure meters, but still remaining true to Walter Zapp's original revolutionary design. One of the great camera designers, Walter Zapp died in 2003 at his home in Switzerland, aged 97.

The Kine Exakta

THE PRECURSOR OF THE MODERN SLR, YET DETERMINEDLY DIFFERENT IN DESIGN, THE KINE EXAKTA SURVIVED A NAZI TAKEOVER AND THE BOMBING OF ITS DRESDEN BASE.

The 35mm SLR is without doubt one of the most influential camera formats in the history of photography. Whilst the principle of the single-lens reflex camera actually pre-dates photography – the concept was used in camera obscuras as early as the seventeenth century – the origins of the 35mm SLR date back only as far as the 1930s. There has been considerable debate among camera historians as to which camera can rightly lay claim to the prestigious title of 'the world's first 35mm SLR camera', but it is now generally agreed that the Kine Exakta was the precursor of all modern single-lens reflex cameras.

The Kine Exakta was manufactured by the Dresden-based firm, Ihagee Kamerawerk. Founded in 1912, Ihagee soon gained a reputation for innovation through the work of its design team headed by the talented young designer Kurt Nuchterlein. In 1933 they introduced an SLR camera for 127 or 'Vest Pocket' film, called the 'Exakta'. The name was carefully chosen to suggest quality and precision – 'exakt' is German for 'accurate'. At the time, most reflex cameras were of a traditional box-form design. The 'VP' Exakta, by contrast, adopted a radically different, compact, trapezoid shape. It was this camera that was to evolve into the Kine Exakta – a camera that shared many of its characteristic features but was designed to use sprocketed 35mm cine film ('Kine' in German).

Plans to modify the VP Exakta to take 35mm film apparently began as early as 1932 when the camera was still at a development stage. The idea of sharing many features must have considerably reduced the design time and costs.

'... the Exakta was conceived as a system camera and a wide range of bayonet-mounted interchangeable lenses and specialized attachments were available.'

However, it wasn't until 1936 that Ihagee were in a position to launch the Kine Exakta at that year's Leipzig Spring Fair.

The Kine Exakta was fitted with a focal-plane shutter that gave a very wide range of speeds, from 12 to 1/1000sec. A peculiarity of Exaktas is that many of the controls, including the shutter release and film wind lever are on the left-hand side of the camera body. This has led to it often being described as a 'left-handed' camera. Key to the camera's success was its viewing system. Rather than being made from flat, ground glass, the viewing screen is a plano-convex magnifier with a ground lower surface that gives a very bright, enlarged image. A round focusing magnifier, hinged to the base of the viewfinder, allowed even more accurate focusing. In cameras produced from 1937 onwards, this was replaced by a rectangular magnifier that covered most of the viewing screen. The focusing hood can be converted into an eye-level viewfinder – useful for action photography since the reflex image was, of course, laterally reversed. Right from the start, the Exakta was conceived as a system camera and a wide range of bayonet-mounted interchangeable lenses and specialized attachments were available.

Following the outbreak of war in 1939, production of Exakta cameras slowed considerably. In 1941 the company was taken over by the Nazi regime who disapproved of its existing management – the founder and owner, John Steenbergen, was a Dutchman. Kurt Nuchterlein, who showed himself to be uncooperative, was dismissed and conscripted into the German army as a private. He was killed fighting on the Eastern Front. In February 1945 the main Ihagee factory in Dresden was totally destroyed by Allied bombing. After the war, however, the company was to rise again, phoenix-like, from the ashes. In what became East Germany, Ihagee continued to produce a range of reflex cameras up until the early 1970s – all derived from the legendary Kine Exakta whose basic design survived with very little modification.

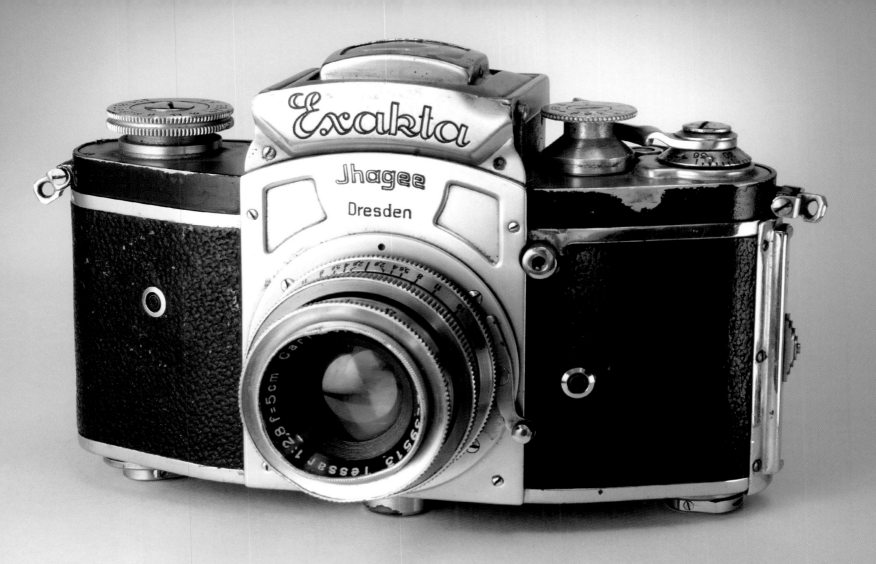

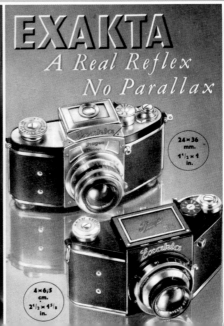

EXAKTA
*A Real Reflex
No Parallax*

24×36 mm.
1¹/₂ × 1 in.

4×6;5 cm.
2¹/₂ × 4¹/₂ in.

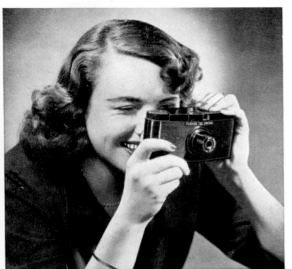

PURMA
— Used by Experts

When it's now-or-never . . and no second chance. For picturing the unexpected, vivid drama, unrehearsed humour, high-speed action. For split-second photography, when setting stops and speed in your usual camera might mean missing the picture. For first-time, FAST-time shots use PURMA the precision-made miniature that needs NO FOCUSING —NO ADJUSTMENT.

Always ready for instant action. Shorn of expensive fittings, the PURMA is carried by leading professional photographers and press cameramer —a valued, trusted adjunct to their more elaborate equipment.

Note these PURMA features
F/6.3 BLOOMED ANASTIGMAT LENS
THREE AUTOMATIC SHUTTER
SPEEDS 16 Pictures on V.P. Film

Price **£7 16 0** Inc. P. Tax

Full range of accessories is available
Send stamped addressed envelope for PURMA Booklet and name and address of nearest stockist to World Distributors :

R. F. HUNTER Limited

Celfix House, 51 Grays Inn Road
London W.C.1. Phone Holborn 7311-2

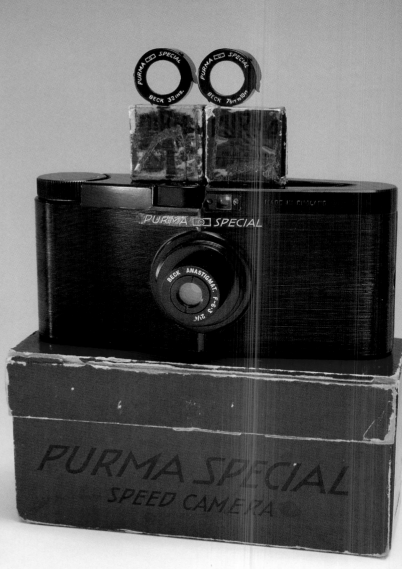

Purma Special

QUINTESSENTIALLY MODERN, THE STREAMLINED PURMA
UTILIZED NEW MATERIALS SUCH AS PERPSEX AND BAKELITE
AND BOASTED A UNIQUE GRAVITY-CONTROLLED SHUTTER.

The unusual name 'Purma' was derived from the names of the two founders of Purma Cameras Ltd, Tom PURvis and Alfred MAyo. Tom Purvis is better known as an artist and graphic designer, responsible for many of the finest railway posters of the 1930s. The Purma Special, introduced in September 1937, was the second camera produced by Purma Cameras Ltd — the first, the Purma Speed, having appeared the previous year. Moulded from black Bakelite, the Purma Special has an elegant, streamlined and very stylish trapezoid-shaped body. Raymond Loewy, the influential American designer known as 'the Father of Industrial Design', is often credited as the camera's designer. More probably, however, the camera was the work of someone in Loewy's London office, with input from Tom Purvis.

The Purma Special is very simple to operate. The wind-on knob is on the left (seen from the front); above the lens there is a lever that sets the shutter and the shutter release is recessed in a well on the camera's right top. Sixteen square exposures could be taken on 127 film. The camera is fitted with a fixed-focus and fixed-aperture Beck anastigmat 2¼ inch (57mm) f/6.3 lens. Since this could only focus beyond about 20 feet (6m), supplementary lenses were available for close-up work. The lens barrel is spring-mounted. A screw-on lens cap pushes the lens into the camera body and locks the shutter release to prevent accidental exposures. Unfortunately, this lens cap was easily lost and is frequently missing from examples that you come across today. The simple eye-level optical viewfinder was made from a revolutionary new material

'... the shutter speed is determined by which way up the camera is held.'

called 'Perspex', making the Purma Special one of the very first cameras to use plastic optics. What truly set the Purma Special apart, however, and prompted contemporary reviewers to comment on its 'unconventional design' was its unique focal-plane shutter. The camera has no external shutter speed selector. This is because it doesn't need one — the shutter speed is determined by which way up the camera is held. The gravity-controlled shutter was invented by the company's founder, Alfred Mayo, and patented by him in 1935.

At its simplest, this is how it worked: a weight was attached to the shutter; when the camera was held horizontally, the shutter was pulled sideways by a spring, giving an exposure of about 1/150sec (medium). When the camera was held vertically in one direction, the weight added to the pull of the spring and reduced the exposure time to 1/450sec (fast), but when it was held vertically in the other direction, the weight acted against the spring and the exposure time was increased to 1/25sec (slow). As a reminder to the photographer as to which way to hold the camera, the words 'Fast' and 'Slow' are moulded into the Bakelite surrounding the viewfinder eyepiece. As a general rule, 'fast' was for bright sunlight, 'medium' for bright but not sunny and 'slow' for overcast. Since the negatives were square, changing the orientation of the camera had no effect on the picture format.

The Purma Special was marketed by R.F. Hunter of London from 1937 onwards. Production stopped in 1940 but the camera reappeared after the war and was still being advertised in the early 1950s.

In 1954, a restyled version, the Purma Plus, was introduced. This had a more angular, metal body but used the same gravity-controlled shutter. Less successful than its predecessor, the Purma Plus only remained in production for a couple of years.

Super Kodak Six-20

THE FIRST CAMERA TO OFFER AUTOMATIC EXPOSURE CONTROL, THIS ADVANCED BUT UNRELIABLE MODEL WAS RETURNED FOR REPAIR SO OFTEN IT WAS NICKNAMED 'THE BOOMERANG'.

USE KODAK FILM
VERICHROME V 620
SS PAN SS 620
PANATOMIC F 620
OR N.C. 620

USE KODAK FILM
IN THE YELLOW BOX
It gets the Picture

PATENTED IN U.S.A.
RE. 20,486
DES. 100,961
DES. 102,023
1,991,110 2,058,483
2,033,703 2,061,909
2,043,902 2,059,032
2,058,531 2,090,060
PAT. PENDING
PRINTED IN U.S.A. NO.66461

'... the Super Kodak Six-20 – a visionary camera that was well ahead of its time.'

Any manufacturer that decides to call their cameras 'Super' might rightly be thought to be setting themselves up for a fall. Yet, over the years there have been dozens of 'super' cameras. For most, it is very difficult to argue that the name is appropriate. For a select few, however, the epithet is fully deserved since they possess qualities that set them apart from the crowd. One such camera is the Super Kodak Six-20 – a visionary camera that was well ahead of its time.

The Super Kodak Six-20 holds the distinction of being the first camera to offer automatic exposure control. Photoelectric exposure meters had first become commercially available in the early 1930s. Subsequently, many patents were taken out for various systems for mechanically coupling photocells with camera exposure controls. However, only one design actually made it onto the market before the outbreak of the Second World War – the Super Kodak Six-20.

Introduced in 1938, the Super Kodak Six-20 was the brainchild of a Hungarian, Joseph Mihalyi. Mihalyi had emigrated to America in 1907 to join his older brother who lived in St Louis. After working for a number of optical instrument makers, Joseph was hired by Eastman Kodak in 1923. As well as the Super Six-20, Mihalyi went on to design several other innovative Kodak cameras, including the Ektra, Medalist and Bantam Special. The camera's distinctive and modernist 'clam-shell' construction was styled by the foremost industrial designer of the day, Walter Dorwin Teague. A pioneering figure in industrial design, Teague was contracted to Kodak from 1928 onwards and brought his

design flair to a range of cameras including the colourful art deco Beau Brownies (see page 115). Later, in 1948, Teague was to design Edwin Land's first Polaroid camera.

As the name makes clear, the Super Kodak Six-20 was designed to use 620 roll film, introduced by Kodak in 1931, giving 2¼ by 3¼ inch (57 x 82mm) negatives. It is fitted with a Kodak Anastigmat Special f/3.5 lens and a shutter giving speeds from 1 to 1/200sec. A direct-vision optical viewfinder is combined with a coupled wide-base rangefinder. The heart of the camera is a large selenium photocell fitted in the body of the camera, above the bellows. Mihalyi had devised a system of linking the output of this cell to the camera's aperture controls. The output from the cell moves the needle of a meter, set in the camera's lens panel. Slight pressure on the shutter release activates a comb-like element that locks the needle in place. A spring-loaded sensor, connected to the aperture control, then moves until it is stopped by the locked needle. This gives the correct aperture setting and the shutter is released. As the publicity explained, 'simply choose a shutter speed to fit your subject ... the ingenious mechanism does the rest.' The camera was fully automatic for shutter speeds between 1/25 and 1/200sec. For slower speeds, the aperture had to be set by hand.

The automatic-exposure control was innovative and ingenious but it was also notoriously unreliable. Kodak repair staff nicknamed the camera 'the boomerang' because of the regularity with which it was returned to the factory for repair. It was also extremely expensive, costing the then enormous sum of $225 (over £70 at the exchange rate at the time). The Super Kodak Six-20 was produced throughout the war years from 1938 until 1944. Estimates of the number produced vary but probably fewer than 1,000 of this landmark camera, described as 'a new page in photographic history', were made, making it highly collectable and earning it the unenviable distinction of being the least widely sold Kodak camera aimed at the general market.

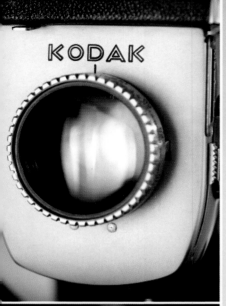

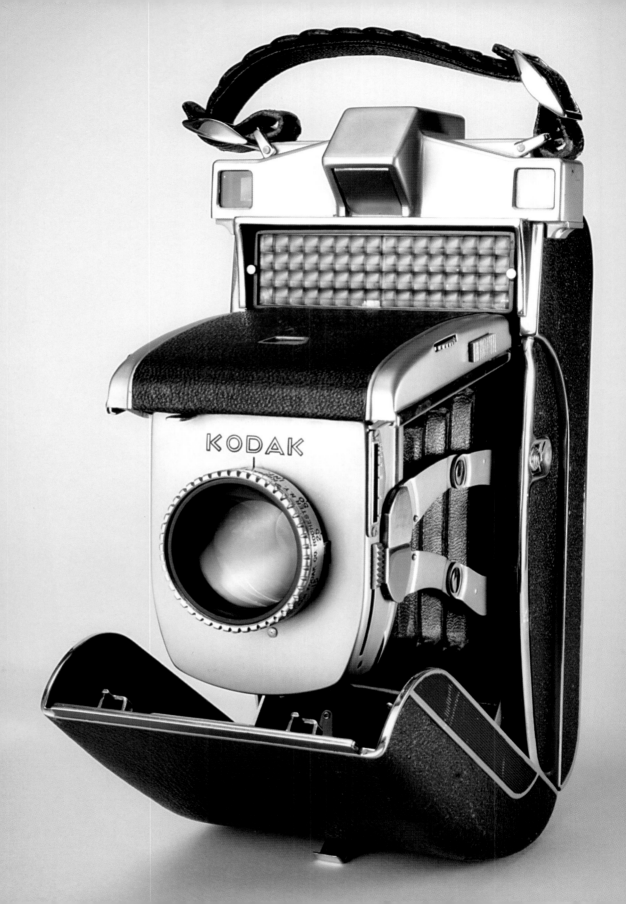

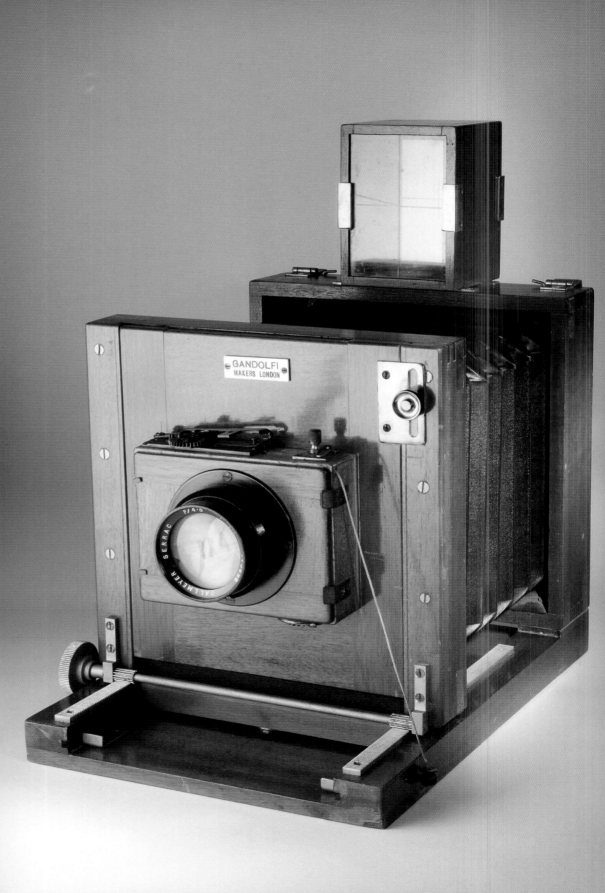

Gandolfi Prison Camera

GANDOLFI, THE OLDEST CAMERA MANUFACTURERS IN THE
WORLD, PRODUCED SPECIALIST CAMERAS FOR THE BRITISH
GOVERNMENT, INCLUDING THIS 1950s MUGSHOT MODEL.

During the nineteenth century, Britain led the world in camera design and construction and British camera makers were renowned for the quality of their craftsmanship. Today, little remains of this once thriving craft industry and our proud heritage is largely confined to museums. However, amazingly, there is still one surviving link to a world before widespread mechanization and mass-production. Founded when Queen Victoria was on the throne and three years before George Eastman introduced his very first Kodak, Gandolfi are the oldest firm of camera makers in the world.

In 1880, sixteen-year-old Louis Gandolfi (left) joined the firm of Lejeune and Perken, optical and scientific instrument makers of Hatton Garden, London, as an apprentice. Five years later, having learned his trade, Louis set up his own business as a manufacturer of 'high-class cameras, camera stands etc', over a tobacconist's shop in Westminster.

'Gandolfi are best known for their traditional large format field cameras.'

In 1928, the company settled at Borland Road, Peckham Rye, where it was to remain for over 50 years. By this time, Louis' ill health meant that his three sons, Thomas, Frederick and Arthur were effectively responsible for running the family business. Thomas was in charge of camera design, Frederick looked after the administration and Arthur, the youngest, did the French polishing. Louis died in 1932 but the company prospered under the stewardship of his sons, producing a limited number of camera designs in small numbers and gaining a reputation for the highest quality of craftsmanship.

In 1968, Thomas Gandolfi died and in 1981 Frederick went into semi-retirement following a car accident. In 1982, a new company, Gandolfi Ltd, was formed and Frederick and Arthur passed on some of their lifetime of experience to a new generation of craftsmen who would maintain the Gandolfi tradition. Frederick died in 1990 and Arthur, the last of the brothers, died in 1993. However, the name and all that it stands for lives on, and Gandolfi cameras are still being made today.

Gandolfi are best known for their traditional large-format field cameras. However, some of their biggest customers were the various government departments for whom they produced specialist cameras for architectural, industrial and scientific work. One of their most lucrative contracts was with the Home Office – to supply and maintain the cameras used in Her Majesty's Prisons.

In Britain, the use of photography to record known criminals – the 'mug-shot'– had begun as early as the 1840s. In 1871, the Prevention of Crimes Act made it a legal requirement that all persons arrested for a crime must have their photographs taken. For many years, all prison mug-shots were taken with Gandolfi cameras.

This comparatively simple and robust prison camera probably dates from the 1930s but may well have still been in use in the 1950s. In an ironic echo of the *carte de visite* studio portrait cameras that first appeared nearly a century earlier, this camera is fitted with a repeating back so that three separate poses can be taken in succession on the same plate – full face, left and right profile.

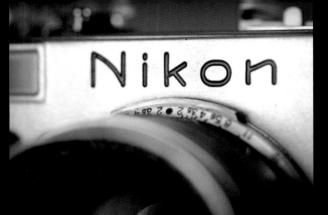

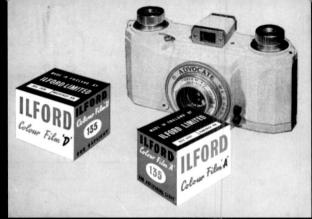

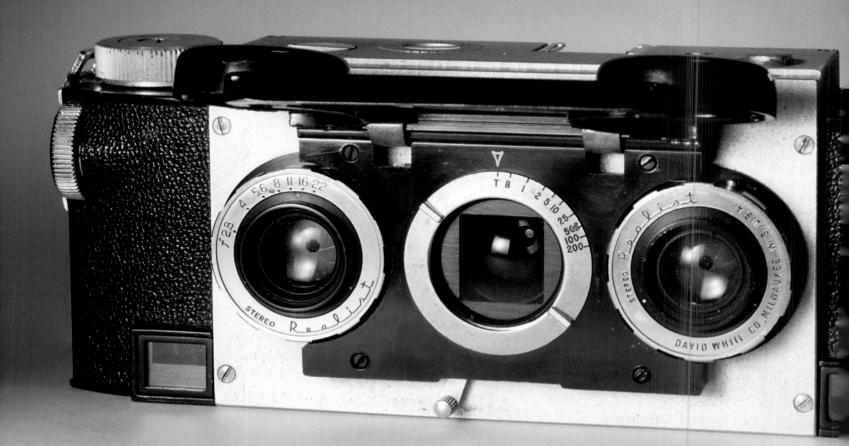

IMITATION AND INNOVATION

SINCE THE SECOND WORLD WAR, THERE HAVE BEEN RAPID AND FUNDAMENTAL CHANGES IN PHOTOGRAPHIC TECHNOLOGY AND CAMERA DESIGN. DEVELOPMENTS, SUCH AS AUTOMATIC EXPOSURE CONTROL, WHICH TOOK THEIR FIRST TENTATIVE STEPS IN THE 1930s, REACHED THEIR FULL COMMERCIAL POTENTIAL. THE 35MM SLR BECAME THE CAMERA OF CHOICE FOR 'SERIOUS' PHOTOGRAPHERS WHILST CARTRIDGE-LOADING 'INSTAMATICS' DOMINATED THE SNAPSHOT MARKET. CAMERAS BECAME INCREASINGLY DEPENDENT ON ELECTRONICS AND EUROPEAN MANUFACTURERS STRUGGLED TO COMPETE WITH THEIR JAPANESE RIVALS. IN THE EARLY 1990s, THE FIRST COMMERCIAL DIGITAL CAMERAS APPEARED, HERALDING THE RAPID DECLINE OF TRADITIONAL SILVER-BASED PHOTOGRAPHY.

Far left: The Nikon M (page 154)
Left: Ilford Advocate (page 157)
Below: The Stereo Realist (page 149)

The Canon IIB

THE JAPANESE CANON CAMERA COMPANY LTD ENJOYED RAPID GROWTH IN THE 1950s, EXPANDING INTO THE INTERNATIONAL MARKET WITH A RIVAL TO THE LEICA AND THE CONTAX.

In its formative years, the Japanese camera industry was characterized by imitation rather than innovation. The first Japanese-made cameras were copies, of varying quality, of European and American designs. In 1933, Goro Yoshida and his brother-in-law Saburo Uchida founded the Seiki Kogaku Kenkyusho (Precision Instruments Laboratory) in Tokyo. However, their plan wasn't simply to produce inferior copies of other people's designs. Their aim was to produce the first original Japanese 35mm camera — a camera that would be the equal of the Leica and the Contax.

The prototype of their first camera, based loosely on the Leica II, appeared in 1934. Yoshida, a devout Buddhist, decided to name the cameras 'Kwanon', after the Buddhist Goddess of Mercy. Uchida, however, took exception to the overtly religious overtones of the name which he felt, with its traditional associations, was unsuitable for a high-technology product. Uchida won the day and Yoshida resigned from the company less than a year after he had founded it. Uchida, now in sole charge, applied for a new trademark which was granted in September 1935. The new name was to become famous worldwide — Canon. That same year, the first production-model camera, using a lens and mounting supplied by Nippon Kogaku (later, Nikon), was advertised in *Asahi Camera* magazine: 'Canon is a Japanese-made imitation of Leica. It is similar to Leica in most parts, although the influence of Contax on its mechanism cannot be overlooked.' The cameras were sold by the Omiya Photo Supply Co and also carried that company's brand name, 'Hansa'. In 1938 the *British Journal Photographic Almanac* carried the first British advertisement for the Hansa Canon camera. 'The Hansa Canon is an [sic]

'In its formative years, the Japanese camera industry was characterized by imitation rather than innovation.'

unique Miniature Camera of chrome finish, fitted with Nikkor F/3.5 lens, range finder, numbering dial and focal plane shutter. Speeds range from 1/20th to 1/500th of a second and bulb.'

Camera production was severely disrupted during the Second World War but expanded once more during the period of Allied occupation after the end of the war. Significantly, and reflecting the sense of a new beginning, in September 1947, the company changed its name to the Canon Camera Company Ltd. New models appeared and camera production rose steadily — from around 5,000 in 1949 to 18,000 in 1952 and over 40,000 in 1954. Also during his period, the company began to make its first tentative moves into the international market. The April 1950 issue of the American magazine *Popular Photography* carried the first advertisement for this particular camera, the Canon IIB. 'Do you wish you had a 35mm camera of exquisite precision? If you're a traveller, a rugged sports fan, or if you simply admire and want a magnificently fine camera — Canon's uniquely adjustable magnifying range finder quickly sharpens the finest details. Canon's superbly engineered, shock-angled frame will last a lifetime … . If you long for the ultimate in 35mm … it's your kind of camera!'

Production of the Canon IIB began in January 1949 and continued for more than three years. About 14,400 were made — more than the total of all the Canons that preceded it. The Canon IIB had a coupled rangefinder and a focal-plane shutter giving speeds from 1 to 1/500 sec, on two speed dials, split at 1/20. This example is fitted with a Serenar 50mm, f/3.5 lens, although an f/1.9 lens was also available as standard. A significant innovation was the first application of an unusual variable-magnification viewfinder that was to become a hallmark of Canon rangefinder camera design over the next decade. The viewer had three modes, set by a lever arm under the rewind knob — 'F' for a 50mm lens, '1' for 100mm and '1.5' for a 135mm lens.

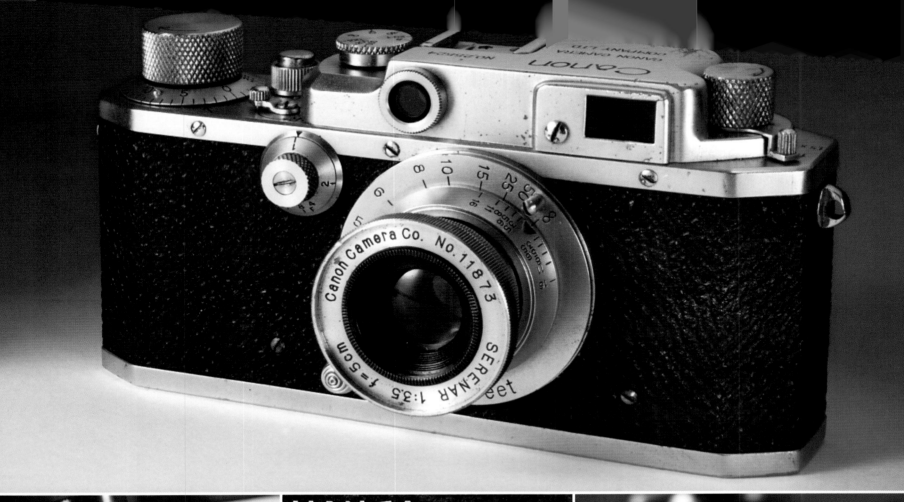

HANSA
PATENT ENLARGER

HANSA
Canon

The **Hansa Patent Enlarger** is constructed with all the merits of the condenser and condenserless types so as to ensure the best results. The Hansa Enlarger can be used vertically or horizontally as required. Sold in three sizes only, with lens :—

For vest pocket Negative fitted with F/5.3 lens
" 6×9cm. " " " F/6.3 "
" 4¼"×3¼" " " " F/6.3 "

The **Hansa Canon** is an unique **Miniature Camera** of chrome finish, fitted with Nikkor F/3.5 lens, range finder, numbering dial and focal plane shutter. Speeds range from 1/20th to 1/500th of a second and bulb.

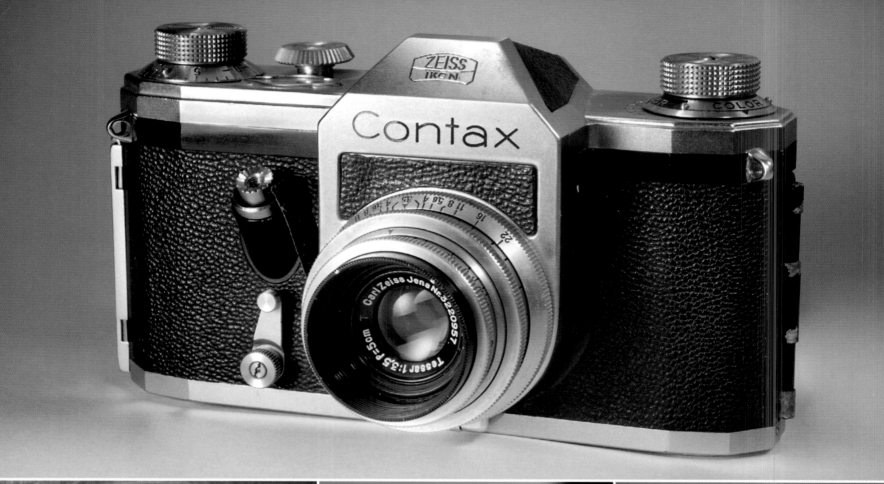

The Contax S

THE FIRST SLR WITH A PENTAPRISM VIEWFINDER WAS DEVELOPED IN THE ZEISS IKON FACTORY IN DRESDEN – THEN UNDER RUSSIAN CONTROL IN DIVIDED COLD WAR GERMANY.

The first 35mm SLR camera, the Kine Exakta, appeared in 1936. The waist-level reflex viewfinder of the Kine Exakta gave a laterally-reversed, wrong-way-round, image. This made action photography difficult, so the focusing hood converted into an eye-level frame finder. The obvious drawback of a laterally reversed image, combined with a growing trend for miniature cameras to be used at eye-level, meant that a way was sought of providing right-way-round, eye-level reflex viewing. The solution was the pentaprism – a five-sided prism that reflects an image through 90 degrees without changing its orientation. In 1947, a British company, Wray, patented a reflex

Before the war, Zeiss Ikon's head of camera design, Hubert Nerwin, had been working on a 35mm reflex-prism camera. Even during the war, Nerwin continued to work on his design during his own time, so that by the time the war ended the prototype of a pentaprism SLR already existed in Dresden. After the war, Nerwin escaped to the West, emigrating to America in 1947, where he worked for the Graflex Corporation, makers of the Speed Graphic camera. Meanwhile, back in Dresden, his successor, William Winzenburg, completed the project. At the 1949 Leipzig Fair the Contax S was launched – the 'S' stands for *spiegelreflex* or 'mirror reflex'. There is an ongoing debate as to whether the Contax S or the Italian-made Rectaflex (page 146), also launched in 1949, was the first pentaprism 35mm SLR. However, the consensus seems to be that the Contax S just qualifies for that distinction.

The Contax S was swiftly followed by a family of variants. Each shared the same basic technical specification – a focal-plane shutter with a range from 1 to 1/1000sec,

'The design of the Contax S was hugely influential, setting the standard for the future.'

camera design with a built-in pentaprism but this did not make it into production until several years later. The first production SLR camera to incorporate a pentaprism viewfinder was the Contax S camera of 1949.

After the end of the Second World War, Germany was divided into various zones of occupation under the victorious Allied powers. As the Cold War emerged, Germany was split in two between East and West. Just as Germany was divided, so too were many of her long-established industries, including camera makers Zeiss-Ikon who had factories in Stuttgart in the West and Dresden in the East. Surprisingly perhaps, it was the Dresden factory, now under Russian control, that was to come up with the first major post-war contribution to camera design.

flash-synchronization, a non-return mirror and a 42mm thread-mount for a range of interchangeable lenses. An estimated 125,000 were produced before the series was discontinued in 1960. By the time the later models appeared, a series of lawsuits meant that Dresden-made Contax cameras were marketed under a number of different names, including Pentacon – an amalgamation of PENTAprism and CONtax. The name 'Pentax' was also a Dresden trademark. However, in 1954 this had been licensed to the Asahi Optical Co in Japan who used it for the first of their successful series of 35mm SLR cameras, launched in 1957.

The design of the Contax S was hugely influential, setting the standard for the future. The pentaprism 35mm SLR was to become the most popular camera type for both amateur and professional photographers.

The Rectaflex

THE IMPRESSIVE BUT ILL-FATED RECTAFLEX WAS CONCEIVED AS THE PERFECT SLR – BUT EVEN PRESENTING A GOLD-PLATED LIMITED-EDITION MODEL TO THE POPE COULDN'T SAVE IT.

The Rectaflex competes, with Zeiss Ikon's Contax S, for the distinction of being the first 35mm SLR camera with a pentaprism viewfinder. Both cameras were exhibited in 1948 and produced in 1949, although the Contax S has an earlier patent date. Manufactured in Rome, the Rectaflex is the only Italian-made 35mm SLR camera.

The Rectaflex was the brainchild of Telemaco Corsi. Trained as a lawyer, Corsi was an enthusiastic photographer who had a dream of creating the perfect 35mm camera. To achieve his dream he assembled a team of craftsmen and persuaded entrepreneurs to invest heavily in his company – S.A.R.A. A prototype camera was displayed at the Milan Trade Fair in 1948 where it generated a great deal of interest. However, it was to be nearly another two years before the Rectaflex finally made it on to the market.

Made from die-cast alloy, the Rectaflex is a high-quality precision-made camera incorporating an eye-level pentaprism viewfinder, a focal-plane shutter and a bayonet lens mount. A large range of lenses was available by leading manufacturers such as Angenieux, Schneider and Zeiss.

'... the Rectaflex is the only Italian-made 35mm SLR camera.'

The earliest models have a top shutter speed of 1/1000sec and cameras produced after about 1952 have a top speed of 1/1300sec. Because of this, Rectaflex cameras are sometimes designated Rectaflex 1000 and Rectaflex 1300.

Introduced in about 1952, the Rectaflex Rotor was a version of the camera fitted with a three-lens rotating turret, similar to those used on cine cameras. Three lenses of different focal lengths (typically 35mm, 50mm, 90mm or 135mm) could be brought into use as required by simply rotating the turret. A hand-grip incorporates the shutter release and a rifle-butt holder was fitted for steadying the camera. Only about 300 Rectaflex Rotors are estimated to have been made.

The rarest of all Rectaflex cameras are a series of gold-plated cameras, covered with lizard skin, which were made as special gifts for prominent figures such as Pope Pius XII, President Eisenhower, Winston Churchill and King Farouk of Egypt. In all, fewer than ten Gold Rectaflexes are thought to have been produced.

Despite a favourable reception, the Rectaflex was not a commercial success. In 1954, *Amateur Photographer* magazine reported that the camera 'was said to be in wide use by the American Army'. In 1955, however, the cancellation of a contract for 30,000 cameras to be supplied to the American military brought about a financial crisis and caused the company to go into liquidation. A new Rectaflex company was subsequently formed – Etablissement Rectaflex International – based in the Principality of Liechtenstein and controlled partly by the Prince of Liechtenstein. The Liechenstein Rectaflex incorporated a number of minor design changes, most notably a re-shaped pentaprism cover which carries the Liechtenstein Royal Crest. The last examples of the Rectaflex were beset by design and technical problems, and production seems to have finally stopped in about 1957.

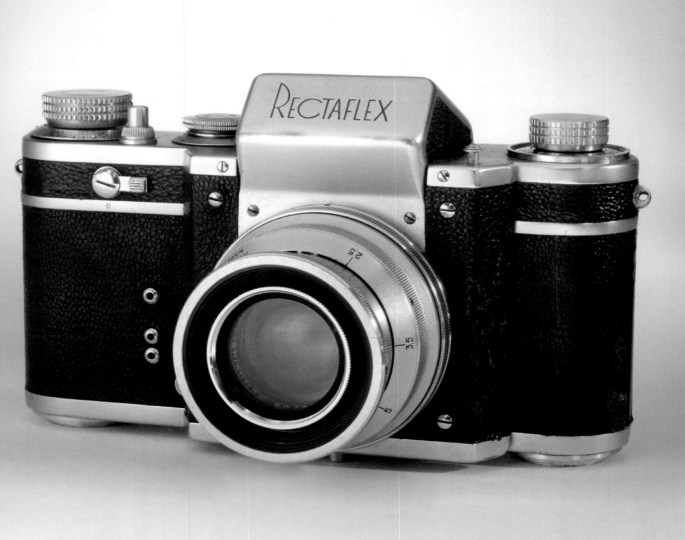

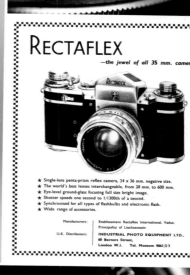

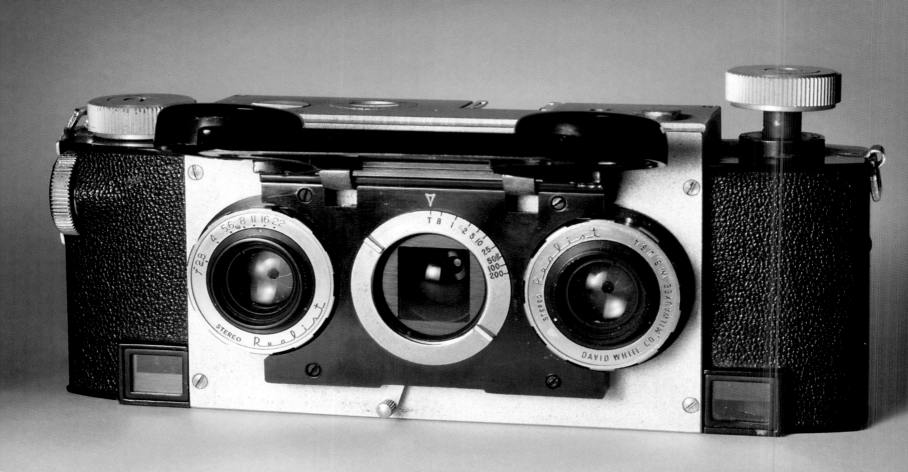

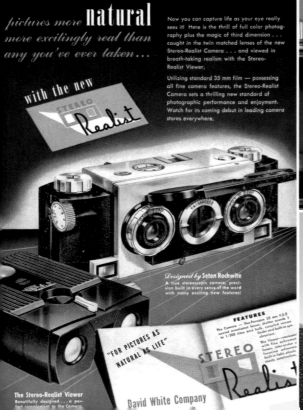

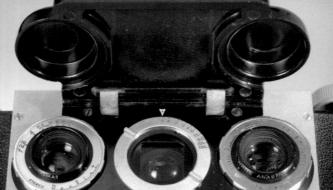

The Stereo Realist

RIDING A WAVE OF ENTHUSIASM FOR '3-D' PHOTOGRAPHY, THE STEREO REALIST WON NUMEROUS CELEBRITY ENDORSEMENTS. IT REMAINED IN PRODUCTION FOR ALMOST 25 YEARS.

Historically, stereoscopic photography has experienced long periods of apathy, interrupted by occasional bursts of intense, but short-lived popularity. Its last brief flowering took place in the 1950s when '3-D', as it was known, caught the imagination of the public. In November 1945 *American Photography* magazine carried an advertisement for a new 35mm stereo camera called the Stereo Realist. This was destined to become the most popular stereo camera ever made.

The Stereo Realist was the brainchild of Seton Rochwite, a young engineer and stereo enthusiast who had built a number of stereo cameras for his own use. In 1943, Rochwite took a prototype 35mm stereo camera to a job interview with the David White Company in Milwaukee, makers of precision optical instruments. Clearly, it did the trick. Not only did he get the job, the company, despite having no experience of making cameras, decided to go ahead with the commercial manufacture of Rochwite's camera.

Although the first advertisements appeared in 1945, it was not until May 1947 that the first, eagerly-awaited, Stereo Realists made it into the shops. The camera was an instant success and production struggled to keep up with demand. This success was partly due to an innovative advertising campaign: a dazzling array of stars lined up to enthuse about the Stereo Realist in full-page magazine advertisements, including Bob Hope, John Wayne, Doris Day and Fred Astaire – 'I take pictures so real they're actually beyond belief'. In 1952, General Eisenhower, soon to be president, was photographed in *Life* magazine using his Stereo Realist.

'Unusually, the viewfinder eyepiece is situated on the bottom of the camera.'

Effective advertising, however, wasn't the only reason for the camera's success. More importantly, the Stereo Realist was a well-made and reliable camera that gave excellent results. The Realist uses standard 35mm film, giving 19 pairs of pictures on a 24-exposure film or 29 pairs on a 36-exposure film. At first glance, the camera appears to have three lenses. The centre lens is, in fact, for the viewfinder. Unusually, the viewfinder eyepiece is situated on the bottom of the camera. In use, the camera is held in what feels like an upside-down position, with the body resting against the forehead. Next to the viewfinder is a second window for the split image rangefinder. The focusing arrangement is also somewhat unusual. Focusing is controlled by a milled wheel on the right of the body. When this is turned, the lenses remain stationary and the film plane moves backwards and forwards inside the camera body. Lens apertures are adjusted by a ring around one of the lenses that is coupled to the second lens. Two different versions of the Realist were produced – fitted with either f3.5 or f2.8 lenses – known as models 1041 and 1042.

For a few years, the Stereo Realist had the market all to itself. However, other companies naturally sought to take advantage of the explosion of interest in stereoscopy. Before long, a dozen or so new stereo cameras had appeared. By the mid-1950s, however, the 3-D boom was to disappear as quickly as it came. Despite declining sales, David White continued with production of the Realist right through the 1960s. Indeed, it was not until 1972 that they finally closed their stereo camera department. By this time, the Realist had been on the market, with little change, for nearly 25 years and an estimated 130,000 had been sold.

The Realist retailed at over $160 (it was never widely available in the UK), twice as much as one of its main rivals, the Kodak Stereo camera, introduced in 1955. Nevertheless, it retained its popularity amongst a small but committed band of stereo enthusiasts.

The Witness

DESIGNED BY GERMAN-JEWISH REFUGEES AND MADE IN BRITAIN, ONLY 350 BEAUTIFULLY CRAFTED BUT EXCEPTIONALLY EXPENSIVE WITNESS CAMERAS WERE EVER PRODUCED.

Immediately after the end of the Second World War, Ilford Ltd decided to re-enter the camera market with a range of models designed to appeal to photographers from beginners right up to serious amateurs and professionals. This decision was probably prompted by a desire to take advantage of the opportunity presented by Board of Trade restrictions at that time that prevented the importation of foreign cameras. However, rather than produce the cameras themselves, Ilford entered into partnerships with a number of established manufacturers. One such partnership led to the development and production of what is, arguably, the finest and certainly one of the rarest post-war British cameras – the Witness.

The Witness was designed by two German-Jewish refugees who had escaped to Britain before the war – Robert Sternberg, who had worked for Leitz, and D.A. Rothschild, who was an ex-Zeiss employee. This combination of backgrounds was to be reflected in the Witness. Although it was developed from scratch and not copied from an existing camera, the Witness blends features of both the Leica and the Contax with Sternberg and Rothschild's own ideas.

In 1947, Rothschild, who had set up a business in Bolton, Daroth Ltd, making spectacle lenses, approached Ilford to finance and market a 35mm camera that he had designed. More by luck than judgement, his timing was perfect and coincided with their decision to develop a range of cameras. Ilford agreed to fund the production of prototypes but this proved to be beyond the capabilities of Rothschild's factory.

'... the finest and certainly one of the rarest post-war British cameras ...'

After several unsuccessful attempts, production was transferred to another company – Peto Scott Ltd of Weybridge, Surrey. This was a precision-engineering firm that specialized in the production of radios and electrical medical instruments. This complex genealogy was evident on the finished production cameras. Nowhere on the camera does the name 'Ilford' appear but a few of the earliest cameras carry the following inscription inside: 'Made by Peto Scott Ltd (Electrical Instruments) for Daroth Ltd, Distributed by Ilford Ltd. British Made.' Although the first prototypes might have been made in 1946, manufacturing difficulties meant that full production didn't begin until 1951 and the first Witness cameras didn't reach the shops until the following summer.

The Witness was a beautifully made camera – a fact that was reflected in its selling price. At over £112 it had the distinction of being the most expensive British camera on the market. The streamlined diecast body is covered with fine-grain leather with satin chrome parts. There is a coupled, coincidence-type, rangefinder with a combined viewfinder and rangefinder eyepiece, a focal-plane shutter giving speeds between one and 1/1000sec, and flash synchronization. For loading, the camera back is fully removable by turning two catches on the baseplate – similar to the system on the Contax. A very few of the first Witness cameras have a Daron 50cm F/2.9 lens but most are fitted with a Dallmeyer 2 inch f/1.9 Super-Six lens. The 39mm interrupted screw mount (a bit like a breech block on a heavy gun) was a combination of screw and bayonet fittings, and would also accept standard Leica lenses.

Production stopped some time in 1953, by which point only about 350 had been produced. All remaining stock was sold off to Dollonds and remaindered at the knockdown price of £80 – much to the annoyance of the original buyers. Ilford responded to complaints with remarkable generosity, refunding £40 to each purchaser.

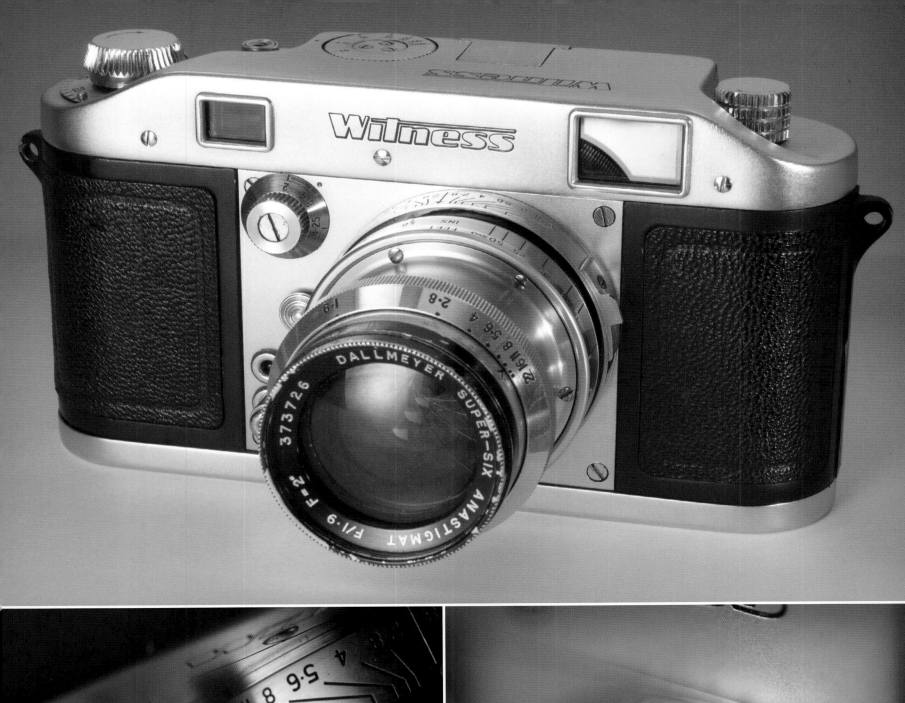

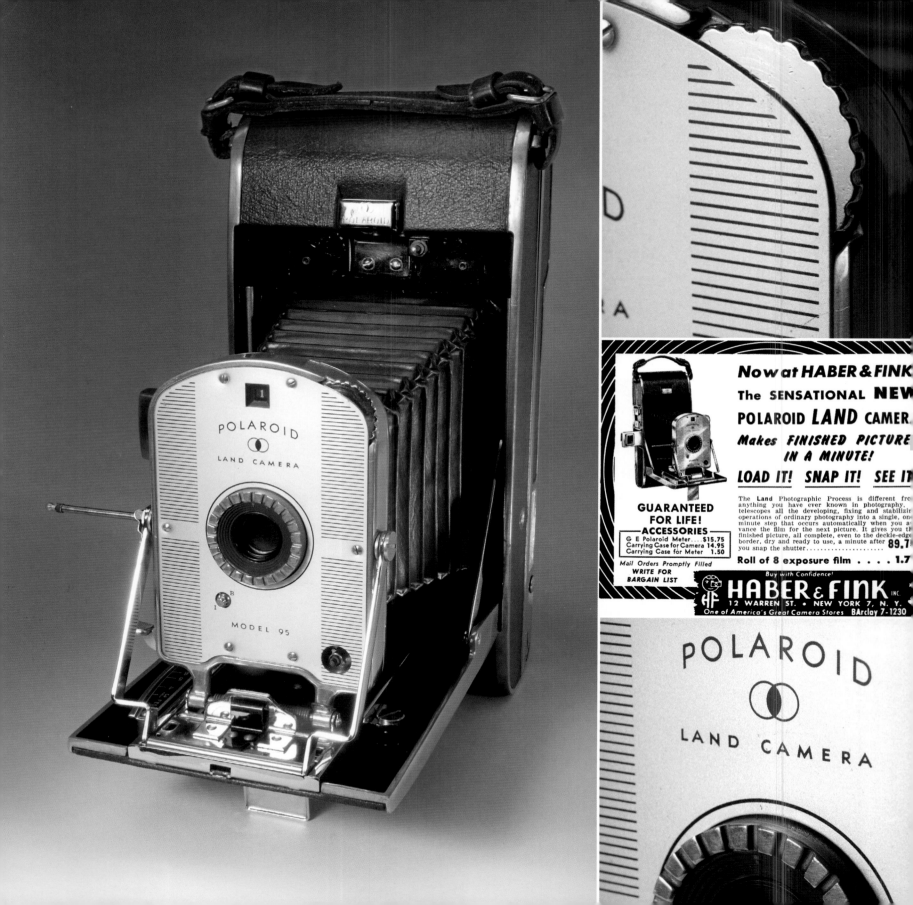

Polaroid Land Camera, Model 95

THE FIRST SATISFACTORY FORM OF INSTANT PHOTOGRAPHY APPEARED IN THE 1940s. IT WAS SOON A HOUSEHOLD NAME, AND ITS INVENTOR BECAME 'THE WORLD'S RICHEST SCIENTIST'.

'His source of inspiration was his three-year-old daughter ... she asked him why she couldn't see a photograph of her which he had just taken ...'

The idea of an 'instant' camera is almost as old as photography itself. The Frenchman Jules Bourdin brought out a commercially successful internal processing camera, named the Dubroni, in the 1860s (see page 36). However, the first fully-satisfactory method of instant photography aimed at the general public didn't appear until the 1940s. Devised by the American scientist and inventor, Edwin Land, its name was to become a household word – Polaroid.

Fascinated by the phenomenon of light polarization, Edwin Land founded the Polaroid Corporation in 1937. During the Second World War, the company prospered as it responded to American government orders for sunglasses, infra-red polarizers, viewfinders and other specialized optical equipment. Even before the end of the war, however, Land was working on a research project that was to transform his already successful business and eventually earn him a place in the *Guinness Book of Records* as 'the world's richest scientist'. His source of inspiration was his three-year-old daughter, Jennifer: in 1944, whilst on a family holiday in Santa Fe, New Mexico, she asked him why she couldn't see a photograph of her which he had just taken: 'As I walked around the charming town I undertook the task of solving the puzzle she had set me. Within an hour, the camera, the film and the physical chemistry became so clear to me.' However, it was to take nearly three years of intensive research before Land was able to demonstrate his one-step system of photography at a meeting of the Optical Society of America in February 1947.

On 26 November 1948 the first Polaroid Land camera, the Model 95, went on sale at the Jordan Marsh department store in Boston. It is a large, heavy (it weighs about 4lb/180kg) camera of conventional folding design, fitted with an f/11, 135mm lens and a shutter giving speeds from 1/8 to 1/60sec. A thumbwheel set in the lens panel controls both aperture and shutter settings. As it is turned, numbers are displayed in a small window above the lens. Each of these numbers indicates an aperture and shutter combination – the lower the number, the greater the exposure – from 1 (1/8sec at f/11) to 8 (1/60sec at f/45).

What made the camera revolutionary was its use of Land's 'Type 40' film. This consisted of two rolls of paper film, one positive and one negative, fitting into the top and bottom of the camera respectively and connected by a paper leader. After exposure, the negative paper was drawn into contact with the positive paper through a set of rollers which burst a pod containing a combined developer and fixer, spreading the solution evenly between the two film layers. The negative image was developed first and the unused silver salts were then converted to a soluble solution which was diffused through to the positive paper where they were reduced to silver, forming a positive image. The whole process took about one minute, after which the two strips of paper could be removed from the camera and peeled apart to reveal the final 3¼ by 4¼ inch (86 x 102mm) sepia-coloured photograph. It wasn't until two years later that black and white Polaroid film first appeared.

The camera was an instant sensation, capturing the imagination of the American public. Sales rocketed and by the time the Model 95 was discontinued in 1953, it is estimated that around 900,000 had been sold. Despite their historical significance, these cameras remain relatively common and are not particularly sought after by collectors.

The Nikon M

NIKON ENTERED THE CAMERA MARKET IN 1948. THEIR SECOND MODEL, THE NIKON M, FOUND FAVOUR WITH PROMINENT AMERICAN PHOTOJOURNALISTS DURING THE KOREAN WAR.

Nippon Kogaku K.K. was formed in Tokyo in 1917. Originally an optical company, it produced a wide range of optical devices for scientific and industrial applications. During the Second World War it was the largest supplier of optical instruments to the Japanese armed forces. As well as binoculars, periscopes and rangefinders, Nippon Kogaku also made photographic lenses under the name 'Nikkor'. All of the lenses supplied for pre-war Canon cameras were Nikkors. It wasn't until after the war that the company they decided to move into camera production.

Because the camera used the so-called Nippon 24 by 32mm format, incompatible with standard slide mounts, exports of the camera were banned by the Allied occupation forces who were still in authority. Only about 750 Nikon Is were made. In August 1949, the Nikon I was discontinued and replaced by a second model, known as the Nikon M. Nikon Ms are easy to identify since the serial number engraved on the camera top plate is prefixed with the letter 'M'. The Nikon M is practically identical to the Nikon I except that it has a slightly larger negative format – 24 by 34mm.

Nikon M cameras gained an international reputation during the Korean War when they were used by several American photojournalists, including photographers for *Life* magazine, who thought they gave better results than German cameras. In 1951, the Nikon M was improved with the addition of flash synchronization and redesignated the Nikon S.

'Since they were already making lenses for 35mm cameras, it seemed a logical step to make a camera to use these same lenses.'

Since the company was already making lenses for 35mm cameras, it seemed a logical step to make a camera to use these same lenses. In late 1945 it set up a research unit to develop a 35mm camera which would be called the Nikolette. Design blueprints were completed by September 1946 but the camera didn't go into production until early 1948. By the time it eventually went on the market it had a different, and now famous, name – Nikon.

For the Nikon I, the designers at Nippon Kogaku had carefully studied the two leading 35mm cameras of the day, the Contax and Leica, and cleverly combined elements of both. Externally, the Nikon I has a strong resemblance to the pre-war Contax II. Internally, however, it is closer to a Leica, with a similar rangefinder and a horizontal-travel focal-plane shutter.

There was some overlap between the two models and there is some confusion as to what exactly constitutes an 'M' or an 'S'. As far as the factory itself was concerned, any camera with flash synchronization was an 'S' – even if the serial number was prefixed with an 'M'. Some collectors, however, believe that any Nikon with an 'M' in the serial number, whether it is synchronized or not, is a Nikon M. This might seem pedantic but changes in nomenclature can have a huge effect on a camera's value amongst collectors. This particular Nikon M is a late production, flash-synchronized model, dating from 1951. It is fitted with a Nikkor 50mm f/1.4 lens. When it was introduced in 1950, this was the fastest 35mm lens in the world. An example of the excellence of Japanese optics, it marked a significant turning point in the gradual reversal of fortunes between the Japanese and German camera industries.

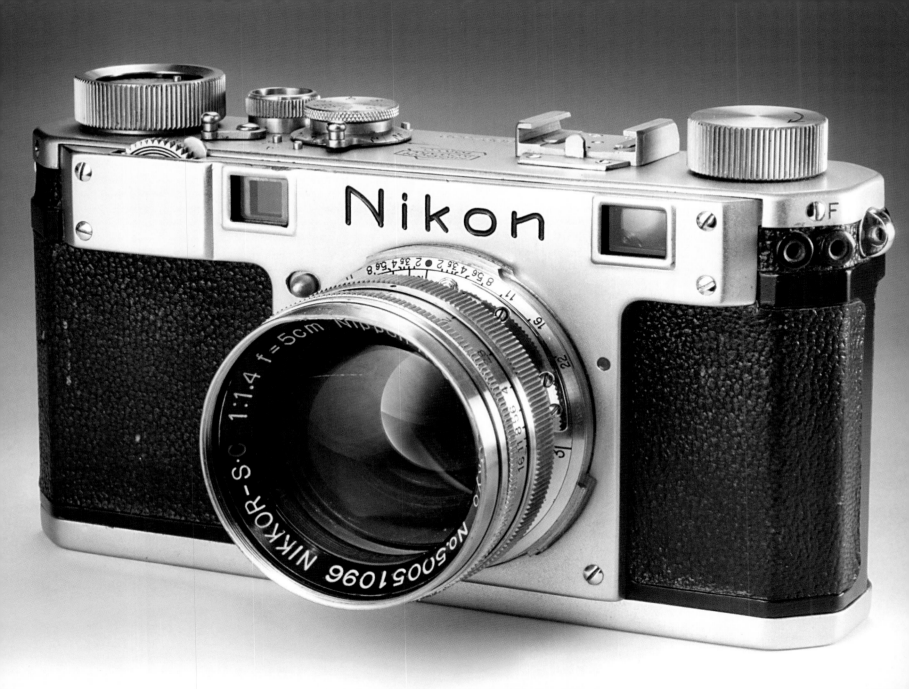

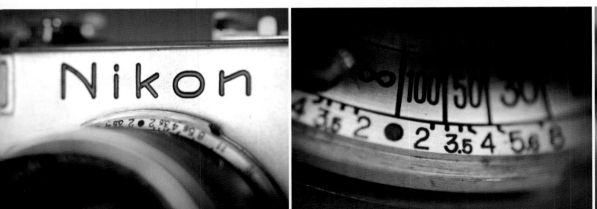

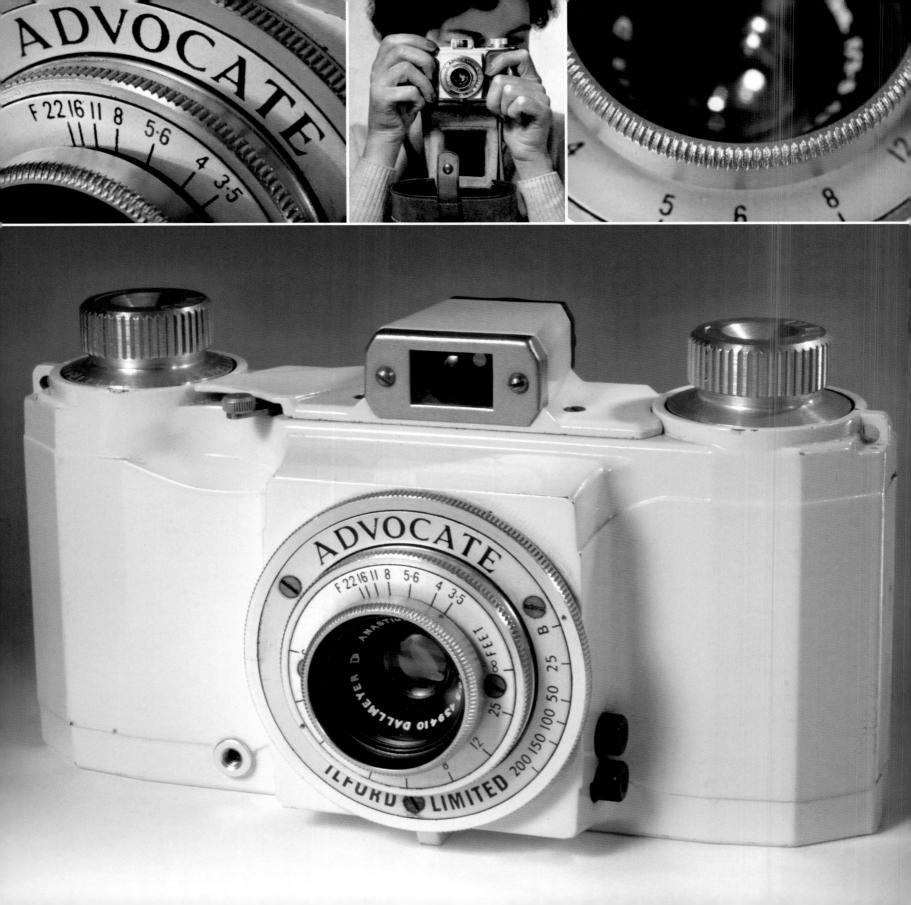

Ilford Advocate

AN AFFORDABLE BUT WELL-MADE BRITISH CAMERA WITH AN IVORY ENAMEL FINISH, THE ADVOCATE WAS PRESENTED AS A WEDDING GIFT TO THE FUTURE QUEEN ELIZABETH IN 1948.

'Undoubtedly one of the most distinctive miniature cameras ever made ...'

Undoubtedly one of the most distinctive miniature cameras ever made, the Ilford Advocate was launched into a post-war Britain of austerity and shortages in a bold attempt to make 35mm photography affordable to the average photographer. The Advocate wasn't Ilford's first foray into the 35mm camera market. In 1946 they had introduced another camera with a name taken from the legal world – the Witness (see page 150). The Witness had an advanced specification but it wasn't a commercial success and probably fewer than 350 were produced. In contrast, the Advocate was much more modest in its aspirations but, ultimately, much more successful.

The Advocate was manufactured by Kennedy Instruments Ltd, a subsidiary of Ilford Ltd run by David Kennedy, an engineer who was an old schoolfriend of James Mitchell, one of Ilford's directors. Its formal launch was at the British Photographic Manufacturers Exhibition held at Olympia, London in May, 1949. A British-made 35mm camera that could compete effectively with foreign competition had been long awaited and the Advocate was enthusiastically received. One reviewer called it 'a landmark in British camera construction'. Ilford's aim had been to produce a quality camera that was precision-made yet still affordable. In this they were clearly successful. *Amateur Photographer* magazine summed the camera up succinctly when they described it as 'low-priced, but quite well made'.

The camera body was made from an aluminium alloy casting that was finished in an unusual and very distinctive ivory stove enamel, such as had been used for scientific instruments for many years.

A second surprise was the lens. The Advocate was fitted with a Dallmeyer f/4.5 lens with a comparatively short focal length of 35mm. This gave an exceptional depth of field – very useful for the average, inexperienced photographer. The wide-angle lens did mean, however, that the Advocate was not really suitable for portrait photography. To paraphrase Ilford's famous advertising slogan, it was a camera for 'places' rather than 'faces'. The shutter gave speeds of 1/25 to 1/200sec and there was a direct-vision optical viewfinder. In 1953, an improved, Series II, Advocate was introduced. The lens aperture was increased to a Dallmeyer f/3.5 (a few, late Advocates were fitted with a Wray Lustrar f/3.5 lens) and flash synchronization was added.

Although aimed primarily at the middle-income bracket photographer, Advocates also found their way into the hands of some of the highest in the land – both figuratively and literally. In March 1948 a pre-production prototype Advocate was presented to Princess Elizabeth and the Duke of Edinburgh by the Borough of Ilford as a wedding gift. Paid for by public subscription, this had solid silver fittings and cost the princely sum of £340.10s. A few years later the camera turned up at the Ilford customer-service department. It had been stolen and had changed hands several times until the unsuspecting current owner sent it in for repair. It was duly repaired and returned to Buckingham Palace. In 1953 Princess Elizabeth was crowned Queen.

That same year, Everest was finally conquered. Once again, the Advocate had a role to play. The expedition team used Advocate cameras to record their assault on the summit – a fact that was exploited to the full by Ilford's advertising department. Ultimately, the Advocate was unable to compete effectively with foreign competition. In 1957, Ilford launched a range of inexpensive 35mm cameras made by Dacora in Germany – the Ilford Sportsman. Production of Advocate cameras ceased soon afterwards.

The Wrayflex

A WASTED OPPORTUNITY FOR THE BRITISH PHOTOGRAPHIC
INDUSTRY, THE WRAYFLEX THAT REACHED THE SHELVES
LACKED MANY OF THE INNOVATIONS ITS DESIGNERS INTENDED.

The Wrayflex is the only commercially successful 35mm SLR camera to have been made in Britain. Few people today, however, have heard of it. The Wrayflex could have been the camera that revolutionized 35mm SLR photography – a camera so ahead of its time that it could have transformed the British camera industry, putting us several steps ahead of both the Germans and the Japanese. Unfortunately, however, the Wrayflex that could have been was very different from the Wrayflex that actually appeared in the shops – an ingenious and well-made camera, certainly, but hardly a world-beater.

Established in 1850, Wray were primarily lens manufacturers and do not seem to have become involved in camera production until the early 1930s. The *British Journal Photographic Almanac* for 1931 carries an advertisement for their recently introduced Farvu camera, designed specially for distance work and fitted with a 20-inch Wray telephoto lens.

The precise origins of the Wrayflex remain unclear but the credit for its design should probably go to two brothers, Harry and Werner Goebbels, former workers in the German camera industry, who came to Britain immediately after the end of the Second World War and were employed by Wray. In 1947 Wray took out a patent for a 35mm SLR camera which incorporated several features that were not to appear on any production camera for several years – a pentaprism viewfinder, through-the-lens metering and motor-drive. Had this camera ever been produced it would have been without any serious rival.

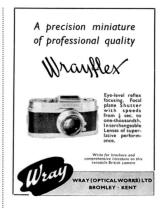

A precision miniature
of professional quality

Wrayflex

Eye-level reflex focusing. Focal plane shutter with speeds from ½ sec. to one-thousandth. Interchangeable Lenses of superlative performance.

Write for brochure and comprehensive literature on this versatile British camera

Wray
WRAY (OPTICAL WORKS) LTD
BROMLEY · KENT

'*Finished in satin*

chrome and

black leather it

has an elegant,

streamlined body.'

However, either because it was impractical or simply too expensive, none of these features appeared on the Wrayflex camera that made it into production a few years later.

The Wrayflex was announced at the British Industries Fair of 1950 and launched the following year. Finished in satin chrome and black leather it has an elegant, streamlined body. As the name implies, the Wrayflex has a reflex, eye-level viewfinder. Crucially, however, it uses a system of mirrors rather than the pentaprism of the original 1947 patent. Using mirrors means that the viewfinder image is the right way up but laterally reversed, left to right. Even more confusingly, if the camera is held on its side to take a portrait-format picture, the image in the viewfinder is upside down. It was estimated, however, that the addition of a pentaprism would have added about £20 to the price of a camera that already cost around £100. The standard lens was a 5cm f/2 Unilite. Additional lenses were a 3.5cm f/3.5 wide angle and a 9cm f/4 long focus.

The first models of the Wrayflex also adopted an unusual negative format – 24mm by 32mm instead of the standard 24mm by 36mm. This meant that at a time of rationing when film was still comparatively difficult to get hold of and expensive, users could get eight extra exposures on a 36-exposure roll. The new format did not meet with universal approval since there were no accessories or projectors that could cope with it. In 1954, Wray introduced a new version, known as the Wrayflex Ia, which reverted to the standard format. The two versions can be distinguished by looking at the film counters – the model I counts up to 44, whilst the Ia only goes up to 36.

In 1959, the Wrayflex II appeared. This was similar to the I and Ia but, crucially, incorporated a pentaprism. Only about 300 Model IIs were produced.

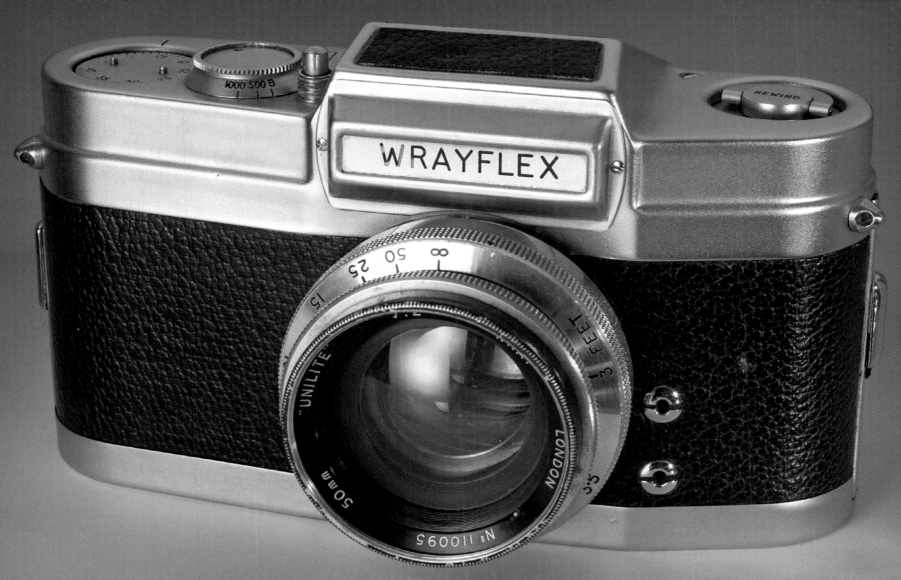

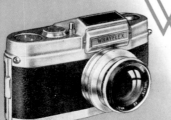

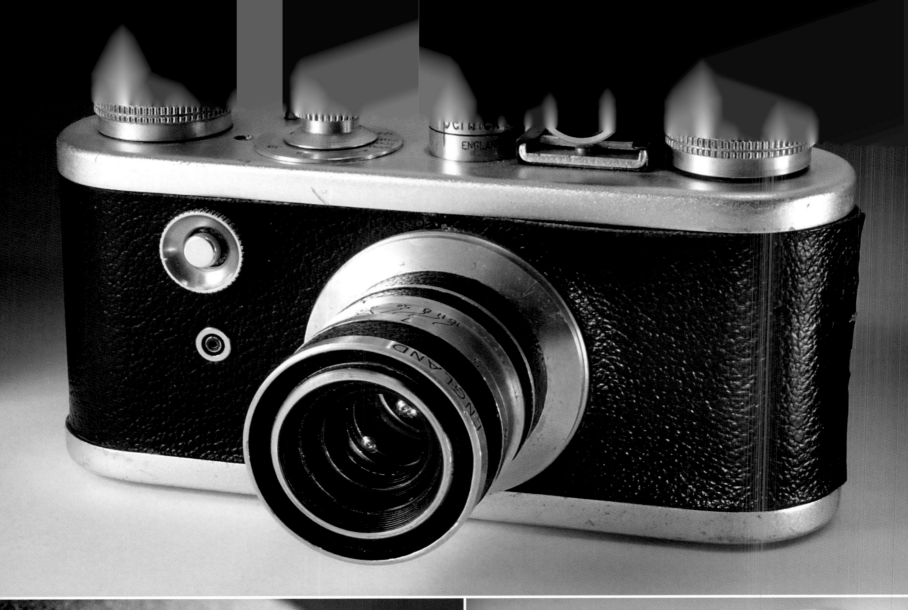

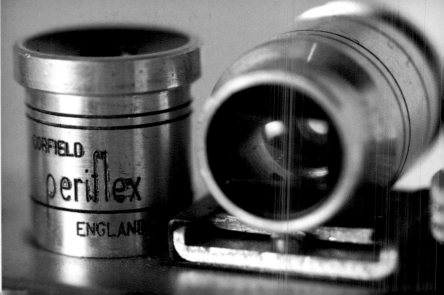

The Periflex

AN INEXPENSIVE BRITISH 35MM CAMERA WITH A UNIQUE PERISCOPE FOCUSING SYSTEM, THE PERIFLEX SHOWED PROMISE BUT SUCCUMBED TO JAPANESE COMPETITION.

During the early 1950s, British imports of quality foreign cameras were severely restricted by the Board of Trade, and it was virtually impossible to acquire a new Contax, Leica or Exakta. Potentially, there was a huge gap in the market for a British-made 35mm camera. Cameras such as the Reid and the Wrayflex were an attempt to satisfy this demand but were too expensive for most people. What photographers wanted was a moderately-priced but precision-made instrument, and this is what they got with the Periflex.

The Periflex was the brainchild of Kenneth Corfield. In 1950, Kenneth and his younger brother, John, had set up a company in Wolverhampton to produce a successful enlarging exposure meter that they had designed, called the Lumimeter. A range of other popular accessories followed but Corfield's real ambition was to produce a camera. At first, he toyed with the idea of designing a 16mm sub-miniature camera but later abandoned this since he felt the real future of the market lay with 35mm. Even though camera bodies were unobtainable, there were lots of secondhand Leica lenses on the market. The Periflex was designed to accept German optics and was conceived initially as an inexpensive second body for Leica photographers. Gradually, however, the camera was seen as a 'stand alone' camera aimed at a much wider market.

A prototype appeared in 1952 with a focal-plane shutter and Leica thread but without a viewfinder or any means of focusing. Some form of focusing was clearly essential. However, the manufacture of a coupled rangefinder was beyond the capabilities of the modest Corfield factory.

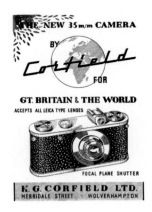

THE NEW 35m/m CAMERA BY Corfield FOR GT. BRITAIN & THE WORLD
ACCEPTS ALL LEICA TYPE LENSES
FOCAL PLANE SHUTTER
K. G. CORFIELD LTD.
MERRIDALE STREET · WOLVERHAMPTON

'What photographers wanted was a moderately-priced but precision-made instrument, and this is what they got with the Periflex.'

An alternative would have been a single-lens reflex design, but the camera body was too slim to take a reflex mirror and this would have required a complete re-design, a lot more capital investment and, crucially, more time. The solution lay in an ingenious compromise, which resulted in one of the most unusual design features of any camera and which was also to provide the camera with its name. Focusing was achieved by using a small periscope that was pushed down into the film plane and gave a magnified image of part of the subject to be photographed on a ground glass screen. A PERIscope provided reFLEX viewing – hence the name, Periflex.

The Periflex went on sale in May 1953, just in time for the Coronation and the ideal time to launch a new British-made camera. Advertised as 'The new 35mm camera by Corfield for Great Britain and the world', the Periflex was an immediate success with demand far outstripping the factory's limited production capacity of around 30 units a week. As well as its unique periscope focusing, the camera had a focal-plane shutter giving speeds of 1/30 to 1/1000sec, flash synchronization and interchangeable optical viewfinders. It was compatible with Leica lenses, but Corfield had also designed a lens for the Periflex – a 50mm f/3.5 lens named the Lumar and produced by the British Optical Lens Company in Walsall. The camera sold for around £20 – body only, or £30 with lens.

The first Periflexes were covered with brown pigskin. This proved to be impractical, however, and was soon replaced by more traditional black leatherette. Only about 200 pigskin-covered examples were made and these are now highly sought after by collectors. Other design changes also followed. In 1955, the original black top and base plates were replaced by a silver anodized version with a re-designed lens mount. The original – or Periflex I – camera was discontinued in 1957 but other, more sophisticated, models such as the Periflex Gold Star appeared until the early 1960s when Corfield, faced with increasing competition from Japan, decided to cease production.

The Reid

THIS 'BRITISH LEICA' WAS BASED ON GERMAN PATENTS AND

DESIGN DRAWINGS CONFISCATED BY THE ALLIES AFTER

THE SECOND WORLD WAR.

'The Reid III was

a copy of the

pre-war Leica IIIb.'

No other camera has been imitated as much as the Leica. Since the 1930s, over 200 copies of Oscar Barnack's revolutionary camera design have been produced. Some are good, some bad, and some indifferent. Only one, however, is British – the Reid.

During the Second World War British amateur photographers were asked to give up their German-made cameras to help the war effort – German cameras were so evidently superior to their home-produced counterparts that only Leicas, Contaxes and Super-Ikontas were deemed good enough to be supplied to our armed forces. At the end of the war, the government was determined that it should not be placed in this embarrassing position again. The victorious allied powers confiscated all German patents registered abroad by means of the Control Council Law of October 1945 and in the London Agreement of the following year, each member government committed itself to making all registered German patents freely available. The Leitz factory at Wetzlar was in the British zone of occupation and all its machine tools, design drawings and spare parts were available for detailed inspection and appropriation.

Some time in 1946 it was decided that a 'British Leica' should be produced for use by the armed forces. Sir Stafford Cripps, who had been Minister of Aircraft Production during the war, approached a Leicester-based firm that he thought would be ideal for the task – Reid & Sigrist. Reid & Sigrist Ltd was founded after the First World War by Major G.H. Reid. Reid had been a pilot during the war and knew the importance of having high-quality, reliable flying instruments.

Reid & Sigrist were a small engineering company making precision aviation instruments to the highest standards. During the Second World War, their products and expertise were in tremendous demand. When the war ended, however, they faced a difficult period of adjustment. It was precisely at this time that Cripps, who clearly knew of their reputation from his war time role, contacted them with the suggestion that they should turn their attention to camera production. Although none of Reid's workers had any experience of making cameras, they were highly-skilled engineers and, with the wealth of material available to them, they managed to produce six hand-made prototypes that were exhibited at the British Industries Fair in May 1947. It was to be four frustrating years, however, before the first Reid cameras actually arrived in the shops.

The Reid III was a copy of the pre-war Leica IIIb camera, with a coupled rangefinder and a focal-plane shutter giving speeds from 1sec to 1/1000sec. Interestingly, it is not an exact copy, since it was designed in imperial rather than metric measurements. The only metric dimension is the 39mm screw thread which is compatible with Leitz lenses. The standard lens was a Taylor, Taylor Hobson, 2 inch, f/2. In 1954, an improved model, the Reid IIIa, with flash synchronization was introduced. This is the most common of all Reid cameras and the one which turns up most regularly for sale.

Some time between 1954 and 1958, the Reid I appeared. This was essentially a Reid III, but without the rangefinder. True to the camera's original purpose, this model was produced for the army rather than for public sale. Practically all Reid Is carry some form of government supply markings, such as a characteristic broad arrow. It is not known exactly when Reid & Sigrist discontinued camera production but it is thought to be around 1964. Certainly, it had stopped by 1970, when the business was taken over by the record company, Decca. Over a period of about 15 years, only around 2,000 Reid cameras had been produced, making them highly-collectable and desirable.

35 mm. Precision
THE REID CAMERA
and 35 mm.
ENLARGER

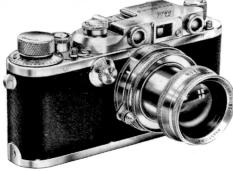

The REID 35 mm. High Precision Camera is manufactured in the works of Reid & Sigrist Ltd., where famous instruments have been made for many years.

LENS. Specially designed by Taylor, Taylor & Hobson Ltd. of Leicester. f/2—5 cm. anastigmat lens coated on all glass-to-air surfaces. Other focal lengths are in course of development.

RANGE FINDER. Twin sighting range and view finder. Range finder coupled to lens.

SHUTTER. Focal Plane shutter with speeds 1 to 1/1000 sec.

The R. & S. 35 mm. Enlarger is available for early delivery and is designed for precision camera users who demand the utmost efficiency.

- One-hand quick release positive locking grip.
- Adjustable anti-friction device.
- 40 in. Ground column—chromium plated.
- Precision focussing.
- Glassless, scratch-free negative carrier.
- New T.T.H. "Ental" or Ross "Resolux" enlarging lenses can be supplied.

Manufactured by REID AND SIGRIST LIMITED
BRAUNSTONE WORKS . BRAUNSTONE . LEICESTER . ENGLAND

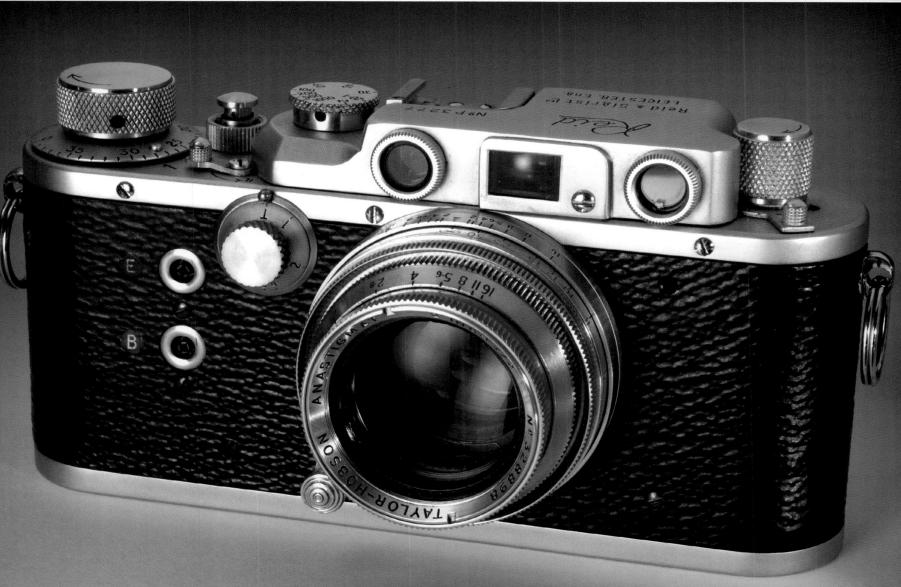

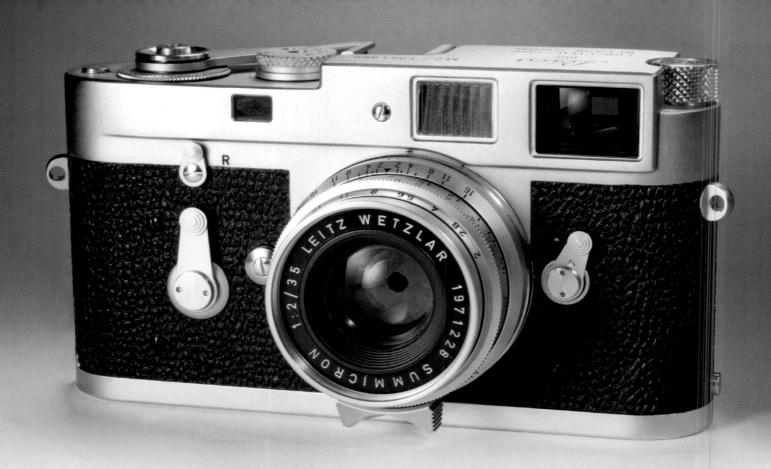

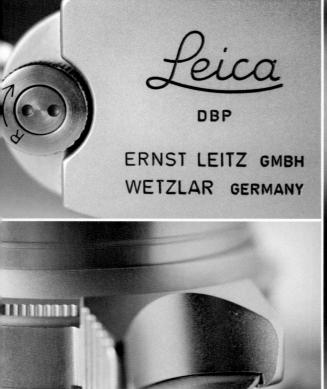

The Leica M3

THE RESULT OF A RADICAL REDESIGN, LEICA'S M3 CAMERA FIRST APPEARED IN 1954 TO WIDESPREAD CRITICAL ACCLAIM. EVEN TODAY IT REMAINS AN ICONIC OBJECT OF DESIRE.

In 2006, *Stuff* magazine asked their readers to vote for 'the top gadget of all time'. Among the top ten gadgets were contenders such as the Apple iPod and the first Sony Walkman. However, perhaps surprisingly considering the average age of the magazine's readership, the eventual winner was the oldest item in the competition – a camera that first appeared over 50 years ago, the Leica M3.

In 1954, almost 30 years after the first Leica had appeared, Leitz caused a stir in the photographic world by introducing a new camera which represented a complete rethink of their product range. The new camera was shown for the first time at the Photokina trade fair held in Köln. Until then, successive Leica cameras, whilst incorporating various improvements, clearly followed the same basic design. Work on a radical re-design had actually begun in the mid-1930s but the Second

So that owners of screw-mount lenses could continue to use them on the new camera, a range of bayonet adaptors was introduced.

As with earlier Leicas, the film was still loaded through the base of the camera. However, the M3 had a hinged door in the back which made loading easier. The shutter gave speeds from 1 to 1/1000sec and was set by a single speed dial rather than the separate fast and slow speed dials on earlier models. The film was wound by a lever rather than the knob that had previously been used on Leicas. Up to 1958, the lever wind required two strokes to advance the film one frame; that year this was changed to one. Because of this, M3s are sometimes described as 'double stroke' or 'single stroke'. A new, parallax-corrected viewfinder system had bright line frames which corresponded to the angle of view of 50mm, 90mm and 135mm lenses. The appropriate frame appeared automatically as different focal-length lenses were attached to the camera.

Around 250,000 Leica M3s were produced between 1954 and 1966. Most have a chrome finish but a few were produced in black. These are sought after by collectors and command much higher prices. Unsurprisingly, fake black M3s are not uncommon.

'... the M3 represented a major departure and its totally redesigned body incorporated several significant changes ...'

World War, followed by post-war devastation and reconstruction, meant that it wasn't until 1954 that the new camera was ready to be launched. When it finally did appear, the M3 represented a major departure and its totally redesigned body incorporated several significant changes from earlier models. *The British Journal of Photography* felt that 'This camera meets the most stringent demands that professionals and serious amateurs can make on modern photographic equipment.' In the M3, the traditional 39mm screw lens mount was replaced by a bayonet mount.

In 1958, a simpler and less expensive version of the M3 was introduced, called the M2. This had most of the features of the M3 but had a viewfinder with frames for 35, 50 and 90mm lenses instead of the 50, 90 and 135mm frames of the M3. The M2 was also long-lived, remaining in production until 1967.

In 1959, the M2 was followed by an even simpler version, the M1, without a coupled rangefinder. The Leica M series continues to this day, the latest model being a digital camera, the Leica M8, introduced in 2006.

The Nikon F

THE CORNERSTONE OF NIKON'S FAMOUS SYSTEM OF CAMERAS, LENSES AND ACCESSORIES, THE FAST AND FLEXIBLE NIKON F COULD DO NO WRONG. IT EVEN MANAGED TO STOP A BULLET.

Founded in Tokyo in 1917, Nippon Kogaku became Japan's leading manufacturer of optical instruments. During the Second World War, they supplied most of the optical equipment used by the Japanese armed forces. After the war, in an attempt to broaden the market for their products, they decided to go into camera production. In 1946, having carefully studied the finest 35mm cameras of the time – the Contax and Leica – they introduced their first camera, a 35mm rangefinder model which they named the 'Nikon', from NIppon KOgaku.

During the 1950s, Nippon Kogaku launched a number of rangefinder cameras that enjoyed a growing reputation. Many photojournalists covering the Korean War were particularly impressed with the results obtained using Nikon lenses. All staff photographers on *Life* magazine, for example, used cameras fitted with Nikkor lenses. In 1959, responding to the growing popularity of single-lens reflex cameras, Nippon Kogaku introduced their first 35mm SLR, the Nikon F – the first 'truly modern' SLR and one of the most influential cameras ever produced.

In terms of design, the Nikon F was very similar to its rangefinder antecedents, with the obvious exception of its reflex viewing and focusing mechanism. The inspiration of the Contax is still evident, particularly in the body shape. Crucially, the Nikon F incorporated a number of features, now taken-for-granted, which first appeared in other manufacturers' cameras – a pentaprism (Contax S, 1948), instant-return mirror (Asahiflex IIB, 1954) and an automatic diaphragm (Zunow, 1958).

'... the first "truly modern" SLR and one of the most influential cameras ever produced.'

A focal-plane shutter consisting of two titanium foil blinds gives speeds from 1 to 1/1000sec. The Nikon F doesn't have a built-in metering system but from 1962, 'Photomic' accessory pentaprism viewfinders were available which incorporated an integrated exposure meter for through-the-lens metering.

The Nikon F camera body was the heart of a complete professional camera system. The concept of the 'system camera' had been pioneered by Leitz and Ihagee, but Nikon brought it forward a quantum leap. As well as an array of bayonet-mount lenses from 21mm to 1,000mm, there was a host of accessories for every conceivable photographic task. A battery-powered motor drive meant that you could shoot at up to four frames a second.

The Nikon F quickly became THE camera of choice for the professional photographer, enjoying an unrivalled reputation for flexibility and reliability. Comparatively light and compact, it seemed able to withstand just about anything that was thrown at it. Famously, when Don McCullin was photographing the Vietnam War in 1970, his Nikon F actually managed to stop a bullet.

The Nikon F remained in production from 1959 until 1974, during which time around 800,000 were sold. It was the first of the famous F-series that continues to this day – F2 (1971), F3 (1980), F4 (1988), F5 (1996) and F6 (2004). Will there be an F7, or have we reached the end of the line for a photographic legend?

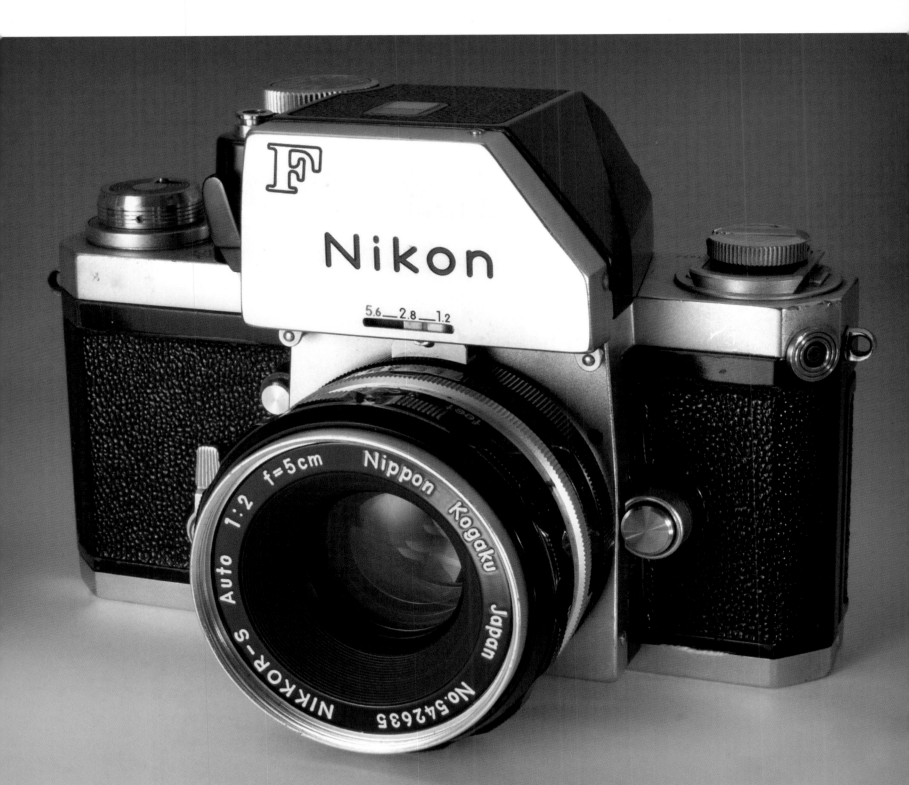

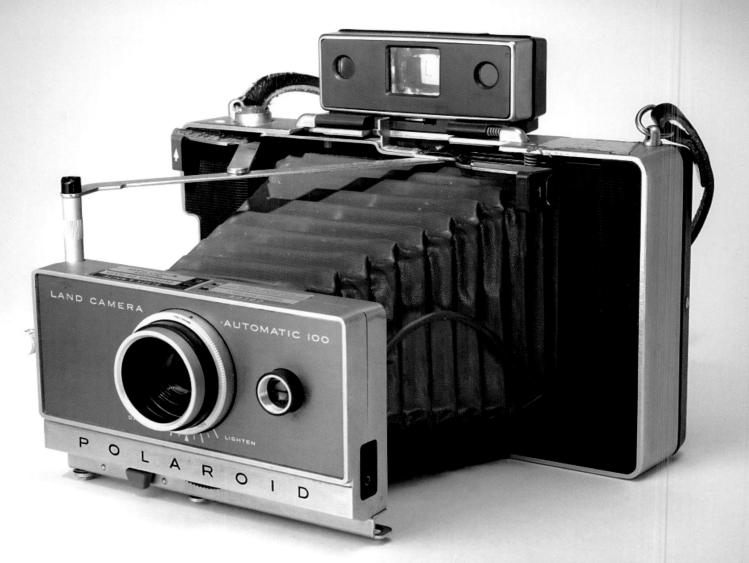

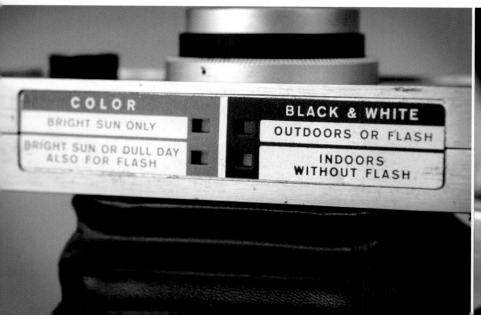

Polaroid Land Automatic 100

THE AUTOMATIC 100 INCORPORATED TRANSISTOR TECHNOLOGY, COLOUR CAPABILITY AND FILM PACKS FOR SIMPLIFIED LOADING. INSTANT PHOTOGRAPHY HAD NEVER BEEN EASIER.

In 1948 Edwin Land introduced the first Polaroid 'instant' print camera – the Polaroid Land camera Model 95 (see page 152). Over the next few years, new models of Polaroid cameras appeared at regular intervals and within ten years the one-millionth Polaroid Land camera had been sold. Reflecting Edwin Land's ever-fertile mind, Polaroid cameras were notable for their innovative use of new technology. Introduced in 1963, the Automatic 100 embodied two important innovations. It was the first camera to have a fully automatic (hence the name) electronic shutter, and it was also the first camera to take Polaroid film packs rather than roll film.

The Automatic 100 was one of the first cameras to incorporate a device that had only recently begun to be introduced into consumer electrical goods – the transistor. Its transistor-controlled shutter was paired with a battery-powered CdS cell, giving continuously variable speeds from 1/1200sec up to 10 seconds in low light. The three-element, 114mm lens had six aperture settings from f/8.8 to f/42 which changed to correspond with two film-speed settings – 75 ASA for colour film and 3000 ASA for black and white. Automatic exposures were also possible with flashbulbs. Focusing was by means of two levers which moved the bellows in and out. The camera had a coupled rangefinder and a parallax-corrected viewfinder. Polaroid advertised it as 'The world's most advanced camera ... The smallest, lightest camera that Polaroid has ever made, it actually weighs less than many well-known 35mm cameras.' (It weighed 2½lbs/1.33kg!)

'Black and white prints, depending on the temperature, took about ten seconds to process.'

The first generation of Polaroid cameras used roll film. The Automatic 100 was the first Polaroid camera to take film packs (for eight exposures), which greatly simplified loading. Unlike earlier models, development took place outside the camera before the negative and positive sheets were peeled apart.

In January 1963 Polaroid had introduced Polacolor – their first film for instant colour prints. Black and white prints, depending on the temperature, took about ten seconds to process. Colour prints were considerably slower, taking about 50 seconds.

In its review of the camera, *Amateur Photographer* magazine concluded: 'In short, the Automatic 100 is a modern miracle, especially in conjunction with the colour film ... After using this system for a while one realizes that 'instant pictures' are really normal and it is a conventional waiting system which is abnormal! There are problems and keen photographers would like a re-usable colour negative and the non-expert often finds the cost too high, but there is no doubt about the fun of using this camera and the pleasure the pictures bring to others.'

As the review suggested, miracles don't come cheap, and the Automatic 100 was no exception. The camera cost a whopping £115 and a pack of Type 108 Polacolor film nearly £3 (Type 107 black and white film was a bit cheaper at £1.13s.11d).

Olympus Pen F

FITTING 72 EXPOSURES ON A 36-EXPOSURE ROLL WAS AN

ATTRACTIVE PROPOSITION IN THE CASH-STRAPPED 1970s.

OLYMPUS ROSE TO THE CHALLENGE WITH THE PEN F SLR.

The majority of 35mm cameras produce 24mm by 36mm negatives. This format was first introduced in the Simplex camera of 1914 and later popularized by the success of the Leica. However, many of the earliest 35mm cameras took negatives half this size (18 x 24mm), which was the standard frame size for cine film. This format became popularly known as 'half-frame' (Technically, of course, this is a misnomer since 18 x 24mm should be called 'single-frame' and 24 x 36mm, 'double-frame.' During the 1960s and 1970s, half-frame cameras enjoyed a brief revival of popularity. Improvements in film emulsions reduced the quality concerns about smaller negatives and, at a time of comparatively high film prices, the potential savings from getting 72 exposures from a standard 36-exposure roll seemed very attractive.

In 1959, Pentacon introduced their Penti camera which took half-frame exposures on 35mm film in 'Karat' rapid-loading cassettes. That same year, in what was to prove a far more significant move, Olympus introduced the first model of what was to become far and away the most popular series of half-frame cameras.

The first Olympus Pen was followed by no fewer than eighteen other models over a period of over twenty years. The last model, the Pen EF, appeared in 1981, by which time over 15 million had been sold. Many other manufacturers, particularly in Japan, also produced half-frame cameras, but none of them embraced the concept as enthusiastically as Olympus. Significantly, it was Olympus alone that combined the popularity of the format with consumer demand for an SLR camera to produce the world's first half-frame SLR camera — the Olympus Pen F.

The Pen F, introduced in 1963, looks very different to a conventional 35mm SLR. An extremely compact, streamlined little camera, the top plate is smooth and shows no sign of the tell-tale bump that houses the pentaprism on most SLRs. To keep the camera as small as possible, the Pen F doesn't use a pentaprism, but instead incorporates a vertically pivoted mirror and a 'porro-prism' (named after its inventor, the nineteenth-century Italian optical instrument maker Ignazio Porro) to reflect the light from the lens to the viewfinder. The shutter is also unusual — a focal-plane rotary shutter made of titanium foil which gave speeds from 1sec to 1/500sec. The Pen F was a system camera, sold with a wide range of accessories and seventeen different lenses, from 20mm to 800mm.

The Pen F did not have a built-in exposure meter. A clip-on external meter was available as an accessory but this rather clunky looking device ruins the smooth look of the camera.

'... the Pen F doesn't use a pentaprism, but instead incorporates a vertically pivoted mirror ...'

Designed by the legendary Yoshihisa Maitani (who would later go on to design the OM series), the camera's name was inspired by the idea of creating a camera that was as convenient to carry and as easy to use as a writing implement — a 'pen'.

In 1966, an improved version, the Pen FT, was introduced with a built-in CdS meter, available in both chrome and black finish. A third model, the Pen FV, was produced from 1967 to 1970. The rarest of the three models, only about 45,000 were made, compared to nearly half a million Pen Fs and Pen FTs.

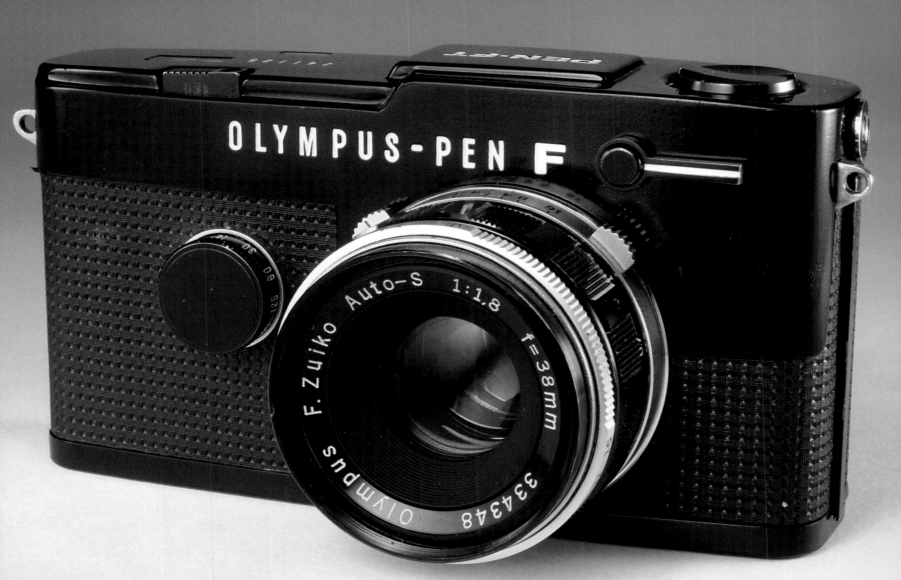

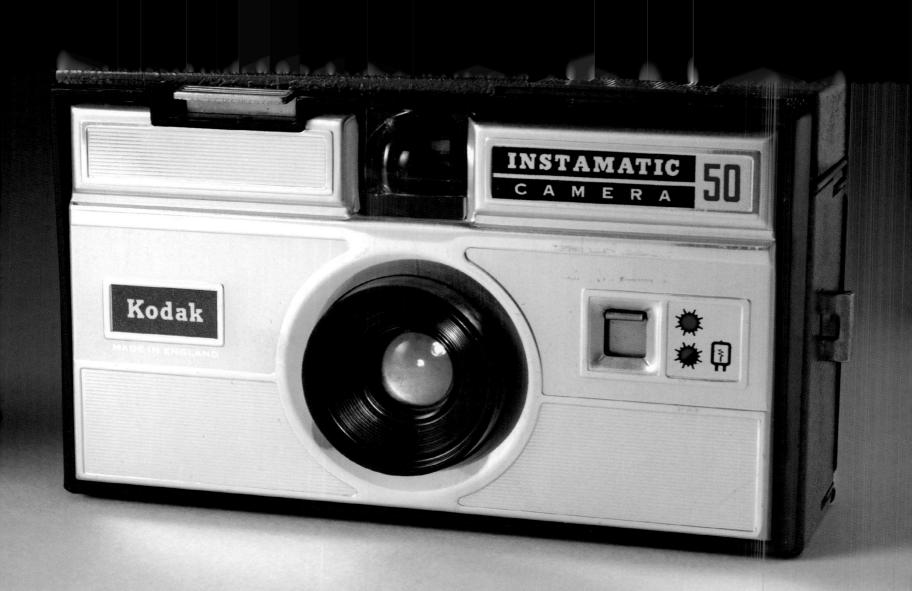

 Kodak

'INSTAMATIC' 50 CAMERA

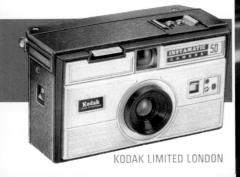

KODAK LIMITED LONDON

LOAD INSTANTLY
AUTOMATICALLY
BETTER PICTURES SO EAS

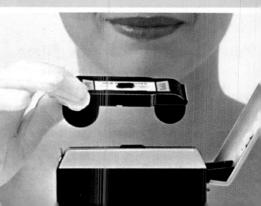

The Instamatic 50

'NO MORE THREADING, NO FUMBLING': KODAK'S INSTAMATIC CAMERAS AND KODAPAK CARTRIDGES TOOK THE UNCERTAINTY OUT OF PHOTOGRAPHY AND PROVED AN UNRIVALLED SUCCESS.

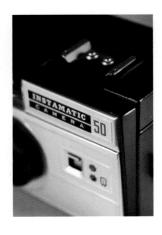

'... this innovative

little camera

brought about

a transformation

in popular

photography ...'

To most people, the phrase 'classic camera' conjures up a picture of gleaming chrome or polished mahogany, not cheap plastic cameras, produced in their millions. And yet, I would argue, if any camera deserves the sobriquet 'classic' it is the humble Instamatic. Launched by Kodak in 1963, this innovative little camera brought about a transformation in popular photography every bit as dramatic as that heralded by the appearance of the very first Kodak camera 75 years earlier.

Loading cameras with film made many snapshot photographers very anxious: if not done correctly, the film might not wind on or it might be accidentally exposed, so many amateur photographers left the loading and unloading of their camera to the photo dealer. The Instamatic solved this problem by incorporating a revolutionary new system of film loading – the 'Kodapak' film cartridge. The concept of a drop-in film cartridge was not in itself new. As early as 1906, the Ticka watch camera (see page 88) used the same idea and the Minox camera of 1938 (see page 130) also used special drop-in cassettes. However, by the 1960s improved techniques of plastic moulding meant that it was possible to mass-produce a film cartridge cheaply but also with a high degree of accuracy.

The plastic Kodapak cartridge contained 35mm-wide film (designated '126' film) with a single registration perforation for each frame. The film was backed with black paper, on which the exposure numbers were printed. These, together with film type information could be viewed through a window in the camera back. To load the camera, the back was opened and the cartridge simply dropped in.

Since it was asymmetrical, there was only one way that the cartridge would fit – the correct way. 'No more threading, no fumbling' the advertisements proclaimed, 'you can load an Instamatic camera in three seconds flat – and in broad daylight' – a natural extension of Kodak's philosophy of making photography as simple as possible, which can be traced back to George Eastman's famous advertising slogan 'You press the button, we do the rest.'

In February 1963, Kodapak film was introduced with a range of four new 'Instamatic' cameras – 50, 100, 300 and 400. The Instamatic 50 was the most basic, entry-level camera, with a specification similar to that of a basic box camera of the time. Indeed, the success of the Instamatic sounded the death knell of the traditional box-form Brownie camera after more than sixty years. The Instamatic 50 was a lightweight, compact, plastic-bodied camera fitted with a 43mm, f/11 fixed-focus lens giving a depth of field of four feet (1.2m) to infinity and an optical direct-vision viewfinder. The shutter had two speeds – 1/40sec for bright sun and 1/90sec for cloudy and flash photography – selected by a lever on the front of the camera and marked by symbols. Unlike the more advanced models of Instamatics, there was no built-in flash. Instead, there was a special hot shoe for a Kodak Instamatic Flasholder that could be bought as an accessory.

In 1963, the Instamatic 50 sold for £2.15s.3d – more than twice the cost of a basic Brownie 127 camera. However, the combination of convenience and simplicity made it an immediate commercial success and over 60 different Instamatic models eventually appeared. The Kodak Instamatic camera range became the most successful in the history of photography, with around 70 million made and sold. Many other manufacturers produced cameras designed to take 126 cartridge film, although, technically, only those made by Kodak can be called 'Instamatics'. In 1972, Kodak extended the drop-in cartridge concept to a smaller format with their range of Pocket Instamatic cameras taking 110 film.

The Canon Pellix

THE PELLIX'S FIXED MIRROR WAS A BRAVE ATTEMPT TO OVERCOME THE DRAWBACKS OF THE CONVENTIONAL SLR. SADLY, THE MAINSTREAM MARKET WASN'T INTERESTED.

'The Pellix was fitted with a pellicle – a thin, semi-transparent, semi-reflecting membrane ...'

Outwardly, with its typical pentaprism viewfinder housing, the Canon Pellix looks like a perfectly conventional 35mm SLR of the 1960s. On the inside, however, it is very different. Most SLRs use a 45-degree mirror to reflect light passing through the lens to the viewfinder – hence the term 'reflex'. To make the exposure, this mirror flips up, allowing light to reach the film, and then drops down again. This system, whilst almost universally adopted, isn't without its drawbacks. When the mirror moves, it causes viewfinder blackout and it can also cause camera shake, particularly at slow shutter speeds. The Canon Pellix, launched in 1965, avoided these problems by using a permanently fixed, semi-reflecting mirror.

The Pellix was fitted with a pellicle – a thin, semi-transparent, semi-reflecting membrane (in the case of the Pellix only 0.02mm thick). The camera gets its name from a combination of PELLIcle and refleX. Pellicles were not a new idea in camera design. They were commonly used in one-shot colour cameras of the 1930s designed to produce colour-separation negatives. However, the Pellix was the first 35mm SLR to incorporate one. The pellicle mirror both reflects and transmits light; some light is reflected to the viewfinder and the rest passes through it to reach the film – with no moving parts.

The Pellix was also the first Canon camera to have through-the-lens metering. By pushing a lever on the front of the camera, a cadmium sulphide (CdS) cell on a hinged frame was brought into position between the pellicle and the shutter.

The shutter was made from titanium foil rather than the usual cloth, probably to prevent the possibility of sunlight burning a hole in it after passing straight through the pellicle.

The first model of the Pellix was made until 1966 when it was superseded by a new version, the Pellix QL. The 'QL' stood for 'Quick Loading' – Canon's system for easy film loading. The film cassette was dropped into position and the leader pulled out until it reached a red mark. Then, when the camera back is closed the film is automatically wound on to the take-up spool as the lever wind is operated.

So, why don't all SLRs use pellicles? No vibration, no blackout; it sounds too good to be true and, of course, it is. The major drawback of the Pellix system is that the light passing through the lens has to do two jobs at once. The pellicle only reflects about one third of the light to the viewfinder, so the viewfinder image is much dimmer than with conventional SLRs. There is also a corresponding reduction in the amount of light reaching the film, since the pellicle only allows about two-thirds of the light to pass through it. Canon attempted to minimize this problem by fitting a faster than normal standard lens – an f/1.2 as opposed to the more usual f/1.8 or f/1.4.

No further models of the Pellix were produced. However, despite its comparative commercial failure, the concept of the pellicle SLR hasn't been abandoned. It is particularly useful for high-speed photography since it does away with the engineering problems associated with extremely rapid mirror movements. Canon revived the idea for their F1 High Speed camera of 1972 and their EOS RT of 1989.

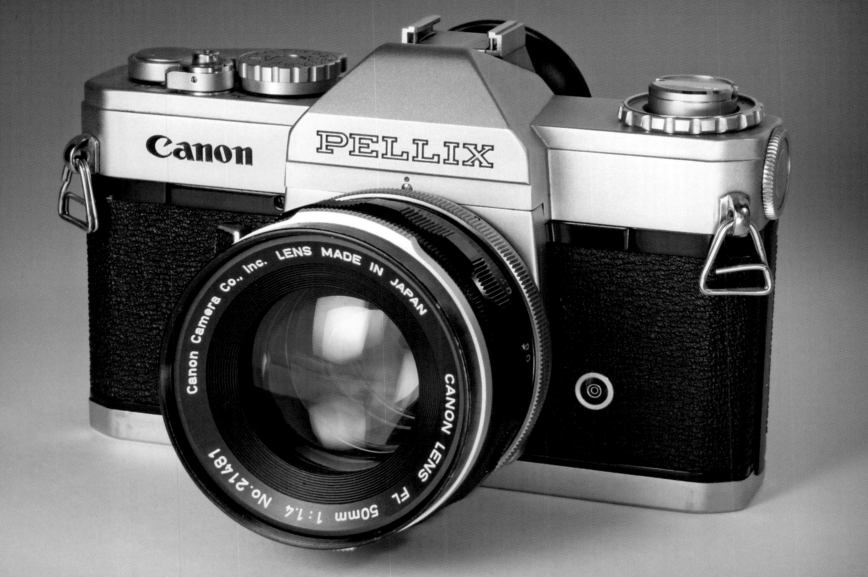

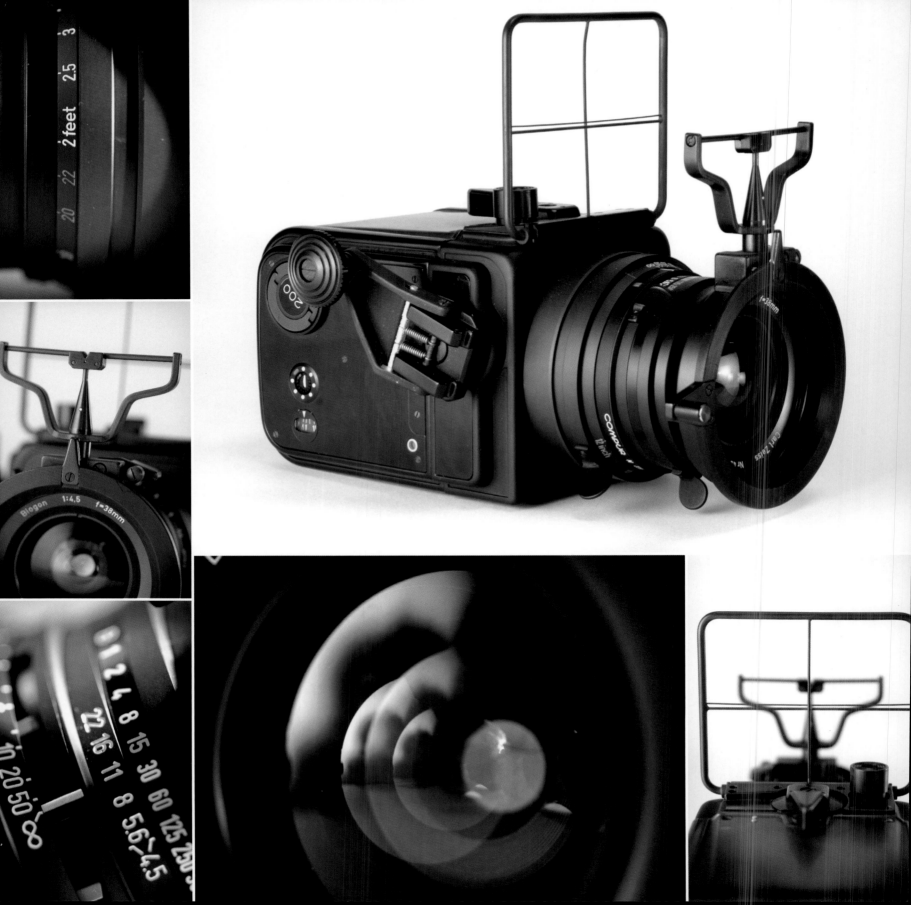

Hasselblad Lunar Surface Camera

WITH THEIR ORIGINS IN MILITARY TECHNOLOGY, HASSELBLAD CAMERAS WERE THE OBVIOUS CHOICE TO ACCOMPANY NASA ASTRONAUTS TO THE MOON. SOME OF THEM NEVER RETURNED.

One of the most significant post-war developments in the history of the SLR camera was the appearance of the Hasselblad camera in 1948. The origins of the Hasselblad can be traced back to the Second World War. In 1940 the Swedish government asked a 34-year-old Gothenburg-based engineer named Victor Hasselblad whether he could make an exact copy of an aerial camera which had been recovered from a German surveillance plane that had crashed on Swedish soil. Victor is famously reported to have replied: 'No, but I can make a better one.' The first non-military Hasselblad camera, the Hasselblad 1600F, launched in October 1948, was based on Victor's innovative design for an aerial camera. The most important feature of the Hasselblad camera was its interchangeable film magazine. The 120 roll-film for 60mm square negatives was held in a detachable roll-holder which could be quickly and easily attached to and removed from the camera, allowing different films (for example, colour and black and white) to be used in rapid succession without losing a single frame.

Other refined and improved models soon appeared – the 1000F in 1952 and the 500C in 1957. Hasselblad cameras soon gained a worldwide reputation for quality of construction and reliability. This reputation was to receive its most famous test when Hasselblad cameras were chosen by NASA for use in space. Hasselblad's role in the US space programme began in 1962.

'Hasselblad cameras soon gained a world-wide reputation for quality.'

The first American in space, John Glenn, took along a modest Ansco-Autoset camera. The results, predictably enough, were not very impressive. The third American to go into space, Walter Schirra, who was a keen amateur photographer, suggested using a Hasselblad instead. A 500C camera was bought from a photo store in Houston, Texas, and modified by NASA technicians for use on the Mercury mission in October 1962. The mirror mechanism was removed and a simple direct-vision viewfinder fitted. The vinyl covering was also removed and the camera body and chrome surfaces painted black, and the controls were enlarged to make them easier to operate when wearing gloves. The superb quality of the photographs taken by Schirra convinced NASA to use Hasselblad cameras on all future missions, including the Apollo programme that culminated in the first moon landing in 1969.

The particular camera shown here is one of a batch of modified Hasselblad SWC (short for 'Super Wide Camera) cameras, fitted with a Zeiss Biogon 38mm wide-angle lens. These were intended to be used on the surface of the Moon. However, none of these were ever used because NASA decided instead to use modified Hasselblad 500EL cameras, which incorporated an electric motor for automatically advancing the film and cocking the shutter. About 30 of these cameras, known as the Hasselblad HDC, were made. Eleven of them are still on the Moon – they were left there and only the film magazines were brought back. They are, quite literally, cameras that are 'out of this world'.

The Canon AE-1

COMBINING COMPUTER TECHNOLOGY WITH INJECTION-MOULDED

PLASTICS, CANON ATTEMPTED TO PACK PROFESSIONAL

FEATURES INTO AN AFFORDABLE BODY – AND SUCCEEDED.

The Canon AE-1 represents a transition in camera history – a watershed where mechanics gave way to electronics and metal gave way to plastic. It was phenomenally successful, becoming the highest-selling SLR camera. For some, the Canon AE-1 marks the end of the era of 'classic' cameras. However, if innovation and commercial success are in any way suitable criteria, then the AE-1 must take its place as a modern classic.

Electronics had become an increasingly important factor in camera design since the 1960s. In 1971, the Praktica LLC was the first camera to have an electronic link between camera and lens, and the following year the Pentax ES became the first camera to incorporate a printed circuit board. In 1976 Canon took these developments a stage further and, building on the expertise they had gained in the manufacture of other electronic products such as pocket calculators, launched the AE-1, standing for 'Automatic Exposure One'.

The body of the Canon AE-1 is made from injection-moulded acrylonitrile-butadiene-styrene, or ABS for short. However, Canon went to great lengths to disguise the fact that this was a plastic camera, giving it a satin chrome or black enamel finish to replicate the look and feel of metal.

The Canon AE-1 is a shutter-priority SLR – quite unusual at a time when aperture-priority was more the norm. The photographer selects the shutter speed (from 2 to 1/1000sec) and the camera automatically selects and sets the appropriate aperture. With the automatic function turned off, the camera can be used manually, with a pointer needle in the viewfinder indicating the recommended f-stop.

The Canon AE-1 sold in unprecedented numbers. In 1977, the one-millionth AE-1 to come off the production line was presented to the Science Museum in London (right).

'... if innovation and commercial success are in any way suitable criteria, then the AE-1 must take its place as a modern classic.'

The AE-1 was the first 'computerized' camera, incorporating a CPU, or Central Processing Unit, to control exposure. The philosophy behind the AE-1 was to produce a camera with features that had hitherto only been found on top-of-the-range models, but at a price that would appeal to the average amateur. Central to this was mass-production and the use of plastics instead of metal.

By the time the model was discontinued in 1984 an estimated five million AE-1s had been sold worldwide. The success of the AE-1 prompted the appearance of several variations. In 1981, Canon brought out an upgraded version, known as the AE-1 Program, with programmed exposure control.

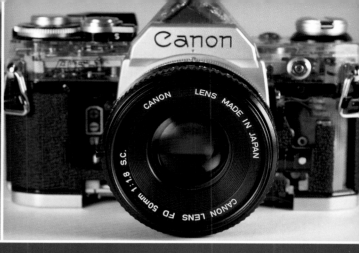
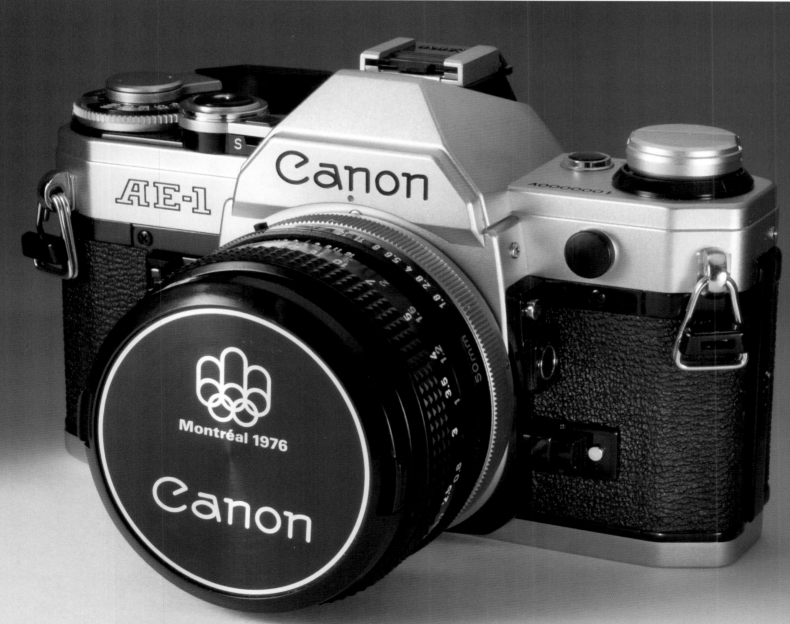

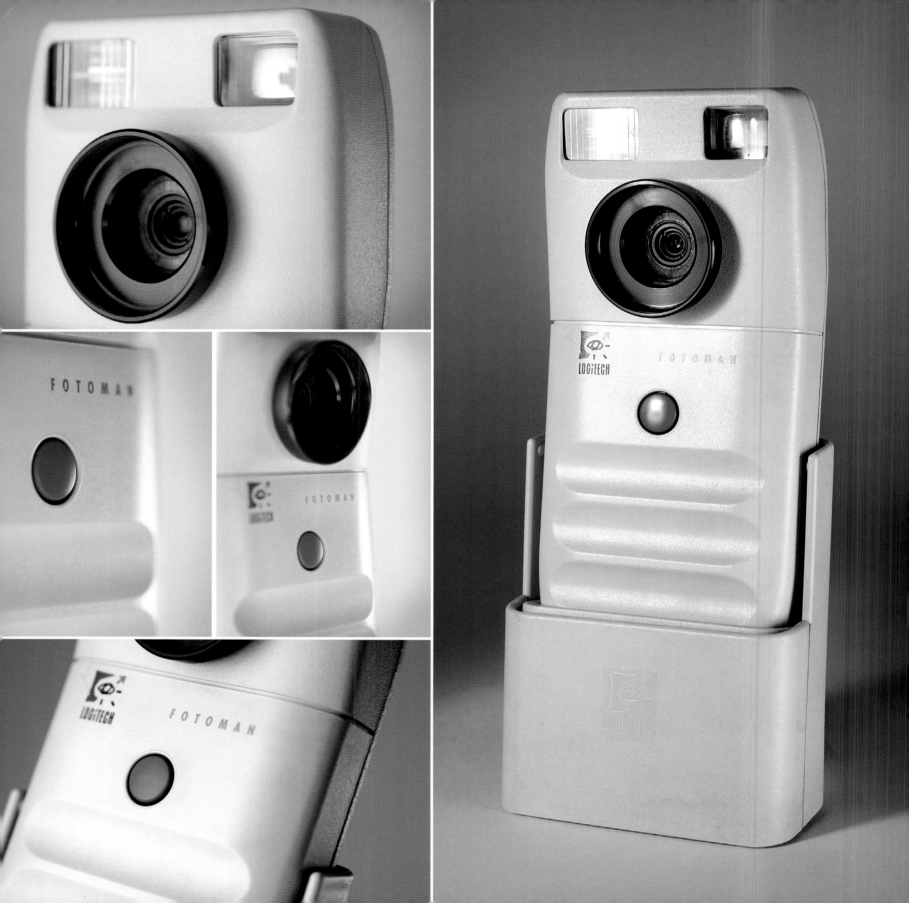

The FotoMan

THE FIRST WIDELY AVAILABLE DIGITAL CAMERA APPEARED IN 1990. CRUDE BY TODAY'S STANDARDS, IT NEVERTHELESS REPRESENTED A WHOLE NEW PARADIGM IN PHOTOGRAPHY.

The so-called digital revolution in photography has been all-consuming – seemingly taking even the hardest-headed brains in the business by surprise – to the extent that it is easy to forget just how recent an innovation digital photography is. True, way back in 1973, Steve Sasson, an engineer at Eastman Kodak in America, made what is regarded as the first digital camera. However, this weighed nearly 8½ pounds (4kg) and took over 20 seconds to download a 0.01 megapixel black and white image onto an audio cassette tape. Needless to say, this prototype never made it onto the market!

The world had to wait a little longer for the first consumer digital camera. In 1988 Fuji introduced their landmark DS-1P digital camera, but this was sold only in Japan. The first digital consumer camera to be widely available was the Logitech FotoMan, which first appeared in 1990.

The FotoMan was manufactured by the Dycam Corporation in the United States. Two versions were marketed – the Dycam Model 1 in black and the FotoMan in white. The FotoMan was aimed primarily at members of the business community, such as estate agents, who wanted to add photographs to documents and for whom convenience and ease-of-use were more important than the quality of the image. In many ways it was the digital equivalent of the first Kodak camera which had appeared almost exactly a century before, and, with hindsight, it might turn out to be equally significant.

'Ergonomically designed, it was a point-and-shoot camera which gave the user very little to do.'

Ergonomically designed, it was a point-and-shoot camera which gave the user very little to do. The FotoMan had a fixed-focus lens with a depth of field from 3¼ feet (1m) to infinity, an electronic shutter operating at about 1/25sec, and built-in automatic flash.

The *New York Times* described it as 'the Brownie of the personal computer set'. The camera produced black-and-white images just 284 by 376 pixels – good enough for screen resolution but not much else. Up to 32 monochrome pictures could be stored in the camera's internal memory. Convenience did not come cheap. The FotoMan cost £499. Back in 1992, you could have bought a Canon EOS 100 or a Nikon F801 for that sort of money.

Basic as it was by today's standards, some people at the time recognized the significance of the FotoMan as heralding the future of photography.

In January 1993, *The Photographer* magazine introduced a new monthly column on electronic imaging. The first camera review, written by John Henshall, was of the FotoMan: 'Logitech's camera is not photography as we know it … . This is the way of the future and the FotoMan camera is so revolutionary, so futuristic, that it is undoubtedly the product of the imagination of some visionary of the future of photography.' Prophetic words indeed.

Further Information

This list of references is by no means comprehensive. It is hoped, however, that it will provide a useful starting point for those who wish to find out more about particular cameras in this book. There are, of course, many additional references to specific cameras in the books listed as 'Suggested Reading'. All of these sources are available, together with a wealth of other research material, by appointment, in Insight: Collections & Research Centre at the National Media Museum, Bradford. The accession numbers refer to the Museum's cataloguing system.

THE APTUS (page 90)

Accession number 1990-5036/4799 John Coathup, 'Not Just An Old-Fashioned Photographic Dealer', *Photographica World*, Number 125, Autumn 2008. Colin Harding, 'Photographs While-You-Wait: Part Three – The Inter-War Years', *Photographica World*, Number 72, March 1995.

ARCHER'S CAMERA (page 28)

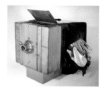

Accession number 2003-5001/1/4880 (The Royal Photographic Society Collection at the National Media Museum.) Frederick Scott Archer, 'On a Camera where the whole Process of a Negative Picture is completed within the Box itself', *The Journal of the Photographic Society*, No 3, April 21, 1853.

THE ARTIST HAND CAMERA (page 70)

Accession number 1950-333 'The Artist', *Photography Annual*, 1891, p. 310.

BEAU BROWNIE (page 115)

Accession number 1990-5036/1655 'No 2 Beau Brownies', *The British Journal Photographic Almanac*, 1932, p. 284.

THE BROWNIE (page 78)

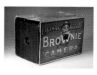

Accession number 1990-5036/1651 Eaton S. Lothrop Jr, 'The Brownie Camera', *History of Photography*, Volume 2, Number 1, January 1978. 'A 5/- Kodak, The Brownie', *The Amateur Photographer*, May 11, 1900. 'The Brownie Hand Camera', *The British Journal Photographic Almanac*, 1901, p. 931. 'The Brownie Kodak', *The Photographic News*, May 11, 1900.

CAMERA OBSCURA (page 12)

Accession number 1937-342 John H. Hammond, *The Camera Obscura: A Chronicle*, Adam Hilger Ltd, 1981.

THE CANON AE-1 (page 178)

Accession number 1978-312 Geoffrey Crawley, 'The Canon AE-1', *The British Journal of Photography*, January 28, 1977 (part one), February 4, 1977 (part two). Stephen Bayley, *The Good Camera Guide*, Virgin Books, 1982.

THE CANON IIB (page 142)

Accession number 1990-5036/4625 Peter Dechert, *Canon Rangefinder Cameras 1933-68*, Hove Foto Books, 1985. Irving R. Lorwin, 'Japan's Cameras', *Popular Photography*, September 1946. 'The Hansa Canon', *The Miniature Camera Magazine*, May 1943.

THE CANON PELLIX (page 174)

Accession number 1990-5036/4698 Geoffrey Crawley, 'The Canon Pellix', *The British Journal of Photography*, June 11, 1965. Neville Maude, 'The Canon Pellix', *Amateur Photographer*, July 28, 1965.

CAPTAIN FOWKE'S CAMERA (page 32)

Accession number 1908-134 John Hannavy, 'Francis Fowke', *The Encyclopedia of Nineteenth Century Photography*, CRC Press, 2008. Fowke's obituary, *The Times*, December 14, 1865.

COMPASS CAMERA (page 128)

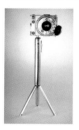

Accession number 1990-5036/2054 'M.C.M. Tests the Compass Camera', *The Miniature Camera Magazine*, March 1937. 'Modern Miniature Cameras: The Compass', *The Amateur Photographer*, May 4, 1938. William White, *Subminiature Photography*, Focal Press, 1990.

THE CONTAFLEX (page 123)

Accession number 1990-5036/1713 D.B. Tubbs, *Zeiss Ikon Cameras 1926-39*, Hove Camera Foto Books, 1977. 'Modern Miniature Cameras: The Contaflex', *The Amateur Photographer*, September 14, 1938. 'The Contaflex Camera', *The British Journal Photographic Almanac*, 1936, p. 266.

THE CONTAX (page 116)

Accession number 1990-5036/4321 'Contax Miniature Camera', *The British Journal Photographic Almanac*, 1933, p. 263. D.B. Tubbs, *Zeiss Ikon Cameras 1926–39*, Hove Camera Foto Books, 1977.

THE CONTAX S (page 145)
Accession number 1990-5036/3923
Charles M. Barringer and Marc James Small,
Zeiss Compendium East and West, 1940—1972,
Hove Collectors Books, 1995. 'The Contax S',
The Miniature Camera Magazine, September 1951.

CUNDELL'S CAMERA (page 24)

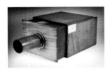

Accession number
2003-5001/1/4158
(The Royal Photographic
Society Collection at the
National Media Museum.). George S. Cundell,
'On the Practice of the Calotype Process of
Photography', *The Philosophical Magazine and
Journal of Science*, Vol XXIV, May 1844.
Michael Pritchard, *The Rise of British Photographic
Manufacturing 1839—c. 1862: Sources and Trends,* in
Pritchard (ed), *Technology and Art — The Birth and
Early Years of Photography*, RPS Historical Group,
1990. W.H. Thornthwaite, *A Guide to Photography*,
Horne, Thornthwaite & Wood, 1851.

DAGRON CAMERA (page 51)
Accession number 1990-5036/7001
Rene Dagron, *Traité de Photographie Microscopique,
Dagron et Cie*, 1864. Jean Scott, *Stanhopes:
A Closer View*, Greenlight Publishing, 2002.

**DANCER'S BINOCULAR STEREOSCOPIC
CAMERA (page 42)**
Accession number 2003-5001/1/4875
(The Royal Photographic Society Collection
at the National Media Museum) J.B. Dancer,
'On the Stereoscope', *Photographic Notes*,
Volume 1, No 5, April 25, 1856. Michael Hallett,
'John Benjamin Dancer 1812—1887:
A Perspective', *History of Photography*, Vol 10,
Number 3, July—September 1986. 'Manchester
Photographic Society', *The Liverpool & Manchester
Photographic Journal*, January 1, 1857.

THE DEMON DETECTIVE (page 65)

Accession number
1990-5036/1196
*The International Annual of
Anthony's Photographic Bulletin*,
1890, advertisement section
p. 97. *Photography Annual*, 1891, advertisement
section p. cxv.

THE DUBRONI (page 36)
Accession number 2003-5001/1/2973
(The Royal Photographic Society Collection at
the National Media Museum.) Colin Harding,
'The Dubroni Camera', *Photographica World*,
No 73, June 1995. Louis Rambert, 'Le Dubroni;
Un appareil à développement instante',
Prestige de la Photo, No 1, June 1977.

THE ERMANOX (page 104)

Accession number
1979-559/174
'The Ernemann Er-Nox F/2
Camera', *The British Journal
Photographic Almanac*, 1925, p. 333.
'The Ernox Camera', *The Amateur Photographer*,
October 29, 1924.

L'ESCOPETTE (page 66)

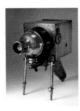

Accession number
2003-5001/1/2978
(The Royal Photographic
Society Collection
at the National Media Museum)
'Our Leaders, No.22, Fred
Boissonnas, Geneva', *The Practical Photographer*,
December 1, 1894. Pascale Bonnard Yersin and
Roland Cosandey, *L'Escopette de M.F. Boissonnas
à la fête des vignerons. Un reportage photographique
avant la lettre, Musée Suisse de l'appareil
photographique*, Éditions Slatkine, 1999.

THE FACILE (page 54) Accession number

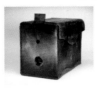

2003-5001/1/4870
(The Royal Photographic
Society Collection
at the National Media
Museum) 'Miall's Patent
Facile Detective Camera', *The Amateur
Photographer*, May 24, 1889. T. Bolas,
'The Detective Camera', *The Photographic News*,
January 28, 1881. 'The Facile', *Photography
Annual*, 1891, p. 296. Roy Fluckinger, Larry
Schaaf and Standish Meacham, *Paul Martin:
Victorian Photographer*, Gordon Fraser, 1978.

FOLDING POCKET KODAK (page 74)

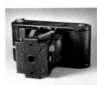

Accession number
1990-5036/0880
Keith Christie, 'Forty
Years of the Folding Pocket
Kodak', *Photographica World*,
Number 69, June 1994. Keith Christie, 'After
the Folding Pocket Kodak', *Photographica World*,
Number 72, March 1995. 'The Eastman
Exhibition', *The Photogram*, December 1897.
'The Eastman Photographic Exhibition:
Apparatus, etc.' *The Amateur Photographer*, October
29, 1897. 'The Folding Pocket Kodak', *The British
Journal of Photography*, November 12, 1897.

THE FOTOMAN (page 181)
Accession number 2007-5044
John Henshall, 'Black 'n' White 'n' Basic',
The Photographer, January 1993.

THE FRENA (page 72)

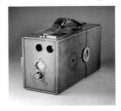

Accession number
1990-5036/2837
Robert White, 'Frena
Cameras', *Photographica
World*, Number 23,
November 1982.

GANDOLFI PRISON CAMERA (page 139)

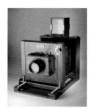

Accession number 1983-833 James Clement, 'Gandolfi Brothers: A Family Firm', *The British Journal of Photography*, August 8, 1980. John Jenkins, 'Louis Gandolfi & Sons – Cameramakers 1880–1981', *The Photographic Collector*, Volume 3, Number 1, Spring 1982.

GIROUX CAMERA (page 19)

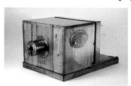

Accession number 1990-5036/6955 Helmut Gernsheim, *L.J.M. Daguerre: The History of the Diorama and the Daguerreotype*, Secker & Warburg, 1956. Ake Hultman, 'Is this the Earliest Giroux Daguerreotype Camera in Existence?' *Photographica World*, Number 102, Winter 2002.

GOERZ ANSCHUTZ CAMERA (page 80)

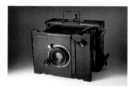

Accession number 1990-5036/0122 'The Anschütz', *Photography Annual*, 1892, p. 358. 'The Goerz-Anschütz Folding Camera (New Model)', *The British Journal of Photography*, April 26, 1907.

HASSELBLAD LUNAR SURFACE CAMERA

(page 177) Accession number 1978-512 Richard Nordin, *Hasselblad Compendium*, Hove Books, 1998.

ILFORD ADVOCATE (page 157)

Accession number 1990-5036/3997 Colin Harding, 'Great White Hope: The Ilford Advocate', *Photographica World*, Number 68, March 1994. R.J. Hercock and George Alan Jones, *Silver by the Ton: The History of Ilford Limited, 1879–1979*, McGraw-Hill, 1979. Andrew J. Holliman, *Faces, People and Places: The Cameras of Ilford Limited, 1899 to 2005*, Andrew J. Holliman, 2006. 'The Ilford Advocate', *Amateur Photographer*, June 29, 1949. 'The Ilford Advocate Camera', *The British Journal of Photography*, June 24, 1949.

THE INSTAMATIC 50 (page 173)

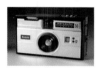

Accession number 1990-5036/4563 Neville Maude, 'Revolutionary Film Cassette in New Kodak Cameras', *Amateur Photographer*, March 20, 1963. 'The New Kodak Instamatic Cameras', *The British Journal of Photography*, March 8, 1963.

THE JOS-PE (page 107)

Accession number 1990-5036/3527 Brian Coe, *Colour Photography: The First 100 Years*, Ash & Grant, 1978. Jack Coote, *The Illustrated History of Colour Photography*, Fountain Press, 1993. 'The Jos-Pe Colour Process', *The British Journal of Photography Colour Supplement*, April 3, 1925.

THE KINE EXAKTA (page 132)

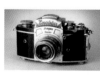

Accession number 1990-5036/4028 Clement Aguila and Michel Rouah, *Exakta Cameras 1933–1978*, Hove Foto Books, 1987. 'The Kine Exakta', *The Amateur Photographer & Cinematographer*, July 28, 1937. 'The Kine Exakta Camera', *The British Journal Photographic Almanac*, 1937, p. 259. 'The New Kine Exakta', *The British Journal of Photography*, August 13, 1937.

KNIGHT'S DAGUERREOTYPE CAMERA

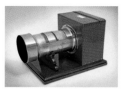

(page 23) Accession number 1982-1501 George Knight & Sons, *Illustrated catalogue of apparatus and materials required in the practice of photography*, George Knight & Sons, 1853. W.H. Thornthwaite, *A Guide to Photography*, Horne, Thornthwaite & Wood, 1851.

THE KODAK (page 61)

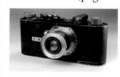

Accession number 1990-5036/1369 Colin Harding, *A Centenary History of the Kodak*, National Museum of Photography, Film & Television, 1988. Reese V. Jenkins, *Images and Enterprise: Technology and the American Photographic Industry 1839 to 1925*, Johns Hopkins University Press, 1975. 'The Detective Camera of the Eastman Company: The Kodak', *The Photographic News*, September 14, 1888. 'The Kodak', *The Amateur Photographer*, September 21, 1888. 'The Kodak', *The British Journal of Photography*, September 14, 1888.

THE LEICA (page 112)

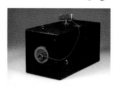

Accession number 1979-559/143 Paul-Henry van Hasbroeck, *Leica: A History Illustrating Every Model and Accessory*, Sotheby Publications, 1983.' Leica Cine Film Camera', *The British Journal Photographic Almanac*, 1926, p. 328. Thurman F. Naylor, 'A New Look at the Old 35: The Origin and Early History of 35mm Photography', *Cameras and Images International Inc*, 1980. Gianni Rogliatti, *Leica: The First 70 Years*, Hove Collectors Books, 1995.

THE LEICA M3 (page 165)

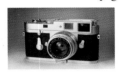

Accession number 1979-559/680 Jonathan Eastland, *Leica M Compendium: Handbook of the Leica M System*, Hove Books, 1994. 'The Leica M3', *The British Journal of Photography*, April 16, 1954.

LOMAN'S PATENT REFLEX (page 69)

Accession number 1989-5002 'Loman's Reflex Camera', *The Amateur Photographer*, May 29, 1891. 'Sutton's New Instantaneous & Portrait Camera', *Photographic Notes*, October 1, 1861. 'The Reflex', *Photography Annual*, 1892, p. 349.

THE LUZO (page 62)

Accession number

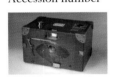

1990-5036/4243 'The Luzo', *Photography Annual*, 1893, p. 361. 'The Luzo Rollable-Film Hand Camera', *The British Journal Photographic Almanac*, 1898, p. 912.

MELHUISH'S KINNEAR-PATTERN CAMERA (page 35) Accession number 1993-5000 A.J. Melhuish, 'The Patent Metal Camera', *The British Journal of Photography*, January 1, 1860. 'Letters to a Photographic Friend, No. II', *The British Journal of Photography*, August 1, 1860. 'Mr Kinnear's Portable Camera', *Journal of the Photographic Society*, February 22, 1858. 'Melhuish's Metal Camera', *The Photographic News*, February 17, 1860.

THE MIDG (page 82)

Accession number 1998-5138 Joe Cooper, *The Case of the Cottingley Fairies*, Robert Hale, 1990. Geoffrey Crawley, 'That Astonishing Affair of the Cottingley Fairies' (Part Two), *The British Journal of Photography*, December 31, 1982.

THE MINOX (page 131)

Accession number 1990-5036/4322 Morris Moses, *Spy Camera: The Minox Story,* Hove Foto Books, 1990. 'The Extreme in Miniatures', *The British Journal of Photography*, June 3, 1938. 'The Minox Miniature Camera', *The Amateur Photographer*, January 31, 1940. 'The Minox Precision Miniature', *The Miniature Camera Magazine*, October 1939. D. Scott Young, *Minox: Marvel in Miniature*, Author House, 2000.

THE NIKON F (page 166)

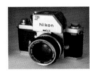

Accession number 1990-5036/6772 Uli Koch, *Nikon F Trilogy*, Peter Coeln, 2003. Brian Long, *Nikon: A Celebration*, The Crowood Press, 2006.

THE NIKON M (page 154)

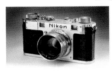

Accession number 1990-5036/3548 John Wolbarst, 'Report on the Nikon', *Modern Photography*, June 1951. Robert Rotolini, *Nikon Rangefinder Cameras*, Hove Foto Books, 1983. 'Watch the Japs! A New Influence in the Camera Market', *Miniature Camera Magazine*, September 1951.

OLYMPUS PEN FT (page 170)

Accession number 1990-5036/6555 John Foster, *Olympus Pen SLR Half-Frame System Cameras – A Definitive Guide for Collectors*, Biofos Publications, 2002. Jerry Friedman, 'Olympus Half Frame Cameras', *Photographica World*, Number 82, Autumn 1997.

OTTEWILL'S DOUBLE FOLDING CAMERA (page 31) Accession number 1990-5036/7299 S.F. Spira, 'Carroll's Camera', *History of Photography*, Volume 8, Number 3, July–September 1984. 'Ottewill's Registered Double Folding Camera', *The Journal of the Photographic Society*, December 21, 1853.

PANTASCOPIC CAMERA (page 40)

Accession number 1990-5036/3827 *Photographic Notes*, July 15, 1863. 'The Pantascopic Camera', *The Photographic Journal*, January 16, 1865. J.R. Johnson, 'On the Pantascopic Camera', *The British Journal of Photography*, March 23, 1866.

THE PERIFLEX (page 161)

Accession number 1990-5036/2406 Sir Kenneth Corfield, 'Recollections', *Photographica World*, Number 71, December 1994. John E. Lewis, *The Periflex Story*, Ericsen Lewis Publications, 1985. 'New Apparatus and Materials: Periflex 35mm Camera', *The British Journal of Photography*, May 18, 1956. 'Periflex 35mm Camera', '*The British Journal Photographic Almanac*', 1956, p. 166. 'Talking Shop', *Amateur Photographer*, May 20, 1953.

PIAZZI SMYTH'S CAMERA (page 48)

Accession number 2003-5001/1/2975 (The Royal Photographic Society Collection at the National Media Museum) John Nicol, 'Photography in and about the Pyramids: How it was accomplished by Prof. C. Piazzi Smyth', *The British Journal of Photography*, June 8, 1866. Larry Schaaf, 'Charles Piazzi Smyth's Conquest of the Great Pyramid', *History of Photography*, Volume 3, Number 4, October 1979.

POLAROID LAND CAMERA, MODEL 95

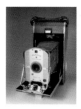 (page 153) Accession number 1990-5036/2828
Victor K. McElheny, *Insisting on the Impossible: Life of Edwin Land — The Inventor of Instant Photography*, Perseus Books, 1998. 'The Land Camera', *American Photography*, March, 1949. 'The Land One-Minute Camera', *Amateur Photographer*, July 6, 1949.

POLAROID LAND AUTOMATIC 100 (page 168)
Accession number 1978-292
Bernard Leblanc, 'Polaroid Story', *Zoom* (special Polaroid issue), 1980. Neville Maude, 'The Polaroid Land Camera Automatic 100', *Amateur Photographer*, October 23, 1963.

POLYFOTO CAMERA (page 127)
Accession number 1990-5036/8583
'Polyfoto – The New Portrait Photography', *The British Journal of Photography*, July 21, 1933. Charles Stokes, 'Polyfoto: The New Portrait Photography', *Photographica World*, Number 64, March 1993.

PURMA SPECIAL (page 135)

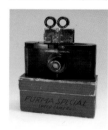 Accession number 1990-5036/6605
'Modern Miniature Cameras:
The Purma-Special', *The Amateur Photographer*, June 2, 1937.
Norman Channing and Mike Dunn, 'Purma Cameras: A New Source of Information', *Photographica World*, Number 82, Autumn 1997. 'The Purma Special Camera', *The British Journal Photographic Almanac*, 1938, p. 254. 'The Purma Special Speed Camera', *The British Journal of Photography*, August 20, 1937.

QUEEN MARY'S DOLLS' HOUSE CAMERA
(page 101) Accession number 1990-5036/7082
Colin Harding, 'Masterpieces in Miniature; Queen Mary's Dolls' House Cameras', *Photographica World*, Number 81, Summer 1997.

THE RECTAFLEX (page 146)
Accession number 1984-173
Marco Antonetto, *Rectaflex – The Magic Reflex*, Nassa Watch Gallery, 2002. 'The Rectaflex', *Amateur Photographer*, May 19, 1954.

THE REID (page 162)

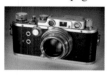 Accession number 1990-5036/2761
Mike Hardy, 'The Reid Camera', *Photographica World*, Number 93, Summer 2000. 'HPR', *Leica Copies*, Classic Collection Publications, 1994. 'The Reid Camera', *Amateur Photographer*, May 23, 1951.

THE RETINA (page 119)
Accession number 1990-5036/1742
David L. Jentz, 'The Retina I Camera', *Photographica World*, Number 67, December 1993. 'Kodak Retina Camera', *The British Journal Photographic Almanac*, 1935, p. 285. Helmut Nagel, *Zauber Der Kamera*, DVA, 1977. 'The Retina Miniature Camera', *The Amateur Photographer*, December 5, 1934.

THE ROLLEIFLEX (page 108)

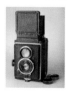 Accession number 1990-5036/0912
Gerald Davies, 'The Rolleiflex at 75 Years Old', *Photographica World*, Number 110, Winter 2004. Ian Parker, *Rollei TLR: The History*, Hove Foto Books, 1992. 'Rolleiflex Roll-Film Reflex Camera', *The British Journal Photographic Almanac*, 1930, p. 338.

SANDERSON CAMERAS (page 86)
Accession number 1979-559/652
Cliff Bulcock, 'Dating the Sanderson', *Photographica World*, Number 120, Summer 2007 (part one) *Photographica World*, Number 123, Spring 2008 (part two).

SKAIFE'S PISTOLGRAPH (page 44)
Accession number 1977-578.
'Letters to a Photographic Friend, No. VIII', *The British Journal of Photography*, November 1, 1860. Larry Schaaf, 'Thomas Skaife's Pistolgraph and the Rise of Modern Photography in the Nineteenth Century', *The Photographic Collector*, Vol 4, Number 1, Spring 1983. T. Skaife, *Guide to the Pistolgraph*, Skaife's Pistolgraph Depot, 1861.

SOHO TROPICAL REFLEX CAMERA

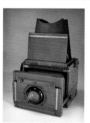 (page 94)
Accession number 1990-5036/1542
George E. Brown, 'Reflex Cameras', *The British Journal Photographic Almanac*, 1909, p. 526.
'New Models of the Soho Reflex', *The British Journal of Photography*, May 14, 1909. 'The Exhibition of Reflex Cameras', *The British Journal of Photography*, June 14, 1907. 'The Soho Focal-Plane Reflex Hand Camera', *The Amateur Photographer*, August 8, 1905. 'The Soho Reflex Camera', *The British Journal Photographic Almanac*, 1906, p. 899.

SPEED GRAPHIC (page 124)

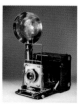 Accession number 1982-40.
Willard D. Morgan and Henry M. Lester, *Graphic Graflex Photography*, Morgan & Morgan, 1971.

STEREO REALIST (page 149)

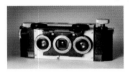

Accession number 1990-5036/4354 Herbert C. McKay, 'The Stereo Realist', *American Photography*, December 1947. Willard D. Morgan and Henry M. Lester, *Stereo Realist Manual*, Morgan & Lester, 1954.

STIRN'S 'AMERICA' DETECTIVE CAMERA (page 56) Accession number 1950-339 'An Improved Detective Camera', *The Amateur Photographer*, May 13, 1887. 'The "American"', *Photography Annual*, 1891, p. 305.

STIRN'S WAISTCOAT CAMERA (page 58)

Accession number 1990-5036/1189 Eaton S. Lothrop Jr and Michel Auer, *Die Geheimkameras*, Heering, 1978. 'Gray's Vest Camera', *The Philadelphia Photographer*, October 16, 1886. *Photographische Geheim — Camera von Rudolf Stirn*, *Jahrbuch für Photographie*, 1888, p. 402.

THE SUPER KODAK SIX-20 (page 136) Accession number 1990-5036/1744 'Trade News and Notes', *American Photography*, September 1938, p. 683.

SUTTON PANORAMIC CAMERA (page 39)

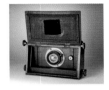

Accession number 2003-5001/1/4343 (The Royal Photographic Society Collection at the National Media Museum.) Brian Polden, 'Photography at Length (Part 3)', *Photographica World*, Number 104, Summer 2003. Thomas Sutton, 'Panoramic Photography', *The Photographic Journal*, March 15, 1860.

See also 'On Panoramic and Plane Perspective', *The Photographic Journal*, April 16, 1860. J. Traill Taylor, 'Photographic Panoramas and the Means of Making Them', *The British Journal Photographic Almanac*, 1892.

TALBOT'S 'MOUSETRAP' (page 16)

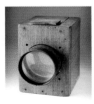

Accession number 1937-343 Larry J. Schaaf, *Out of the Shadows: Herschel, Talbot & the Invention of Photography*, Yale University Press, 1992. John Ward, 'The Fox Talbot Collection at the Science Museum', *History of Photography*, Volume 1, Number 4, October 1977.

THOMPSON'S REVOLVER CAMERA (page 47)

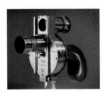

Accession number 1991-5101 'Le Revolver Photographique', *Bulletin de la Société Française de Photographie*, July 1862.

THE TICKA (page 89) Accession number 1990-5036/1723 'The Ticka Camera', *The British Journal Photographic Almanac*, 1907, p. 905. 'Watch-Face and Focal-Plane Ticka Cameras', *The British Journal Photographic Almanac*, 1909, p. 715.

UNIVERSAL SPECIAL B (page 93)

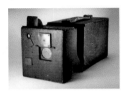

Accession number 1990-5036/4042. 'How Messrs Newman & Guardia Make a Hand Camera', *The British Journal of Photography*, January 17, 1896. 'The N & G Special Pattern B', *Photography Annual*, 1896, p. 358. Martin Russell, *Newman & Guardia Ltd*, Emanem Books, 1988.

VEST POCKET KODAK (page 97)

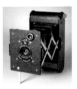

Accession number 1990-5036/4403 Jim Anderson, 'The Lazy-tongs Vest Pocket Kodak', *Photographica World*, Number 82, Autumn 1997. 'The Vest Pocket Kodak', *The Amateur Photographer & Photographic News*, July 1, 1912. 'The Vest Pocket Kodak', *The British Journal Photographic Almanac*, 1913, p. 743.

VOIGTLANDER DAGUERREOTYPE CAMERA

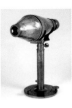

(page 20) Accession number 1990-5036/6956 Ian Parker, 'Josef Max Petzval', *Photographica World*, Number 92, Spring 2000. Rudolf Kingslake, *A History of the Photographic Lens*, Academic Press, 1989.

THE WITNESS (page 150)

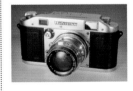

Accession number 1990-5036/0450 Percy W. Harris, 'The Witness: A New British Precision Miniature Camera', *The Miniature Camera Magazine*, April 1951. Dave Todd, 'Ilford Witness', *Photographica World*, Number 57, June 1991.

THE WRAYFLEX (page 158)

Accession number 1990-5036/1704 Frank Porritt, 'Wrayflex Revealed — An Engineer's View', *Photographica World*, Number 120, Summer 2007. John Wade, *The Wrayflex Story*, Wordpower Publishing, 2008. 'The Wrayflex', *Amateur Photographer*, December 9, 1953. 'The Wrayflex', *The Miniature Camera Magazine*, July 1951.

Suggested Reading

Michel Auer
The Illustrated History of the Camera from 1839 to the Present,
Fountain Press, 1975.

Norman Channing and Mike Dunn
British Camera Makers: An A-Z Guide to Companies and Products,
Parkland Designs, 1996.

Brian Coe
Cameras: From Daguerreotypes to Instant Pictures,
Nordbok, 1978.
Kodak Cameras: The First Hundred Years,
Hove Foto Books, 1988.

Harry I. Gross
Antique and Classic Cameras, Amphoto 1965.

Paul-Henry van Hasbroeck
150 Classic Cameras: From 1839 to the Present,
Sotheby's Publications, 1989.

Roger Hicks
A History of the 35mm Still Camera, Focal Press, 1984.

Edward Holmes
An Age of Cameras, Fountain Press, 1974

Gordon Lewis (Ed.)
The History of the Japanese Camera,
George Eastman House, 1991.

Eaton S. Lothrop Jr
A Century of Cameras, Morgan & Morgan, 1973.

Ivor Matanle
Collecting and Using Classic Cameras,
Thames and Hudson, 1986.

James M. McKeown
McKeown's Price Guide to Antique and Classic Cameras,
Centennial Photo Service, 2006.

Cyril Permutt
Collecting Old Cameras, Da Capo Press, 1976.

Michael Pritchard and Douglas St. Denny
Spy Camera: A Century of Detective and Subminiature Cameras,
Classic Collection Publications, 1993.

Kate Rouse
The First-Time Collector's Guide to Classic Cameras,
The Apple Press, 1994.

R.C. Smith
Antique Cameras, David & Charles, 1975.

S.F. Spira
*The History of Photography — As Seen Through the Spira
Collection,* Aperture, 2001.

The Science Museum Camera Collection,
The Science Museum, 1981.

D.B. Thomas
The Science Museum Photography Collection, HMSO, 1969.

John Wade
A Short History of the Camera, Fountain Press, 1979.
The Collector's Guide to Classic Cameras, Hove Books, 1999.
Cameras in Disguise, Shire Publications, 2005.

Robert White
Discovering Old Cameras 1839–1939,
Shire Publications, 2001.
Discovering Cameras 1945–1965, Shire Publications, 2001.

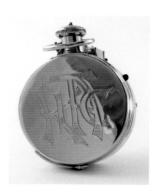

Acknowledgements

Over the past 25 years I have had the pleasure and privilege of meeting many curators, collectors and photo-historians who have graciously and generously shared their knowledge of classic cameras. This book is a modest and sincere expression of my enormous debt and gratitude.

The original idea for this book came from a series of articles on 'Classic Cameras' which I contributed to *Black & White Photography* magazine. I should like to thank the past and present editors of the magazine, Ailsa McWhinnie and Elizabeth Roberts for their enthusiasm, help and support.

I should also like to thank all my friends and colleagues at the National Media Museum, especially Toni Booth, Paul Goodman, Ruth Kitchin and Brian Liddy.

I should particularly like to thank Paul Thompson, not only for his superb photography but also for his professionalism in coping with the many and sometimes conflicting demands on his time and for doing so with both patience and good humour.

Inevitably, writing a book consumes an enormous amount of time and effort – time which could otherwise have been devoted to more pressing and important tasks. This book would not have been possible without the patience, understanding and support of my family. I should like to thank my wife, Judith, for putting up with me, and my children, Rachael and Tom, for coming to terms with having a 'geek' as a father.

This book draws extensively on many secondary sources and I make no claims for original scholarship. Any insights stem from the work of others. However, any deficiencies, errors or omissions are my responsibility and mine alone.

FILM NATIONAL MEDIA TELEVISION RADIO MUSEUM WEB PHOTOGRAPHY

Picture Credits

All of the cameras in this book are from the collection of the National Media Museum. All of the images are copyright National Media Museum/ Science and Society Picture Library and must not be reproduced without permission. The following cameras are from The Royal Photographic Society Collection and are copyright The Royal Photographic Society Collection at the National Media Museum/SSPL: Cundell's camera (page 24), Archer's camera (page 28), The Dubroni (page 36), Sutton's panoramic camera (page 38), Dancer's camera (page 42), Piazzi Smyth's camera (page 48) The Facile (page 54), L'Escopette (page 66). The portraits of William Henry Fox Talbot (page 17) and Frederick Scott Archer (page 28) also form part of the Royal Photographic Society Collection and are copyright The Royal Photographic Society Collection at the National Media Museum/SSPL.

If you would like to buy a copy of any of the photographs in this book, or have an enquiry regarding their reproduction, you should contact:

The Science and Society Picture Library
The Science Museum
Exhibition Road
South Kensington
London
SW7 2DD

Telephone: (+44) (0) 20 7942 4400
Facsimile: (+44) (0) 20 7942 4401
E-Mail: piclib@nmsi.ac.uk
www.scienceandsociety.co.uk

Index

PHOTOGRAPHERS' INSTITUTE PRESS
Castle Place, 166 High Street, Lewes, East Sussex BN7 1XU, United Kingdom
Tel: 01273 488005 Fax: 01273 402866 Website: www.pipress.com

Contact us for a complete catalogue, or visit our website. Orders by credit card are accepted.